Meta-luxury

Meta-luxury

Brands and the Culture of Excellence

Manfredi Ricca

Rebecca Robins

First published 2012 by
PALGRAVE MACMILLAN

Palgrave Macmillan in the UK is an imprint of Macmillan Publishers Limited,
registered in England, company number 785998, of Houndmills, Basingstoke,
Hampshire RG21 6XS.

Palgrave Macmillan in the US is a division of St Martin's Press LLC,
175 Fifth Avenue, New York, NY 10010.

Palgrave Macmillan is the global academic imprint of the above companies
and has companies and representatives throughout the world.

Palgrave® and Macmillan® are registered trademarks in the United States,
the United Kingdom, Europe and other countries

ISBN-13: 978-0-230-29357-1

This book is printed on paper suitable for recycling and made from fully
managed and sustained forest sources. Logging, pulping and manufacturing
processes are expected to conform to the environmental regulations of the
country of origin.

A catalogue record for this book is available from the British Library.

A catalog record for this book is available from the Library of Congress.

10 9 8 7 6 5 4 3 2
21 20 19 18 17 16 15 14 13 12

Printed and bound in Great Britain by
CPI Antony Rowe, Chippenham and Eastbourne

To Cecilia and Lavinia,
l'amor che move il sol e l'altre stelle.

And to my family,
quattro stelle non viste mai fuor ch'a la prima gente.

Manfredi

To M.E.R and K.J.R.

For sharing a love of language and literature.

**For inspiring words that sparkle in the sun
and shine in the night.**

Rebecca

Contents

Foreword

The world of luxury is a source of inspiration, controversy, admiration, awe and, of course, considerable commercial success. The sector has undergone incredible change over the past few years and whilst this transformation has given rise to fascinating case studies, and some amazing news stories, it has also created a considerable degree of confusion around the very meaning of luxury. Today, companies with completely different offers, target audiences and business models use the term 'luxury' to describe themselves, rendering it virtually meaningless.

The questions that started to be raised for us were 'How do we articulate luxury now, how is the market evolving and what are the implications for brands?' And because beauty is in the eye of the beholder, the need to reconsider the idea of luxury does not originate from the offer side alone; it has to do, most importantly, with people. We live in times when change seems to be the only constant, uncertainty the only certainty, and variance the new average. So, what does luxury really mean to each of us as the context shifts?

The recent economic trials and tribulations force us to look hard at our values, and what we value. In times like these, we anchor ourselves to unquestionable truths and authenticity, and we look for objects, experiences and stories that remind us of what we value as individuals. Some brands manage to reflect these truths. They are born of a visionary ambition. They come to stand for unadulterated and unsurpassed excellence. They embrace change while staying relevant in a fast-paced world and preserving their original DNA. Ultimately, they escape short-term compromise to ensure prosperity across generations. Their authenticity is paramount and unquestioned.

This book celebrates these brands, their founders and their guardians, by defining the paradigm of *meta-luxury* – or luxury beyond luxury. Combining an in-depth analysis of the unique cultural, strategic and economic traits of meta-luxury brands with inspiring insights from outstanding thinkers, creators and business leaders, these pages take us on a journey into excellence.

Associating meta-luxury with the nostalgic cliché of the century-old 'artisan workshop' as opposed to the modern global corporation may be instinctive. However, it is also a mistake. To these brands, notions such as authenticity, sustainability, innovation and talent are not recent catchwords, but innate principles. They are not opportunities to reinforce the brand's positioning in the mind of the consumer; they are at the heart of the operating principles of the organisation.

At Interbrand, we believe that brands have the power to change the world. In many ways, meta-luxury brands are the most amazing living testimonies to this belief.

I am confident that the notion of meta-luxury will become part of the common language among those who wish to see excellence as a conviction, rather than luxury as a convention.

I hope you enjoy the read.

Jez Frampton
Global Chief Executive
Interbrand

About this book

There is nothing like diversity and dialogue to encourage thinking and questioning, and the genesis of the notion of meta-luxury was no exception. The idea of a 'luxury beyond luxury' was inspired largely by a considerable number of conversations around the subject of luxury across different continents over the course of over a year.

Despite taking place in diverse contexts and on numerous occasions – from meetings with clients to international conferences, from conversations and interviews with journalists to personal exchanges – these discussions gradually began to reveal a single, albeit unspoken, unifying theme: the increasingly obscure and often negative meaning of the term 'luxury'.

That obscurity is evident in the plurality of synonyms and the sub-set nomenclature that term has evinced. As 'luxury' has become, increasingly, a discourse about 'showing', about the external manifestation of ownership, it is no surprise that the definition, or indeed attempts at the redefinition, of luxury has grown by accumulation. Superlatives such as 'hyper-luxury', 'super-luxury', 'ultra-luxury' and 'high luxury' are used in such proliferation that they are all but self-replicating. Relative terms such as 'premium', 'super-premium', 'high end' and 'exclusive' serve only to demonstrate how diluted the language of luxury has become. Perhaps one of the most problematic – and increasingly pervasive – uses of terminology is to be found in the oxymoronic 'accessible luxury', 'affordable luxury' and even 'masstige' (a compression of 'mass market' and 'prestige'). Whether by way of hyperbolic appendages or by convoluted and diluted neologisms, this very compulsion to label luxury is symptomatic of the level of obfuscation around the original term.

But it is not just about confusion. At the same pace with which certain brands have been, and are, proclaiming or reaffirming their status as luxury brands, many other companies and customers have been, and are, distancing themselves from the same concept.

We believe that this dissociation is not merely the manifestation of a Barbarians-at-the-gate syndrome. Rather, it seems to suggest the genuine longing for a purity that the term 'luxury' no longer encapsulates. The increasingly frequent use of phrases such as 'real' or 'authentic' luxury is the symptom of the term's inadequacy to reflect certain brands and businesses and, most importantly, the very principles that they hold dear.

We coined the term 'meta-luxury' as an internal name. Its absence of a singular definition was part of its simple appeal. It referred to the indefinite, pristine territory lying beyond the chaotic sphere of 'luxury'. As we released it, slowly, into external conversations, to our beautiful surprise, the term seemed to immediately resonate. It appeared to evoke a new world.

A world, of course, whose boundaries, features and culture have yet to be explored. This is precisely the premise of this book.

It is the duty of good hosts to begin by introducing their guests. This book being the result of reflections on countless conversations, we felt passionately that, since its inception, an essential part of its preparation would involve listening rather than writing. Sowing the seed of meta-luxury early on, we anticipated its germination, but we did not categorically presuppose it. We were not interested in the mere positing of a theory. Before even contemplating putting pen to paper, we wanted to obtain valuable opinions on our initial conclusions. We therefore sought the opportunity to discuss the subject of excellence and meta-luxury with several remarkable personalities from a variety of backgrounds. Such diversity reflected our firm intention to escape any conventional wisdom, stereotype or prejudice, and to break away from the temptation to produce yet another business book on luxury.

Our firm belief in meta-luxury as a culture rather than as an industry, and as the result of human longing rather than as a business target drew us to apparently distant worlds of human achievement and, true to the spirit of Romanticism, the journey proved as inspiring and magnetic as the goal itself. These discussions were not planned as a structured research programme; on the contrary, they were the result of a sometimes serendipitous, often Joycean and consistently delightful chain of interlacing debates, convictions, discussions and discoveries.

Some of these conversations took place as informal but enlightening, exchanges on specific facets of meta-luxury. Others were broader, more personal conversations, which went on to form a constellation of individual *témoignages*. We hope that each of them will be as stirring to our readers as it was to us.

These conversations are scattered within the overall flow of the book, which is aimed at building an in-depth understanding of the paradigm of meta-luxury. Not intentionally, but not surprisingly, such a structure intuitively mirrors the logical process through which the notion of meta-luxury came to be in the first place.

This is evident in the first, brief, chapter, *Introduction: Why Meta-luxury?*, where we discuss the need to move beyond what we feel, and what is considered widely now, to be a hollow expression – luxury.

The title of the second chapter, *Defining Meta-luxury*, is self-explanatory. In it, we explore the core of the paradigm: the concepts of knowledge, purpose and timelessness, and their corollary – the notion of unique achievement.

The third chapter, *The Pillars of Meta-luxury*, sets the context for the central part of the book. In these pages we introduce the four pillars of meta-luxury: craftsmanship, focus, history and rarity.

Chapters V to VIII are individually dedicated to capturing the nature, the essence and the implications of the four pillars. We discuss them both individually and as a combined construct.

The ninth chapter, *The Economy of Meta-luxury*, adopts a different approach, looking at the primary brand and business management implications of meta-luxury.

Our very brief epilogue aims to be more than a dry synopsis. Daringly titled *Manifesto*, it is about convictions as much as it is about conclusions. More than anything else, it is the authors' humble tribute to those brands that stand for unique achievements, and to the individuals behind their pursuit.

Acknowledgements

The making of *Meta-luxury* began with a few humble steps. As those steps gathered pace, we began to realise that the journey upon which we had embarked was evolving rapidly into a quest. That quest could not have been accomplished without the inspiration and support of a number of people, who have been vital and valuable at various stages of the development of *Meta-luxury* – from engaging in discussions and debates that helped to inform and challenge our thinking to providing the keys to open doors that might otherwise have remained closed.

Our sincere and heartfelt thanks to:

Caterina Piras, Jean-Baptiste Danet, Adriana Armaroli, Diane and Julian Barrans, Francesca Bianchi, Laura Buonocore, Stefania Canta, Stefano Cantino, Bertrand Chovet, Laura Gorna, Dr Juergen Häusler, Ryuichi Hayashi, Atsushi Iwashita, Niccolò Moschini, Catia Pramazzoni, Paolo Piantella, Carlotta Sapia, Nicola Stanisch, Andrea Tremolada, Elena Turrin, Francesco Zappacosta.

With a special thank-you to Marco Gualdi, without whom all this would not have been possible.

Finally, a special acknowledgement and thanks to the business leaders, practitioners, thought leaders and experts in their respective fields whom we have had both the privilege and pleasure to interview for this book:

Maestro Salvatore Accardo, Dr Hans Peter Danuser Von Platen, Simon Jacomet, Paolo Fazioli, Francis Kurkdjian, Kazumi Murose, Horacio Pagani, Renzo Piano, Dr Michael Scott, Francesco Trapani.

The authors and publishers would like to thank the following for providing photographs:

Maestro Salvatore Accardo
Portrait photograph copyright Davide Vico Chamla, by kind permission of Maestro Salvatore Accardo. Violin photograph copyright Bruce Carlson, Carlson & Neumann – Cremona S.n.c.

Dr Hans Peter Danuser von Platen
Portrait photograph copyright Deutsche Bank (Switzerland) Ltd. Landscape photograph copyright Arianna Ricca.

Paolo Fazioli
By kind permission of Fazioli Pianoforti.

Simon Jacomet
By kind permission of zai.

Francis Kurkdjian
Portrait photograph copyright Nathalie Baetens. Aqua Universalis Forte photograph copyright Maison Francis Kurkdjian.

Kazumi Murose
By kind permission of Mr Kazumi Murose. Box photograph copyright Mr Kazuhiko Ohori, portrait photograph copyright Mr Kentaro Kumon.

Horacio Pagani
Portrait photograph copyright Pagani Automobili SpA. Huayra photograph copyright Roberto Carrer/Roberto Morelli.

Renzo Piano
Portrait photograph copyright, and by kind permission of, Gianni Berengo Gardin. Hands photograph copyright Stefano Goldberg, by kind permission of RPBW.

Dr Michael Scott
By kind permission of Dr Michael Scott (www.michaelscott.com) and Bamburgh Castle.

Francesco Trapani
By kind permission of Bulgari S.p.A.

Book cover design, illustrations and conversation layouts courtesy of Emanuela Ferrandi, Interbrand.

Chapter I

Introduction: Why Meta-luxury?

Luxury, as a concept, has been used in many different ways. As a term, 'luxury' has amassed a multitude of meanings and, in that very process of accumulation, its true meaning has become diluted.

The word luxury has its roots in Latin: *luxus*, meaning 'abundance' and 'sumptuous enjoyment'. Roman history relays a number of accounts of the term, often with the decidedly insalubrious connotation of sinful enjoyment, or with a pejorative tone, deriding the extravagance of the *nouveaux riches*. The Greeks had a number of words for luxury, each with its own subtle, or in some cases less subtle, connotations.

Today, the generic, middle-of-the-road definition sees luxury referring to those goods whose price makes them exclusive, affordable only to a limited number of affluent individuals. While in principle this concept is sufficiently precise, it is in fact rather blurred. How expensive? How exclusive? There is certainly a strong degree of subjectivity in its interpretation, which makes it difficult, for instance, to establish the boundaries between the idea of a premium and the concept of luxury. High price is possibly a necessary, yet certainly not a sufficient, condition for luxury. The phrase 'reassuringly expensive' is rather un-reassuring. To make matters even more confused, the first decade of this century saw the rise of 'accessible luxury', an oxymoron that became the way in which many businesses, in different sectors, went on openly to define their models, before that idea was swept away by the 2008–9 economic meltdown.

In other cases, the idea of luxury is defined through a number of specific product categories, such as jewellery, fashion, perfume,

wines and spirits. While it is true that the conventional idea of luxury is normally associated with these categories, this also would appear to be a circular and self-defeating logic – the idea is defined through products that are in turn defined by the idea. It is a loop that can be supported only by an assumption – that certain products and services are excluded – which is of course subjective and debatable. Can a €50 bottle of perfume distributed in self-service stores be considered in the same way as a €500,000 highly customised car? Apart from such contradictions, defining luxury through certain categories would appear to be a rather static definition in a fast-changing world. As new products and services evolve and as behaviours change and cultures blend as never before, this type of definition seems to originate from pure convention rather than from true conviction. As such, it has a high risk of becoming – or being – outdated.

Some would suggest that luxury is about a product that represents one, or the absolute, pinnacle in its respective category. And yet, everyday language – be it in a business, academic or other context – contradicts this notion. Many of the so-called luxury brands offer, as part of their portfolio, products that are, fundamentally, commodities. Consider, for instance, eyewear. In most markets, sunglasses and frames are designed and produced by a handful of manufacturers, each licensing a selection of brands that very often occupy the same competitive space. The obvious result is an offering that is standardised – extremely similar products that fail to clearly outperform competing alternatives under any quality criterion, and are thus easily substitutable.

Could luxury be associated with products that exist in limited quantities? Not unless we come to accept that the vast majority of those that are universally referred to as global luxury brands, in fact, are not. A radical and highly debatable position.

Luxury products and services are sometimes described as those for which the brand represents a key driver of purchase – to an extent where it is the dominant force in attracting demand and commanding a substantial price premium. While there are certainly elements of truth in this line of thought – and we will look at this in greater

detail – this is a somewhat forced simplification of reality. The importance of the brand is neither necessary nor sufficient to outline luxury. On the one hand, brands have been shown to play a major role in categories that escape any acceptable notion of luxury. In the case, for example, of mid-price fashion, or leading global denim brands, there is no doubt that the brand itself almost always plays a primary role in securing choice for these companies. Yet, none of these could be defined as luxury brands. Of course, the opposite is also true. Certain customised, one-of-a-kind, extremely expensive products owe their success not to a well known, established brand, but rather to their intrinsic technical performance or aesthetic qualities. This is typical of those circumstances in which the craftsman meets the connoisseur.

All these definitions of luxury also imply that the idea is a relative one. Price, quality, category of origin, volumes and brand importance are all parameters that are difficult to assess in the absence of a benchmark. We describe a product or service as being expensive as a consequence of the price of similar products, and as a function of who we are and where we live. Which means, quite simply, bidding farewell to an absolute definition of luxury.

The difficulties encountered in approaching the term 'luxury', however, are not just a question of definition. They also originate from prejudice and interpretation, and that is partly due to the very lack of clarity surrounding the term. To some, 'luxury' conveys much more than an objective meaning, and goes on to imply a moral judgement – unnecessary, exaggerated, ephemeral, arrogant and socially unfair. To others, it seems simply to have the stigma of the déjà vu, the stereotypical, the predictable. It appears shallow and vacuous, conjuring images of glittering shop windows, high-heeled shoes and catwalks.

As we have seen, the term 'luxury' has been overexposed, overstretched, deformed and diluted, and as a result is now worn out beyond recovery. We believe there is no longer the opportunity to reshape its meaning, and to bring back a deeper, comprehensive and universally acceptable sense to it. Every year brings to the shelves new books on the subject, new conferences convening discourses on

variations on the theme of luxury. As a result, every year seems to bring up *new* new definitions, with the ultimate result of making the word ever more meaningless.

This book could indeed have focused on the quest for yet another definition of luxury. However, we feel there is little value in adding to an increasingly theoretical, and potentially endless, debate about what luxury really is. This book therefore takes a different approach.

We observe the existence and rise of an increasingly prominent space of offer and demand, whose cultural, market and business traits transcend the current banal notion of luxury. And, rather than trying to redefine luxury accordingly – a hopeless task – we simply coin a different name for such a paradigm.

It is a paradigm resurrecting authentic art and science, and bringing together craftsmen and connoisseurs rather than manufacturers and consumers. It is about *métiers*, numbered series and ateliers rather than positioning, volumes and networks. It is about signatures as we knew them rather than luxury brands as we have become accustomed to know them. Ultimately, it is about a culture in itself, based on the quest for the absolute.

In seeking to express, in a concise and effective way, what stands beyond luxury – more precisely, beyond both the debate about luxury and the common notion of luxury – we turn to one of the cornerstones of Western culture.

Aristotle's *Metaphysics*, centred on the subject of existence and the nature of being, stands as a pinnacle in the history of human thinking. One of the most influential works ever conceived, its intellectual power shaped the course of Greek, Arab and Christian thinking, across both the arts and the sciences. Today, the term *metaphysics* has come to indicate the branch of philosophy focusing on the same, fundamental, topics.

It is ironic that a masterpiece of that scale should be passed on to posterity with a name that is certainly not the author's intended title,

and whose origin is debated. The term combines the Greek terms *meta* ('beyond', 'after') and *physika* ('physics') and is thought to have been introduced in the anthologisation process in Alexandria. Whilst certain scholars once believed that the title had been applied to works concerned with what is *beyond* physics, today's most widely accepted etymology is much more earthly: archived in complete editions as the work following another of Aristotle's works, titled *Physics*, *Metaphysics* simply denoted 'the book after *Physics*'.

This very ambivalence is to us a good reason to coin the term *meta-luxury*.

The term 'meta-luxury' would seem to capture, in an effective and memorable way, the double intent of this book. On the one hand, we wish to move away from what we feel is a tired debate. On the other, we want to explore a rising paradigm that does not deserve to be defined through a word that has become meaningless and empty. Meta-luxury is a form of luxury that escapes the clichés of so-called luxury. It is about luxury beyond luxury.

It is about the culture of excellence.

Chapter II

Defining Meta-luxury

Although what we define as meta-luxury acquires a special relevance as a result of the global crisis of 2008–9, it is by no means a new phenomenon. Rather, it is the rediscovery of a paradigm and a set of principles deeply entrenched in European culture. For this reason, defining it in a precise way and fully appreciating its meaning requires a somewhat sinuous, but also fascinating, journey across centuries and cultures.

The Origins

The works of St Thomas Aquinas (1225–74) are usually identified as being the most significant milestones of Scholasticism, the intellectual force that throughout the Middle Ages blended the rediscovery of classic philosophers with Christian theology. The influence of St Thomas on the development of philosophy and the Catholic religion in the subsequent centuries is immense – such that the school of thought stemming from his thinking has come to deserve a specific designation, and is known and studied as Thomism.

In today's impoverished language St Thomas would probably be described as an innovator. In truth, his role can be described only as revolutionary. His theology combined two apparently conflicting elements – faith and reason – and recognised their convergence as being instrumental to an understanding of the ultimate truth about God.

By far his most extensively studied book, the *Summa Theologiae*, includes what are known as the 'five ways' of St Thomas – five

demonstrations of God's existence, each articulated as a different argument on the same logical skeleton.

Of these, the 'fifth way' is known as being the demonstration *ex fine* (from the purpose, or end), or the *teleological demonstration*. In St Thomas's words:

> The fifth way is taken from the governance of the world. We see that things which lack intelligence, such as natural bodies, act for an end, and this is evident from their acting always, or nearly always, in the same way, so as to obtain the best result. Hence it is plain that not fortuitously, but designedly, do they achieve their end. Now whatever lacks intelligence cannot move towards an end, unless it be directed by some being endowed with knowledge and intelligence; as the arrow is shot to its mark by the archer. Therefore some intelligent being exists by whom all natural things are directed to their end; and this being we call God.[i]

It is difficult not to be captivated and distracted by the pristine incisiveness and concise elegance of what is just a very small fragment of the opus. There is, however, a specific aspect that should not be overlooked, and it is neither the conclusion nor the reasoning, but the very assumption. The entire demonstration revolves around one beautifully compelling observation: *knowledge and intelligence are the differentiating attributes of all that moves towards an objective.* There can be no purpose without knowledge (the Latin *cognitio*) and intelligence (the Latin *intelligentia*), St Thomas notes.

This is a uniquely powerful statement in its simplicity. It is profoundly individual and yet absolute. It connects intellect and intention. It sets human qualities within the universal flow of things. It adds depth to ideas such as sense, determination and mission.

It is interesting to draw a parallel with another phenomenon taking place in approximately the same period – the rise of Gothic architecture. Originating from France and Germany, and subsequently absorbed in Italy, this style is seen by many historians and critics[ii] as the architectural expression of Scholastic philosophy: just as the latter pursued a self-sufficient, consequential logical

structure, Gothic architecture displayed a coherent combination and progression of individual elements.

Gothic architecture is based on the concept of verticality, and juxtaposes a strong rooting in the ground with a dynamic thrust towards the heights, achieved through elements such as pointed arches and ribbed columns. What arresting masterpieces of art, engineering and craftsmanship such as the cathedrals of Chartres, Reims or Cologne express is a constant, rhythmic ascension towards divinity, generated by elements which tend to disappear in the vastness above – an unmistakable sense of reaching higher, which permeates each and every element of these complex buildings. In celebrating a universal direction, Gothic architecture is the tangible manifestation of St Thomas's 'fifth way'.

The higher sense of purpose encapsulated in the great Gothic cathedrals is so much more than a purely architectural matter – it is profoundly human. Their conception was a challenge to physical laws and to the conventions of space; their construction, a colossal endeavour spanning decades and entire generations. Again, knowledge and intelligence put to the service of a greater end.

This same notion of endless pursuit appears in a very distant context, stemming from a radically different background – the Romantic movement of the 18th and 19th centuries.

It is extremely dangerous to simplify the traits of a movement spanning many fields of human thought and expression – from music to literature, from philosophy to the figurative arts – and diverse cultures. However, one of the consistent themes which distinguish Romanticism is the relentless, unending quest for the infinite and the unexplored. It is a quest that is deeply individual, and has to do with intellectual and emotional qualities.

Lord Tennyson's *Ulysses* is recognised as being one of the most representative works of Romanticism. In this dramatic monologue, an aging but still restless Ulysses, surrounded by his loyal companions, prepares to set sail for his last journey. The final verse of this work is in itself a manifesto:

To strive, to seek, to find, and not to yield.[iii]

Once again, there is here a sense of restless pursuit, which, however, in the Romantic vision takes on a specific connotation. It coincides with a desperate attempt to escape from the limitations of human nature and an unquenchable desire to connect with the absolute and the timeless.

Knowledge, Purpose and Timelessness: Defining Meta-luxury

There are a variety of other philosophical, religious or artistic references where the sense of purpose is the central, if not the defining, element. Overall, what we see across different cultures, centuries and disciplines is a consistent sequence. *Knowledge, in its widest possible sense, is essential to purpose. Purpose is, in turn, the path towards timelessness.*

Knowledge. Purpose. Timelessness. A stirring chain – in which each of the three elements has to do at once with individual longing and universal aspirations.

As human beings, we live in the flow of the one force that is both irreversible and unstoppable: time. Everything we perceive, as well as all that we do, is subject to the transformation and decay that time implies. And yet, we sometimes use the term 'timeless'. Interestingly, whatever we may be referring to, the term is invariably used to describe an *achievement*.

Achievement is, in fact, the one notion that encompasses the sequence of *knowledge*, *purpose* and *timelessness*.

An achievement stems from *knowledge*, in the widest possible sense. Be it a leap forward in a field of science or technology, or a masterpiece in art, or even a groundbreaking sports attainment, an achievement is necessarily the result of some kind of experience, consciousness and *savoir-faire*.

And, although serendipity does certainly play a role in human advancement, an achievement is also by definition the fulfillment of a sought-after *purpose* – the end of a process of striving towards a clear goal.

Finally, an achievement can have the power to withstand the flow of time, and transcend the limitations of a lifetime, passing on from one generation to the next. Be they world-changing innovations or influential works of the intellect, it is past achievements that define cultures and history. An achievement stems from the pursuit of *timelessness*.

In these pages, we suggest that there is no better way to outline the concept of meta-luxury than, simply, through the notion of 'unique achievement'. In short, ***meta-luxury is an enterprise paradigm based on knowledge, purpose and the pursuit of timelessness, ultimately embodied in a unique achievement.***

This definition is an effective way to break away from the overused concept of luxury. There are many brands that define themselves as belonging to the world of 'luxury'. Yet, how many of them can credibly claim to represent a unique achievement? How many of them are based on distinctive *knowledge* of some kind? How many pursue a *purpose* which stretches beyond mere commercial performance? Ultimately, how many have reached or effectively strive to reach the stature of *timelessness*?

Only some of the so-called luxury brands do, and that is precisely where we draw the line between 'luxury' and meta-luxury – the former often being a stale convention, the latter being always an authentic conviction.

'Luxury' is often a self-proclaimed status; meta-luxury is always a restless pursuit. 'Luxury' is often about showing; meta-luxury is always about knowing. 'Luxury' is often about stretch and surface; meta-luxury is always about focus and depth. 'Luxury' is sometimes about ostentation; meta-luxury always about discovery. 'Luxury' is often merely about affording; meta-luxury is always first and foremost about understanding.

Because meta-luxury is a philosophy and approach, it cannot be defined through specific product categories. It is true, though, that certain categories may have reached a point where the complexity of the knowledge inherent in them, the meaning of their endeavour and the near-perfection of their results provide them with an affinity to meta-luxury.

For instance, it is difficult not to see the paradigm of meta-luxury manifest itself in some of the world's most respected winemakers, where the wealth and depth of diverse competences, often passed on from one generation to the next for centuries, blend with an intrinsic conviction about wine being the celebration of the fullness of life in the creation of rare masterpieces, some vintages remaining as benchmarks. Knowledge, purpose and timelessness.

In a completely different context, some automotive icons are born of the combination of unprecedented technology, taste-defining design and advanced engineering (knowledge). They challenge notions of safety, physical laws and the parameters of man–machine interaction (purpose). They become standards, often representing an era (timelessness).

The diversity and breadth of what underlies such absolute and universal concepts as knowledge, purpose and timelessness do not impose a constraint on the concretisation of meta-luxury.

From Culture to Business ...

Today, a cotton T-shirt sporting the logo of a well known, expensive brand will be categorised as a 'luxury' product. But so will a unique, handcrafted watch embodying centuries and generations of unrivalled skill and innovation in time measurement. We would all agree that there is a distortion in this – the two are completely incomparable entities.

But why, exactly?

Beyond all obvious and superficial considerations – price, availability and so forth – what fundamentally sets the two objects apart is the concept of unique achievement; and, within it, the notions of knowledge, purpose and timelessness. These notions apply to the latter product, and clearly not to the former.

The deeply philosophical roots of meta-luxury should not mislead. Stemming from a distinct cultural approach, meta-luxury is in fact a specific business model, with a number of traits and implications. Distinguishing meta-luxury from the traditional notion of 'luxury' is not just a theoretical exercise in business language. It is much more consequential and tangible.

At the heart of all differences is a simple but fundamental one. Contrary to classical market doctrine, in meta-luxury business results are not a target; they are a means. They are merely a way to fund the ongoing pursuit of unique achievement.

This may read as a dangerous statement. Does it mean that meta-luxury is hostile, or indifferent, to the notion of profit? Are we trying to split the world into ruthless return-seekers and disinterested craftsmen? Absolutely not. The right term to describe meta-luxury would, in fact, be one that is now abundantly used in other contexts – *sustainability*. In meta-luxury, business results are meant to sustain – and never to drive – the enterprise's mission and ethos. Economic success is therefore a requisite and a consequence, but not the primary objective.

While this is indeed in contradiction to the notion that the maximisation of shareholder value is an enterprise's goal, it is not in contradiction to its being a result. Escaping the obsession with quarterly financial reports and short-term targets, meta-luxury generates shareholder value by focusing on the uncompromising, ongoing quest for unique achievement.

It is through the long-term preservation of ever-improving skills and nurtured talent, of a clear mission and undying values and of an unblemished reputation for pursuing timeless results that meta-luxury enterprises deliver value.

As we shall see, meta-luxury is a paradigm that generates value at a pace and with a gradient of risk that differs from those of typical financial markets.

... and from Business to Branding

There is one entity in which an enterprise's skills, mission and reputation are preserved and through which they generate value: its brand.

Meta-luxury brands embody an organisation's – or individual's – knowledge and talent. They express its, or her/his, purpose and mission. Ultimately, they reflect its ambition for a place in history. It is by standing for knowledge, purpose and pursued timelessness that meta-luxury brands reduce or eliminate substitutability. They drive demand and secure it for the future by representing unique achievement.

Brand management is often about leveraging and flexing a brand in order to benefit from emerging business opportunities. That can lead to complete re-engineering of the brand's meaning and equity, and even to the transformation of its scope.

This is not true of meta-luxury brands. Because of their deep and absolute significance – again, knowledge, purpose and timelessness – meta-luxury brands simply cannot be reshaped on the basis of short-term profit targets or opportunities. They would be diluting their entire *raison-d'être*.

This does not mean that meta-luxury brands can or should stand still: they are living assets. Simply, their evolution and their optimal management are inside–out, rather than outside–in, processes. While generally we can speak about a brand's proposition or positioning, for meta-luxury brands it is more appropriate to talk, first and foremost, about a brand's DNA. That unique and immutable character shapes and orientates the brand's growth in time, ensuring that it allows for relevance as well as loyalty to its original significance. In other words, meta-luxury brands are based on a set of eternal

chromosomes, which combine and manifest themselves in different ways, at different times.

This gives rise to a fundamental distinction. *While normally – and even in so-called luxury – it is the business that drives the brand, in meta-luxury it is the brand that drives the business.*

It is for this reason that drawing a clear line between traditional luxury and meta-luxury provides an indispensable strategic brand management platform.

Understanding the difference between the two models is essential to the determination of the nature and degree of change that can help a brand compete in the future. It is key to identifying attractive combinations of return and risk, thus securing the business's sustainability. It is, ultimately, about seamlessly connecting culture and long-term business performance.

[i] *Summa Theologiae*, St Thomas Aquinas, 'Quinta via sumitur ex gubernatione rerum. Videmus enim quod aliqua quae cognitione carent, scilicet corpora naturalia, operantur propter finem, quod apparet ex hoc quod semper aut frequentius eodem modo operantur, ut consequantur id quod est optimum; unde patet quod non a casu, sed ex intentione perveniunt ad finem. Ea autem quae non habent cognitionem, non tendunt in finem nisi directa ab aliquo cognoscente et intelligente, sicut sagitta a sagittante. Ergo est aliquid intelligens, a quo omnes res naturales ordinantur ad finem, et hoc dicimus Deum.'

[ii] *Gothic Architecture and Scholasticism*, Erwin Panofsky (1951), Archabbey Press.

[iii] *Ulysses*, Alfred, Lord Tennyson (1833).

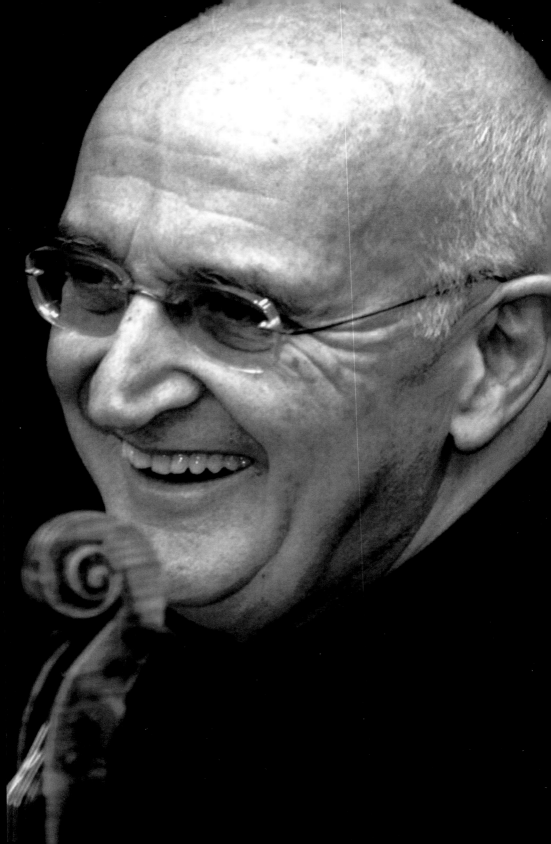

Salvatore Accardo

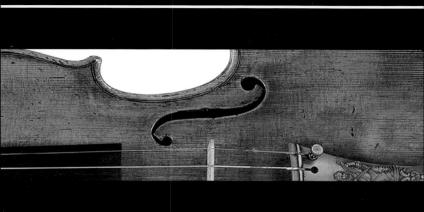

Salvatore Accardo is universally regarded as the greatest Italian violinist of modern times. Since his début recital in 1954, aged 13, he has performed across the world with the greatest conductors and orchestras, himself frequently taking the role of conductor. His extensive recordings for the world's most respected labels include works by Bach, Beethoven, Brahms, Mozart, Paganini, Schubert and Tchaikovsky. Astor Piazzolla, a close friend of Accardo, dedicated a number of pieces to him. Italy's highest honour, the Cavaliere di Gran Croce, was bestowed upon Accardo by the President of the Italian Republic in 1982. In 1996 the Beijing Conservatoire named him 'Most Honourable Professor'. In 1999 he was granted the order of 'Commandeur dans l'ordre du mérit culturel', the highest title of the principality of Monaco, and in 2002 he received the prestigious 'Una Vita per la Musica' Award. The Art of Salvatore Accardo: a Life for the Violin, a boxed anthology, was recently released by Universal. Accardo is also the founder of the internationally acclaimed Orchestra da Camera Italiana, which brings together the best pupils and alumni of the Stauffer Academy in Cremona. Salvatore Accardo plays the 1727 Hart-ex-Francescatti Stradivarius, as well as a 1733 Guarneri del Gesù and a 1620 Giovanni Paolo Maggini.

'Well, maybe *that* is what real luxury is after all.' Salvatore Accardo smiles as one of his daughters toddles toward him. 'Looking at children's eyes and feeling the love. That is just beyond comparison.'

The winter afternoon we spend in Milan talking to one of the greatest violinists of all time quickly turns into a mesmerising flow of reflections and anecdotes on the past, the future and the eternity of music.

'To a musician, a first form of real luxury is playing a great instrument,' the Maestro begins. Playing, not necessarily owning. 'You see, we are never really the owners of these instruments. We are merely stewards, whose duty is to preserve them for those who will come after us.' He pauses. 'Yet, some musicians fail to understand this. They treat these masterpieces as if they were their property. They'll do anything to them – change the bridge over and over, open and close them at will. It's like repeated surgery on a human being.'

Ownership inevitably takes us to the question of value. 'When I was young, even though it required huge sacrifices, purchasing an excellent instrument was still possible. Today, that is no longer the case.' Prices have soared beyond reason, he explains. Pumped by people who 'started buying anything, at any price,' prices have become a question of market ('ugly word,' he jokes), driven by offer and demand.[i]

A spontaneous question is whether, beyond the auction craze, the instruments of the likes of Stradivari or Guarneri really do have something more. 'No, they don't have something more,' Maestro Accardo chuckles. 'They have a lot more. Two things, essentially: the quality of the sound, and its power. Antonio Stradivari's violins were already the most expensive during his lifetime, between the 17th and 18th centuries. He made instruments for the royal families, and there are amazingly beautiful examples at the Palacio Real in Madrid. He lived a very long life, especially by the standards of that time, and

produced over two thousand instruments, the last of which dates from the year of his death. All that, by the way, made him extremely wealthy. A popular expression in Cremona at that time was "you're as rich as Stradivari".'

Is time the secret of these instruments, we wonder. 'Time does a lot, but that isn't the explanation. There are some very good makers around today. Their instruments play well, and will get even better in time. But I don't believe they'll ever reach the excellence of Stradivari and, to a certain extent, Guarneri. Even Amati and Guadagnini, who were superb masters, never reached those peaks. Let's face it,' he smiles, 'those two [Stradivari and Guarneri] were simply better than the others. Even with today's sophisticated examination techniques, all we have discovered are a few hints about the use of certain varnishing ingredients,' Accardo explains. 'On the whole, the mystery remains. There's a story – a legend, perhaps – about Stradivari keeping his violins in his bedroom for one month before varnishing them. Could it be that he radiated a special energy? Perhaps there is a kind of magic in this story after all,' he adds, pensively.

What could arguably be called the greatest brand ever – Stradivari – is now history. The logical question is whether Antonio Stradivari developed a school. 'Well, Antonio did have pupils, including two of his sons. Also, remember,' he explains, 'that it all goes back to Andrea Amati, maker of the first example of a violin as we now know it. Antonio Stradivari and Andrea Guarneri were apprentices of his nephew, Nicola Amati. These were the roots of the great school of Cremona, which includes the likes of Guadagnini, Ruggeri and many other masters.'

Calling these instruments works of art is amply justified. However, he notes, 'they are not paintings. You can't have them just sit there. An instrument is a living entity. It gets better in time if it gets played, and deteriorates if it is played badly or not played at all. Wood is a living material,' he explains passionately.

'Even the varnish is. Scrape it away for whatever reason, and it
will quickly expand to cover the clearing. Like a living organism,
it will regenerate,' he concludes. 'Sound is about vibrations. Keep
the wood still, and it will gradually atrophy. Throughout 1982, the
year marking Niccolò Paganini's 200th birthday, I played around
80 concerts on his violin. The sound regained its full excellence
and power only towards the final performances. That instrument is
seldom played,' he observes, 'a crying shame.'

The importance of wood stretches beyond the instrument itself.
Great architects, the Maestro notes, know that concert halls
can only be made of wood. 'I produce sound through a wooden
instrument,' he reasons. 'Only through more wood can it be
amplified and still be my own sound. Where other materials
interfere too much, I no longer hear my sound. That's why playing
in halls like the Musikverein in Vienna, the Bibbiena Theatre in
Mantova or even the Disney Hall in Los Angeles is indeed a form of
luxury. A great instrument, a fantastic hall. Come on, what else can
you want?' he laughs.

'You know, as string players, we have a very sensual relationship
with the instrument. Think of a pianist. Several mechanical
elements stand between his or her fingers and the string. A violinist,
instead, has an immediate contact, and that makes a colossal
difference. When playing Paganini's violin, I place my chin and my
fingers where he used to. An emotion that defies description. It is a
kind of symbiotic relationship, in which one gives life to the other.

'Let me tell you this story,' he continues. 'It happened to me
when I bought a 1727 Stradivari from Zino Francescatti, one of the
greatest violinists who ever lived. He had played it for over 40 years.
He insisted that before buying it I should play it for a month or so. I
performed my very first concert at Carnegie Hall with that violin. A
man from the audience came to me after the concert and said, "I'm
sure your favourite violinist is Francescatti." "I love Francescatti, but
he's not the only one," I answered. "Why do you say so?" "Because

you sound exactly like him." I was amazed – and he was, too, when I told him that this was, in fact, Francescatti's violin. *I* was playing, but *his* sound was what was coming out. Today, many years on, that man wouldn't make the same remark. A violin that is played for so many years by a violinist inevitably absorbs his or her sound.'

The subject of sound leads us to discuss 'another form of luxury that as a musician I have the privilege to enjoy – the opportunity to work on the masterpieces of the great composers. For instance, delving deep into the works of Beethoven. Mind you, it is not just about the beauty of the score itself, but about the fact of bringing it to life again. That is truly a miracle,' he muses. 'Hundreds of different musicians read the same score. The notes are identical. And still, the interpretations will be disparate. And there's something else,' he goes on. 'You can play a great concerto or sonata hundreds of times, and every single time you'll discover something new about it. The moment this stops being true, you should get worried – *you* are the one who's got nothing left to add. This influences the relationship between the musician and the audience. If your playing expresses nothing, nothing is what you'll get from the audience, and vice-versa. The circle is broken.'

Luxury is never about ostentation, Accardo suggests, and that applies perfectly to music. 'Some musicians seem to throw their talent in your face. I'll never forget the words of one of the greatest musicians of all time, David Oistrakh.[ii] "We don't go onstage to show how good we are, but to share how lucky we are," he once told me. Our emotion in conveying the miracle of music should be so intense that it should keep you focused on doing just that. It should prevent you from showing off or doing anything else. Yet, nowadays, everything seems to be transformed into entertainment. Music is a lot more than that. I have had the opportunity to meet, and play with, some of the greatest musicians of the 20th century. Oistrakh himself. Stern, Casals, Rostropovich, Celibidache. Their common trait was their humility in front of music – the belief that they were the servants of music, not the other way around. Having

listened and spoken to them, having spent time and played with them – well, I assume that has been indeed an extraordinarily rare form of luxury.' He pauses, and then adds, 'And I would have given anything to live in another century and meet Brahms, Beethoven or Mozart. Can you imagine? Doesn't that really resize the notion of luxury? Overall,' he concludes, 'I suppose luxury isn't what most people believe it is. Luxury is something deep. If you agree that one of Mozart's scores is luxury, then I guess you must also accept that most other things aren't.'

Looking forward, the Maestro reveals that one of his dreams is 'to see young people – not musicians – who really choose what music they should listen to. You may not like Beethoven's music. I can accept that. But you must have listened to it first and developed a point of view. Isn't choice a form of luxury, too? I'm afraid many young people don't have this.' In more general terms, he observes, 'luxury is created by those people who allow us to know, and force us to think and choose. People who create culture are producing luxury. In the extreme, those individuals that risk their own life to expose unfairness, corruption and criminality. In the end, nothing is more dangerous to cruel people than knowledge and words – and, sometimes, music.'

Salvatore Accardo pauses for a moment. 'You know, after all, music has the power to encapsulate a fragment of existence.'

ⁱ In June 2011, shortly after this interview, the 'Lady Blunt' Stradivari violin fetched €11 million at a charity auction whose proceeds were destined for the relief effort following Japan's 11 March earthquake.

ⁱⁱ David Fyodorovich Oistrakh (1908–74), born in Odessa, is regarded as one of the greatest and most influential virtuosi of the 20th century. Aram Khachaturian and Dmitri Shostakovich dedicated their violin concertos to him.

Chapter III

The Pillars of Meta-luxury

In the previous chapter, we defined meta-luxury as a paradigm founded on the concept of unique achievement, itself encompassing the ideas of knowledge, purpose and timelessness. In this and the following chapters, we look at how meta-luxury brands leverage these principles to create long-term economic value.

As thus defined, meta-luxury seems a compelling and far-reaching idea – but an apparently very abstract one, too. What is its relevance? Where does it lead? What does it materially imply? Moreover, in what ways does it connect to the reality and the everyday challenges of business and brand management?

Very simply put, meta-luxury is a business model that translates some profoundly human principles and yearnings into a well defined set of drivers of choice. Its economy is founded on the encounter between the pursuit of and the desire for unique achievements. It is therefore a marriage between an offer and a demand that are drawn together by consciousness, not mere consumption.

Consciousness and motivation are the fundamental differences between what is traditionally called luxury and meta-luxury. In meta-luxury it is never a mere question of what to buy but, more importantly, if not most importantly, why buy. This discernment is the red thread[i] of meta-luxury, seamlessly running from the creator to the customer. What is being traded is not a good as such, but rather its authentic significance as a unique achievement. In other words, meta-luxury is not afforded exclusively from an economic point of view, but also from an intellectual perspective. To this extent, meta-luxury brands do not

just stand for excellence as a qualitative result. They embody, to both the maker and the customer, excellence as a culture.

But in more precise terms, what is the common denominator between meta-luxury brands? How do they drive demand? What are customers ultimately looking for? What makes these brands and products unsubstitutable, and therefore valuable, to them?

Why do we tend to value the small number of units crafted by a fourth-generation family-owned watchmaking firm more than series products stemming from, say, a global licensed watchmaking operation? What is the difference between young, highly innovative entrepreneurs and century-old craftsmen? Why do we generally regard the work of a small, specialised manufacturer as being more valuable than the output of a generalist conglomerate?

Four unifying themes have emerged from our careful sieving of the wealth of insights and observations gathered across countless conversations, projects and exchanges. These themes are the origin of what we have identified as constituting the *four pillars of meta-luxury.*

The building blocks of the paradigm, the four pillars represent concise answers to four fundamental questions: How, What, When and Who? Consequently, they are the four characteristics that define a meta-luxury brand and through which it drives demand, ultimately creating economic value.

The first pillar places the question 'How?' within a culture of excellence. In what manner is the quest for an absolute pinnacle reflected in a certain 'way of doing things'? How is this approach inspired by the pursuit of unique achievement? We identify the first pillar of meta-luxury as *Craftsmanship.*

As we will discuss in proper detail in the next chapter, this notion refers to a philosophy of creation that aims for excellence, not efficiency. It embodies an expertise and a commitment that is often passed on from one generation to the next; a living legacy of years, decades and sometimes centuries of continuous innovation and

preservation, teaching and learning. An approach that envisions each unit as an autonomous element rather than a replica. Thus, craftsmanship is, to makers, a principle as much as, to customers, it is a fundamental driver of demand. As such, it contributes to generating economic value. When it comes to 'how?', meta-luxury is about craftsmanship.

As is evident, the pillar of craftsmanship is tightly connected to the concept of knowledge, in the widest possible sense – from intellectual competences to manual techniques.

The second pillar is born of the question 'What?'. What is the latitude, or scope, that is most consonant with a company's and brand's commitment to excellence? The insights collected throughout our dialogues consistently suggest that the idea of excellence goes hand in hand with the notion of specialism, that is, concentration on a well defined region of expertise. A culture of excellence, in other words, is connected to depth rather than to breadth; to concentration rather than dispersion. On the one hand, specialists appear to be those who are more likely to reach a unique achievement. On the other, as customers, we have a natural inclination to attribute greater value and credibility to things that absorb the entirety of someone's time, skills and passion than to the work of generalists. This is especially true when considering goods with a high degree of emotional investment and/or technical complexity.

This line of thought has led us to select *Focus* as the second pillar of meta-luxury. All in all, this notion is strongly connected to the idea of purpose. Focus is all about the unwavering determination to be the absolute best at something rather than fairly good at a bit of everything – a clear choice that is in many ways the quintessence of a culture of excellence.

The third pillar stems from the question relating to 'When?'. In an ever-changing world, longevity is in itself an achievement. However, it becomes a unique achievement when such longevity is not merely about surviving, but about continuously evolving. Some brands manage to preserve their past while constantly reinventing

their future: holding true to an immutable DNA, they succeed in remaining relevant over time.

As human beings, we seem to need to anchor ourselves to things and symbols that stand firm in the flow of time, and brands are no exception. We are attracted by those brands that transcend the span of our own lifetime, standing the test of time to epitomise a sense of accomplishment and eternity.

This is what makes *History* the third pillar of meta-luxury, breathing life and meaning into what would otherwise be mere objects. It is extremely important to clarify that history is not only about age. Meta-luxury brands are not simply, and not necessarily, old brands. Rather, they are brands that possess the ability to leave a mark; to influence and to embrace change in time. History does not relate exclusively to the past. It is about having a strong sense of a brand's place in time. Our conversations include the perspectives of Horacio Pagani and Simon Jacomet, the minds behind two relatively young brands, Pagani and zai. Both are strongly imbued with this consciousness.

These observations highlight the inherent link between the pillar of history, as thus explained, and the concept of timelessness, introduced in the definition of meta-luxury.

The fourth pillar relates to the question 'Who?' or 'For whom?'. A question that touches on choices such as exclusivity versus accessibility, distinctiveness versus universality, quality versus quantity. What is the degree, along such scales, that is consistent with a culture of excellence?

From a customer perspective, the correlation between scarcity and value is a basic market rule. Given an equal level of utility, we regard as more valuable those resources that are offered to us in smaller quantities. Precious metals are rare; time is valuable because it cannot be extended; in a more concrete way, goods are released in limited editions to gain additional value.

Thus, we see *Rarity* as the fourth pillar of meta-luxury. It is key to observe that, in providing this definition, we do not refer to

unjustified or artificial exclusivity, but to rarity as an inevitable and natural implication of the pursuit of excellence. Such rarity is usually driven by different factors, which go from the cost of effective materials or specialised labour to limitations on capacity imposed by quality requirements. Hence, this notion of rarity never rests on a deliberately high price driving perceived value, but always on an intrinsic value that necessarily imposes a consequent price.

Rarity is the result of an overarching approach. Broadly speaking, mass production is driven by an expected level of demand; quantity is the constant, and everything else follows. On the contrary, meta-luxury is driven by a pursued level of offering. Quality is the constant, and everything else follows. This difference is a reflection of the brand driving the business rather than the opposite.

As can be seen, rarity is the driver of demand corresponding to the notion of uniqueness within the idea of unique achievement.

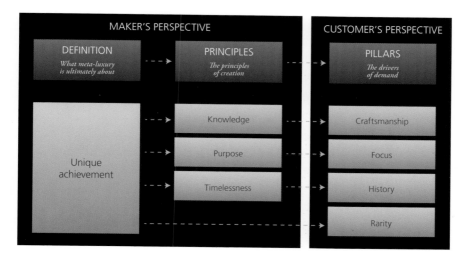

The Paradigm of Limitation

As we have seen, the four pillars are the essence of the meta-luxury proposition. As such, they represent the drivers of demand for meta-luxury. They represent what customers are ultimately looking for and

the thing to which they are appropriating value. In other words, the pillars are the translation of the principles of knowledge, purpose and timelessness into elements that, for customers, are both relevant and desirable.

The next four chapters will explore in greater detail each of the four pillars. As an apposite antecedent, it is interesting to highlight a compelling common denominator among them. Each of these drivers can be seen as the choice of deliberate limitation and short-term sacrifice; and yet, paradoxically, such immediate self-restraint constitutes the very engine of meta-luxury in the long term.

Craftsmanship is all about principles of production that are contrary to the idea of high volumes. Often, such principles mean that, in the short term, demand is much higher than the offer, or that production costs are an objective disadvantage. However, it is through this concentration on quality rather than quantity that the brand can pursue continuity of demand in the longer term.

Focus implies the choice to avoid diversification. Of course, this may mean delaying, or indeed declining, opportunities for which there may be a market in the short term. However, the reward for this conduct in the long run is a brand that credibly epitomises a deep expertise driven by a clear purpose.

History also has a sense of limitation to it, whereby it ultimately means sowing rather than reaping. This pillar implies that all choices are meant to find their place within the order of longer-term events. Consequently, any quick gains that may benefit the fiscally driven domain but endanger the long term will be carefully avoided.

Finally, the notion of rarity is inherently descriptive of a clear understanding of presence, visibility and availability as necessary consequences – not levers. This may have commercial drawbacks in the short term, but it is a key value driver in the long run, safeguarding the desire that the brand creates.

Overall, generating economic value through the pillars of craftsmanship, focus, history and rarity is never a shortcut. On the contrary, it is a position to be earned. The path to the summit is not an easy one; soundly based on a culture of excellence, the paradigm of meta-luxury revolves around the resolve to sacrifice alluring short-term returns for the sake of long-term, low-risk prosperity. It is, fundamentally, about the courage to say 'no' today for the privilege of doing so over time. Ultimately, it is about the creation of value across generations.

[i] 'All of the ropes of the royal fleet, from the strongest to the thinnest, are braided so that a red thread travels through all of them, and you cannot remove it without untying all of them. Even the smallest fragment will still allow you to recognise that the rope belongs to the crown.' *Elective Affinities*, Goethe (1809), as referenced in 'The Red Thread: Creating and Managing Brand Value', Jez Frampton, Interbrand Best Global Brands 2008.

ichael

Dr Michael Scott was formerly the Moses and Mary Finley Research Fellow in Ancient History and is now Research Associate at Darwin College, Cambridge University, and Affiliated Lecturer in the Faculty of Classics, Cambridge. His research focuses on the ancient history and archaeology of the Greek and Roman worlds, subjects on which he has written and taught extensively in Europe as well as in North and South America. He recently presented a BBC documentary series on luxury and the ancient and medieval worlds. Alongside a host of published work in academic journals, Dr Scott is author of From Democrats to Kings: the story of how the Greek world changed from Athens to Alexander the

Having celebrated its 800th anniversary in 2009, the University of Cambridge is the second oldest university in the English-speaking world and its alumni count more Nobel Prize winners than any other's. This is the locus of some of the world's truly unique achievements, ideas that have changed the world, from the discovery of the structure of DNA and the establishment of the fundamentals of physics to some of the most seminal works of philosophical thought and literature.

It is a midsummer morning in Cambridge. There is a hushed and hallowed serenity to the Colleges after the end of term. Yet, still, there is a sense of energy to this place that is almost palpable. This is a place that seems to pulse with potential. Darwin College, in which we meet today, pays tribute to none other than Sir Charles Darwin. Indeed, 2009 was a year that also celebrated the life and work of Darwin, marking 200 years since his birth and 150 years since the publication of *On the Origin of Species*. On the wall behind us, in Dr Michael Scott's office, is a small picture that we subsequently discover to be a self-portrait by Gwen Raverat (née Darwin) – Darwin's granddaughter. It is an apposite backdrop for a debate on the evolution of luxury through the ages.

the past and look into explanations for how we worked with and managed luxury over time.'

Dr Scott talks passionately about the complex relationship that the Ancient Greeks had with luxury. 'Throughout history our relationship with luxury has been a complicated one. Luxury has always been more than a concept of the expensive, the rare and the beautiful, whose exclusive domain was for the rich and the powerful. It is about an idea that touches on democracy, patriotism, social harmony and our relationship with the divine.

'The debate around luxury in Ancient Greece is a particularly relevant one for us today, because ancient Athens was the first experiment in democracy. Luxury had to be reconciled with a society of equality and egalitarianism. As such, luxury was taken out of the private and into the public domain. For example, one of the true luxuries at this time was meat. As sacrifices took place at the Acropolis, the meat from the sacrificed animal was shared amongst the whole community. In other instances, wealthy individuals sponsored plays or public events. Here we see luxury used essentially as a positive, unifying force. The Greeks chose to take a luxury and democratise it, unifying the community in the process.

'What is particularly interesting also about Greece is the sheer diversity of approaches to luxury within a single geographic region. Greece comprised a number of city-states, each with its own culture. As such, they ran the whole spectrum, from the abject abstention from luxury by the Spartans to the outrageous overstatement of luxury on the part of the Macedonians. Luxury was measured in terms of the possession of objects, whether based on the precious nature of the raw materials or the distance over which they travelled. The Macedonians embraced this notion, through an ever more overstated accumulation of and demonstration of luxurious things. The Spartans rejected it. In either case, there is no ideal solution. In the case of Sparta, it rejected every conceivable trapping of luxury, devoting itself to a culture of self-sacrifice and absolute dedication to

the military. In the end, partly as a result of its attitudes to luxury, it imploded. The enduring human desire for luxury ultimately refused denial.'

Luxury defied single definition then, as it continues to do today. Dr Scott goes on to explain how the already problematic nature of luxury was giving rise to a language of luxury. 'Our relationship with luxury was articulated through different kinds of behaviour, and a new set of words emerged along with them, such as *truphe* – effeminate luxury; *habrosune* – sophisticated luxury; *poluteles* – ostentatious luxury. If we consider *truphe*, there is a delicacy and effeminacy to this term. In the context of a time where one's duty as a citizen is to be prepared to go to war, 'to be effeminate', to have the opportunity 'to be effeminate', in and of itself became a luxury. As a result, it was also the defining feature of the greatest (and most luxurious) enemy the Greeks faced: the Persians.'

The advent of Christianity, however, created a new dilemma in the notion of luxury – a moral one. 'Whereas in the world of Ancient Greece and Rome, luxury had been a barometer of social status, in the Middle Ages it took on a much darker connotation, as deadly sin. The question was how to reconcile [the conflicting notions of] luxury when, on the one hand, we were being instructed to avoid it (as preached by the Church) and, on the other, the Church was seen to be one of biggest consumers of luxury. Again, the management of luxury, by both Church and state, came into play, as mechanisms such as the code of knighthood and chivalry were used to codify secular luxuries through the promotion of moral behaviour.'

Dr Scott offers his perspective on the notion of luxury today. 'One of the issues for luxury today is that it has become a highly relative concept. That relativity is both a rhetoric and a reality. My hope, however, looking ahead, is that we won't lose the concept of *variety* in luxury. As China is predicted to be the largest consumer of luxury goods by 2020, how will the gravitational pull affect the manufacturers of luxury goods?'

He adds: 'I do think luxury has a role to play in the value we put on things. In what has become an increasingly throwaway society, can luxury help to turn the tide back towards a greater sense of value and longevity?'

Dr Scott affords an apposite conclusion to the debate on the evolution of luxury: 'Ultimately the want and need for luxury is endemic in human nature. It always has been, and will continue to be, a problematic concept. History has shown us that it is much better to find ways in which to manage it than to deny and suppress it.'

There is an equal measure of precision and passion in the way in which Dr Scott recounts his thoughts. Words, clearly, matter to him and it is no surprise when he comes to reveal one of his most personal luxuries. 'One of my true luxuries is buying books. Books are something that I treasure as objects as well as reading material – although the greater luxury these days is having the time to read them! Perhaps time is our greatest luxury of all. The paradox is that many of the products that I own – and value – are intended to speed up our lives and in so doing, to free up our time. Of course, the reality is that they often only allow us to squeeze more into our daily schedule. True luxury for me would be to slow down time, to create time!'

Dr Scott being a historian, it is inevitable that the subject of time takes prominence in our conversation. 'Luxury is about the time taken to make something – and to wait for something. Natural landscapes, which have taken years to form, are a truly rare and unique experience. Travel plays a significant part in my life and, for me, peace, quiet and the simple beauty of a landscape are true luxury – precisely because they have become the hardest things to find in everyday life. Earlier this year, as part of my research, I found myself on the island of Delos, now a UNESCO World Heritage site. For two days, I was alone on an island that was unreachable by others. It was a truly precious and rare experience.'

Dr Scott goes on to recount a beautiful story about craftsmanship from the Middle Ages. 'It is a story about the creation of a pattern-welded sword, one of the most precious luxuries of the time, from Bamburgh Castle, Northumberland. The sword began as 92 individual pieces of iron, which were welded into six and finally into one blade. It is a truly stunning creation, its beauty and strength testimony to the exacting work of master craftsmen of the time.' The intertwinings of luxury and time are inextricable.

It is unsurprising that the closing words of our discussion have Classical roots. 'At the end of the day, perhaps the best example of what luxury means to me', Dr Scott goes on to say, 'is articulated by Odysseus, in the middle of Homer's *Odyssey*. Here is a man who has seen it all, done it all, had it all, lost it all and regained it all again. And for him, the ultimate luxury is "when the festive mood reigns and banqueters listen to a singer while the tables are laden with bread and meat and the wine glass is full." '[i]

[i] *The Odyssey* 9.5–11.

Chapter IV

Craftsmanship

'Aquí en este objeto
en el que la pupila se demora y vuelve
y busca el eje de la proporción, reside
por un instante nuestro ser,
y desde allí otra vida dilata su verdad
y otra pupila y otro sueño encuentran
su más simple respuesta.'[i]

José Ángel Valente

There are several reasons why the making of Michelangelo Buonarroti's 'David' is considered as one of the greatest achievements in human history. It is, of course, first and foremost because of the astonishing result – one of the best known sculptures in the world, often and sometimes stereotypically used as a symbol of the Renaissance. No matter how many times the statue may have been seen by the visitor in photographs, the encounter with it, at the Galleria dell'Accademia in Florence, is without exception a humbling and cathartic experience.

Reaching well beyond the four-metre mark, excluding its pedestal, the 'David' is imposing if only because of its sheer dimensions. And yet, what is authentically captivating is the sense of perfection that the statue exudes: an arresting feeling that possibly derives from a unique

combination of two aspects that combine to create such perfection. On the one hand, one cannot but wonder at the perfection in the masterpiece's *conception*: the numerous subtleties of the character's stance and expression, the overall feeling of suspense and anticipation, as well as the choice of a precise, defining moment within the invisible narrative that surrounds the statue. Imagination in the purest sense of the term: Michelangelo working with a beautifully pellucid effigy in his mind. On the other hand, the eye is inescapably attracted by the perfection in the *execution* of that conceived representation. Several critics, scholars and biographers have spent considerable portions of their careers and lifetimes investigating and commenting on each of the many, often minute, anatomical details that, through a complex and rigorously studied interplay of proportions, blend into what is indisputably a pinnacle in human accomplishment.

And yet, to focus exclusively on Michelangelo's conceptual and executive genius would mean overlooking one of the aspects that stand behind such achievement: the Herculean *labour* of a 28-month battle against a colossal and recalcitrant block of marble – a task that, in fact, Michelangelo was not the first to attempt. Work on the block had been begun and almost immediately abandoned by Agostino di Duccio and, subsequently, Antonio Rossellino. Both sculptors, who had been requested to complete a giant statue of King David for the Cathedral of Florence, had come to the conclusion that the marble's quality was insufficient to enable the task to be completed. Michelangelo, then 25, must therefore have started working on a block that already showed some initial anthropomorphic resemblance. This anecdote highlights the role played not just by the artist and the genius, but also by the *craftsman* in Michelangelo; the one personality within his character that did not imagine and depict King David, but physically liberated his body with perseverance and precision from the amorphous anonymity of a marble block.

Beyond being the tale behind one of the most universally admired works of art of all time, the story of the making of Michelangelo's 'David' is therefore also one of conviction, expertise and ambition. It is a formidable testimony to the relationship between talent, motivation and hard work. Most importantly, it is a story in which

the threads of art and craftsmanship intertwine, giving birth to a masterpiece.

In a recent, engaging book aptly titled *The Craftsman*, Professor Richard Sennett, a well known sociologist and essayist as well as – interestingly – a former professional musician, relates the term to 'the desire to do a job well for its own sake'.[ii] Such a desire is seen as a basic human impulse and is tightly connected to the skills required to deliver such quality. Professor Sennett, specifically, discusses the relationship between art and craft, looking at the latter as necessary to the former, through an improvement that takes place in an ongoing, constantly dynamic manner; a regular, naturally time-consuming sequence of problem solving and problem finding, rather than a succession of sudden outbursts of inspiration. Ultimately, it is a process that often requires the subsequent acquisition of a set of adjacent skills and competences in a spiral of unending improvement.

These reflections are a good place to start when discussing the reason for recognising the role of craftsmanship as one of the four pillars of meta-luxury, alongside focus, rarity and history. It is, in fact, hard to find a facet of human activity and spirit that is more consistent with a paradigm that we define as being based on unique achievement.

In many ways, craftsmanship is as inextricably connected to the primary idea of achievement *per se* as it is to the condition of its uniqueness. This is because, as we will see, there is a sense of individual expression, talent and determination that is at the very heart of the notion of craftsmanship. Above and beyond this, craftsmanship is quintessentially connected to the three defining elements of unique achievement – knowledge, purpose and timelessness.

Craftsmanship and Knowledge

The liaison between craftsmanship and *knowledge* is immediately apparent. The process of learning, accumulating expertise and

becoming proficient in something through the repetition of a certain set of activities is quintessential to human nature, and transversal to various disciplines. What is particularly engaging is the powerful sense of the individuality of knowledge that is intrinsic to the notion – and even, literally, to the word itself. The concept of craftsmanship relates implicitly to the knowledge of an individual; a form of knowledge that is therefore structured in a way that is not replicable, as it is influenced by the unique combination of qualities and by the life course of that specific individual: the time, the place, the encounters and the events that characterise them. This does not mean that a craftsman's knowledge cannot be shared or passed on from one individual to another, typically across generations or 'schools'. It does mean, however, that as this process of transfer happens, such knowledge cannot stay the same but evolves or changes to some extent because of the recipient's own uniqueness. There is, in other words, a strong sense of ownership in a craftsman's knowledge – the awareness that such knowledge is continuously informed and shaped, and cannot therefore be coded in a way that is all-encompassing and definitive.

Associating the notions of craftsmanship and knowledge also implies rejecting the simplistic separation between the so-called intellectual and manual activities. Such a division looks forced and misleading. We maintain that, on the contrary, true craftsmanship corresponds to the breaching of such barriers. When looking at the work of many unsung master craftsmen embellishing some of the world's most beautiful buildings, palaces and cathedrals, it is undeniable that their hands must have been guided by rational intelligence;[iii] and that the completed result of their work, as well as ultimately belonging to a greater, unique unity, must have held a profound emotional significance. The line between the material and the immaterial becomes blurred.

Conversely, think about the sublime cantos of Dante's *Divine Comedy*. It is impossible not to revere Dante's 'overwhelming poetic power'[iv] and sense of the absolute which cause this masterpiece to transcend the boundaries of poetry itself; and yet, it is also very difficult not to admire the mere precision of the poem's metrics: verses that are carved out of language, crafted syllable by syllable. Here, too,

trying to isolate abstract inspiration from verbal technique looks like a sterile exercise.

Or finally, in the performance of a virtuoso violinist, where does the understanding of the author's musical message end? And where does the pure manual ability to translate that message into the apposite vibration of strings begin?

Craftsmanship and Purpose

There is a strong sense of *purpose* embedded in the notion of craftsmanship. For instance, while we are used to categorising studies (in the general meaning of the term) as the progress from one attainment to another in a scale of discrete levels – from elementary classes all the way to PhD's – we tend to associate craftsmanship with a seamless, and unending, stream of experience and improvement. Of course, there have been, and still are, 'master' titles and schools in the world of the so-called crafts. And yet, there is a sense of continuing, ongoing learning, acquisition of expertise and improvement beyond official recognition and diplomas. It is an *in fieri* quality that is deeply intimate, and reflective of an endless pursuit of perfection. We sometimes refer to studies that have been completed; yet we never identify a point in time where a craftsman's advancement comes to an end.

The act of making something, in the most tangible sense of the phrase, is the transformation of purpose into a physical result, through the persistent targeting of ideas, talent and energy towards the creation or refinement of an object.

Moreover, craftsmanship represents a clear choice between effectiveness and efficiency, preferring the former over the latter. While effectiveness is all about the extent to which things are done in the best possible way, efficiency is all about the extent to which they are done in a labour-, cost- and time-saving way. In effectiveness, quality is the driving constant, where processes are the variable. In efficiency, quality becomes the variable, where processes are

the driving constant. We will turn back to this peculiarity when discussing the economy of meta-luxury.

Hence, craftsmanship represents a production approach that is about purpose, not means. It is about compromising on cost and time to achieve the best, not the other way around.

Craftsmanship and Timelessness

The last point also brings to the foreground the relationship between craftsmanship and *timelessness*. It stems from a profoundly human longing: the desire to leave a trace that will survive us – a longing that craftsmanship expresses in a double sense.

On the one hand, it is about passing on to generations distinctive skills, learning and principles that can remain unique and be continuously improved upon; a legacy to be further enriched, not diluted. During a visit to Gucci's factory in Casellina, near Florence, where all of the brand's bags see the light, our talks with craftsmen often revealed that they were second- or third-generation artisans, and focused on the years of required apprenticeship working beside a senior colleague.

On the other hand, timelessness is pursued through the creation of a physical object that stands as the testimony to our own life and times, and an expression of those skills.

As can be seen, craftsmanship embodies the pursuit of timelessness in two ways. In a static sense, as the wish to leave a tangible expression of skills that can stand the test of time; in a dynamic sense, as the constant nurturing, protection and improvement of those skills. An endless virtuous cycle between timeless evidence and timeless pursuit that marks the history of many of the world's greatest artisan dynasties and, in several cases, brands.

There is hardly a better example of the relationship between craftsmanship and the passing of time than the Japanese Living

National Treasures, or *Ningen Kokuhō*. This is the popular term for the official title of *Jūyō Mukei Bunkazai Hojisha*, or 'Keepers of Important Intangible Cultural Properties'. Induction to this group is restricted to those individuals or groups that possess the unique skills that are vital to the creation of cultural properties: masters who have devoted their entire lives to the pursuit of perfection of an art or craft – from music to *kabuki* theatre, from metalworking to lacquerware. In these pages, we are honoured to record our conversation with Kazumi Murose, a Living National Treasure who has devoted his life to the mastery of *urushi*.[v]

Interestingly, inclusion in this elite is aimed at ensuring future continuity as much as it is about recognising past achievements. The grants awarded by the government as part of the recognition are also aimed at contributing to the training of a successor or to public performances, as well as other activities that promote the attraction and education of new generations of artists or craftsmen. Most Living National Treasures take over their trade – but never their title – from their fathers and grandfathers, weaving a thread of skills that passes on from one generation to the next. A lineage that is kept alive by passion, commitment and even sacrifice as much as it is by pure talent.

Tradition and Innovation

As a distillation of an individual quest based on knowledge, purpose and the pursuit of timelessness, craftsmanship for meta-luxury brands is much more than merely the choice of a manufacturing process. It reflects a deeply rooted conviction.

Craftsmanship is the one principle through which these brands encapsulate their unique skills within their offering. Of course, technology and outsourcing can make most production processes quicker and cheaper. They can increase productivity; and, very often, today, they can do so with little or no impact on the tangible quality and performance of products – at times, they can actually improve it. So what prevents these companies from opting for what would

instinctively look like a sensible business decision, and one that might look like a beneficial factor from an economic perspective?

We do not think it has anything to do with obtuse conservatism, fear of change or lack of vision. Many of our encounters and conversations showed that there is a proud determination in maintaining, preserving or even reviving production processes and methodologies based on manual skills. Craftsmanship is generally a choice, not the lack of one. It is never about tradition for tradition's sake.

To this extent, there are very often stereotypical associations between craftsmanship and tradition on the one hand, and between industrial technology and innovation on the other. These relationships are often misunderstood or looked at in a superficial way. In truth, any form of craftsmanship has innovation in its genes and at its heart. Craftsmanship is the result of continuous progress and endeavour; it is about looking ahead much more than about looking back. Tradition originally begins with – and, over time, is consolidated through – innovation. Very often it is the outcome of an aggregate of man-centuries of trials, mistakes, problem solving and advancement, sometimes across different cultures and often across diverse disciplines. The craftsman employs tools, skills and techniques that are not rudimentary, but, on the contrary, extremely sophisticated. A process based on human skills is usually much harder to replicate than most industrial processes.

In our conversation with Simon Jacomet, co-founder of zai, maker of what many consider to be the world's best skis, he observes how the firm employs a combination of skilled handcraft and sophisticated technology, depending on what provides the best results in a specific phase.

Most importantly, craftsmanship is based on human insight, not on digital memory. It does not allow for mechanical repetition, but only for the re-ignition of an inspired challenge. It is about passion, wisdom and intelligence, not merely about productivity, compliance and qualification. When transferred, it inevitably allows for reinterpretation, but never straightforward duplication.

Craftsmanship does not work by crystallised standards, but evolves as a living, pulsating point of view and evaluation.

The craftsman chases a dream, not a standard. Hence, what craftsmanship is fundamentally about is the value of individual judgement in a production process. It is the refusal to sacrifice that judgement for the sake of potential economic advantage. The craftsman will change the rules to fit the desired result, never the opposite. Craftsmanship stands as the ultimate link between the human and the inanimate, breathing life into objects.

Craftsmanship as a Driver of Choice

To meta-luxury brands, craftsmanship is not simply a self-referred choice relating to the way of making things. Most importantly, it is a value creator in the marketplace. Craftsmanship drives demand and engenders loyalty, generating long-term economic value and making the business model sustainable. It fundamentally trades in-house efficiency for marketplace effectiveness.

We often instinctively associate the concept 'handmade' with something that is precious. This connection, however, is not automatic. What is it that makes craftsmanship ultimately desirable and valuable?

First and foremost, there is a specific meaning and value that as customers we attribute to objects that encapsulate the history and the continuity of competences that have been built over time. As human beings, we simply seem to value more highly the results of a continued commitment to delivering superb products. A possible interpretation of this lies in the fact that we regard such commitment as being directed towards our own individual needs and desires. We regard ourselves as being deserving and discerning. We feel we are not passive consumers, but active and recognised connoisseurs. We feel honoured and valued by this devotion, and we wish to reward it. Craftsmanship is, after all, a form of indirect customisation; we feel treated as individuals rather than as units within a market share.

A second answer to the question 'Why craftsmanship?' is that we seem to be attracted by things that in one way or another are larger than life, almost literally: by things whose significance stretches beyond the scale of our own lifetime. By capturing in a single object a form of mastery developed across decades, if not centuries, the craftsman's work reconnects us to a kind of wealth that is irreplaceable in the span of one lifetime. It is a materialisation of the value of time, the one resource and dimension over which we have no control. The result of the craftsman's skills enriches our own life with the purpose and meaning of the lives of other women and men – often from a number of generations.

There is also a more emotional side to the value that craftsmanship adds to meta-luxury brands. As we have mentioned, the individual dimension is at the heart of the concept of craftsmanship. The physical and sensual contact between the craftsman's hands and the object that is being created seems to allow for a transfer of an emotional and conceptual nature, building a relationship that is no longer about mere production, but rather of inheritance and even parenthood. The spirit of the creator is encapsulated in the creation, which absorbs his or her individuality, becoming a unique, inimitable entity in itself. A typically human characteristic, uniqueness, is forever infused in the object. In a way, the object acquires an emotional and symbolic life that goes far beyond its tangible qualities.

Craftsmanship is therefore not about the mere the act of shaping, cutting or assembling; it is about giving life to an object, providing it with a significance and individuality that transcends its mere tangible qualities. It is about a value that no longer resides only in the material qualities of the creation, but in its origin, a meaning that reflects the human longing expressed by the most instinctive of questions: 'Where do we come from?'

Thus, as we can see, the role of craftsmanship in meta-luxury stretches far beyond the intrinsic quality provided by a production technique. It is, in fact, about the creation of objects or, more generally, the reaching of accomplishments that are unique and not substitutable – and, therefore, intrinsically valuable.

In meta-luxury, craftsmanship can be defined as ***the creation of individual objects that are unique and non-substitutable due to tangible and intangible, rational and emotional qualities deriving from the predominant use of human judgement, skills and techniques in their conception and execution.***

Craftsmanship versus Competence and Inspiration

Contrary to conventional wisdom, it is somewhat difficult, and probably wrong, to try to separate the worlds of craftsmen and of industrial processes by means of a straight line. It is commonly thought, for instance, that technology is an alternative to craftsmanship. This is a simplification of reality.

First and foremost, technology, in the most pristine sense of the term, is quintessential to any kind of manual activity; any trade is inseparable from its tools, and the relationship between the two stretches back to the dawn of history. From the shoemaker's awls to the luthier's bending irons to the painter's brush, the act of making something has always involved the use of tools. Of course, in time tools have become more complex, effective and efficient, allowing for a degree of precision and reliability – or, simply, a physical result – that is unattainable by hand. They have evolved into machinery, providing a higher degree of independence from man's work, encompassing a sequence of different tasks, or further improving the precision with which such tasks are carried out. Albeit with some crucial leaps and breakthroughs, technology is a continuously evolving concept, extending from primary tools to laptop computers. In recorded history, there is no before or after technology, but a sequence of stages in its development.

This takes us to the second point. More often than not, making something involves a combination of tools, machinery and handwork. The involvement of technology is not a matter of 'with' or 'without', but rather of 'to what extent'. Thus, except in extreme cases, it is arbitrary to trace a precise boundary between what can be claimed as being an artisan's product and what is an industrial one.

When asked about this, Salvatore Ferragamo S.p.A., a company with proud artisan origins, provided reflections on:

the values that have allowed an enterprise well rooted in Florence's arts and crafts tradition to keep this DNA intact, even throughout the difficult transition to industrial production. Belief in sharing and developing skills, in craftsmanship intended not only as manual 'know-how' but above all as a mental process in which passion for one's work, the desire to keep progressing, an obsession with quality and continual research into materials and technology are side by side with well established expertise based on one's Italian cultural roots, are tangible expressions of a zeal and dynamism that belong anywhere but in the past, that now more than ever represent elements of distinction and important levers for facing the future. Today's craftsman is the artist who plays the music, the shoemaker who operates and controls the machine at work, the young person who creates a new website. [...] Since the Sixties, enormous work has been done at Ferragamo to serialise made-to-measure footwear, to the extent of producing more than 80 fittings per model. Most of the manufacturing stages are done by machine, but the machine is always guided by man's experienced hand.[vi]

For these reasons, recognising a brand as being a meta-luxury brand along the axis of craftsmanship is a question that is sometimes less than straightforward. There are, of course, the obvious cases of brands that represent the quintessence of craftsmanship, and others that are the epitome of mass-production; in other circumstances – and this is true for some of the so-called luxury brands – the boundaries are decidedly blurred.

As we have seen, for some highly respected brands, craftsmanship is a fundamental principle; to their following of connoisseurs, it is a crucial driver of choice. Therefore, it makes sense to define a categorisation that can help distinguish meta-luxury brands, for which craftsmanship is a prerequisite, from brands whose proposition is less closely linked, or not linked at all, to this principle. As will be the case with the other pillars of meta-luxury, the intent is not to measure what cannot be measured, but simply to trace a convincing logic that is consistent with the notion of unique achievement. This leads us to see brands based on craftsmanship as part of one of three clusters.

I. Craftsmanship Brands

This cluster includes brands for which craftsmanship is an essential part of their *raison-d'être*. For their makers it is not simply a philosophical approach or a production process choice; it is a value-generating differentiator, stirring desire and generating demand on the market. As such, craftsmanship drives a considerable portion of the economic profit created by the company, and is therefore an integral part of the business model.

Every single item created by these brands stands not only as an achievement, but one that is unique, both in qualitative and in quantitative terms: on the one hand, it is born of the skills of craftsmen that represent the peak of a certain *savoir-faire*. On the other hand, each piece stands as an individual creation, not as a unit of production.

This is the world of the one-off, the custom-made and the limited series, where nothing is completely replicable. It is a world of natural, not deliberate, rarity, which derives from the uncompromising prioritisation of quality over efficiency. Excellence is the constant and the guiding principle; all other parameters – cost, time, effort – are dependent variables, and it is this very conception that draws the connoisseur to the craftsman. What is being purchased is, beyond the object itself, the excellence and devotion that have brought it to life, as well as a sense of profound connection between individuals.

In this book, we talk to Horacio Pagani, the founder of Pagani Automobili, whose cars have often been rated by commentators as the best in the world. Every single car delivered by this company originates from a passionate commitment to the customer's desires and is the work of a small team of skilled people. Each Pagani aims at being a unique achievement.

This cluster includes, very often, those creators that do not have the competitive strength or sheer magnitude to be referred to as brands in the common sense of the word, but whose works encapsulate the notions of knowledge, purpose and timelessness, addressing a

relatively small circle of connoisseurs. Artisans who are discovered and recommended, not advertised, and who may well be the initiators of the meta-luxury brands of tomorrow.

II. Competence Brands

Brands in this set possess a distinctive expertise and a recognised excellence, as well as unique production solutions and methodologies, some of which may require the contribution of human skills. However, they cannot (or can no longer) claim craftsmanship as it has been defined, that is as *the creation of objects that are unique and non-substitutable due to tangible and intangible, rational and emotional qualities deriving from the predominant use of evolved human skills and techniques in their conception and execution.*

In fact, the products that brands in this cluster offer do indeed embody an achievement. As objects, however, they do not possess the virtue of uniqueness in the sense of each being an individual creation, differing from the preceding and from the following one, and being exclusively connected to a single moment in time. These brands stand for achievements that, however, cannot be called unique.

The role played by the skills, the labour and the commitment of an individual is distinctly present in the conceptual development of a given product in this class; yet, such a role remains concentrated there. It does not extend to its actual production, which does not involve in a predominant way the dedication of an individual. In other words, there is uniqueness in conception, but not in execution.

This is the case with some distinguished watch brands. Their models are often extraordinary accomplishments in terms of design and conception, reflecting the remarkable creative and technical talent of an individual or a number of individuals. However, the actual production takes place through a highly automated process. The absence of human insight in the physical production of a specific item cuts the thread between the individual customer, the individual object and the individual maker. The same can be said of several long-standing high-end car manufacturers, whose offering consistently

represents a unique combination of performance, style and groundbreaking technology. Yet, they cannot claim their products to be the work of craftsmen. Porsche would be an example of this. This extremely valuable and revered brand stands for a number of 'principles',[vii] as they are defined, which are consistently and thoroughly met, even when it comes to vehicles like the Cayenne or the Panamera, which successfully shatter conventional wisdom about what type of cars can embody the spirit of Porsche. This brand draws on the notion of engineering in the service of victorious performance, whilst deliberately not claiming the craftsman's touch of uniqueness on each single unit.

Admittedly, the rationale behind a process that is largely independent of human supervision is often, but not necessarily, time or cost efficiency; in some cases, such systems are aimed at ensuring a consistently high quality in output. Whatever the reasons, the desire for the products offered by brands within this set is not – or no longer – triggered by the rational and emotional implications of craftsmanship. It is not, or no longer, a driver of demand.

III. Inspiration Brands

This tier includes brands whose products do not stem from a specific skill set or a proven excellence at making things. Craftsmanship is not a part of these brands' propositions; it is not a differentiating element vis-à-vis the competition, nor is it a driver of demand for their customers.

This does not mean that these brands are not desirable, but simply that they are so for reasons that escape the notion of craftsmanship. There are several examples of global fashion brands that are based on the symbolic power of a signature deployed on a mass production of scarcely differentiated goods. We call them 'inspiration brands' to evoke the notion of brands whose products represent a label rather than embody a principle or a human skill. Typically, these brands focus on quality as a necessary factor, rather than on excellence as an ethos. Their model is based on efficiency.

The logic around which these brands revolve is essentially antithetical to the way in which craftsmanship creates value for meta-luxury brands, for at least two reasons.

In the first place, while in the case of meta-luxury brands the intrinsic qualities of a product serve to create, develop and consolidate the brand's reputation[viii] over time, in the case of inspiration brands the reverse process is in place: their desirability adds value to products that have relatively little value *per se*. Second, we have seen how craftsmanship is based on the passing on of skills. Conversely, as a rule rather than an exception, inspiration brands are centred on the creative talent of an individual.

Overall, these differences are reflected in two opposite value-generating profiles. Compared with craftsmanship brands, inspiration brands tend to be larger in scale, but also to be much riskier because of the higher degree of substitutability of their offering and, very often, the hinging on an individual talent rather than on a continuing lineage of skills.

A typical occurrence is the migration from one model to another, whereby what was once a brand soundly based on craftsmanship evolves, later in its lifecycle, into a brand that generates value through other, typically more ephemeral, factors.

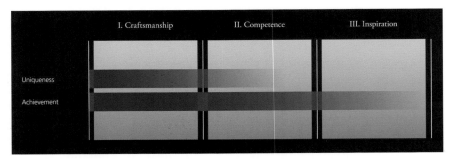

Craftsmanship, Competence and Inspiration

Summary

For the first time in man's history, culture no longer appears to be a question of acquisition, but of mere retrieval. The power of networked information and the rise of cloud computing seem to break apart who we are and what we know. Information and knowledge are things that we increasingly seem to access rather than possess.

The dawn of this shift makes individual *savoir-faire* more important and valuable than ever. Craftsmanship is about women and men imagining and creating, failing and succeeding, searching and finding, preserving and challenging – and developing unique expertise in the process. It is, just as importantly, about the constant flow of such expertise from one generation to the next, across decades and centuries.

Craftsmanship breathes humanity into objects, allowing the individual to create for the individual. In doing so it translates the principles of knowledge, purpose and timelessness into products that represent unique achievements.

Meta-luxury brands attract demand and desire by creating products that are born of a culture of excellence, and that as such are destined for discerning individuals rather than hollow men.

[i] 'Here, in this object / Which the shifting eye explores, / Seeking the axis of proportion, our being settles for a moment; / Through it some other life extends its truth, / Another eye, another dream achieve / Their simplest answer.' El Signo, *Noventa y nueve poemas*, Literatura Alianza Editorial, page 90.

[ii] *The Craftsman*, Richard Sennett (2008), Yale University Press, New Haven and London.

[iii] It seems appropriate to quote one of Michelangelo's best known poems: 'Non ha l'ottimo artista alcun concetto / c'un marmo solo in sé non circoscriva / col suo soverchio, e solo a quello arriva / la mano ch'obbedisce all'intelletto' ('Even the greatest artist has no vision which a single block of marble does not envelop; and only the hand that obeys the intellect can reach it'). *Rhymes*, anthologised by Michaelangelo Buonarroti il Giovane in 1623.

[iv] *The Western Canon: The Books and School of the Ages,* Harold Bloom (1994), Harcourt Brace & Co.

[v] The term *urushi* is translated as the art of Japanese lacquerware.

[vi] Quote kindly submitted by Salvatore Ferragamo S.p.A.

[vii] Source: Porsche AG website.

[viii] It is perhaps interesting to point out a synonym of the term 'brand' that is now virtually disused: 'make'. A terminology suggesting that a brand's reputation would coincide with the product's physical qualities.

Horacio Pagani

Passionate about cars and automotive design since his childhood days, Argentinean-born Horacio Pagani studied industrial design and mechanical engineering in his native country. In 1983 he moved to Italy, where he started working for Lamborghini, eventually being responsible for several milestone design and engineering projects. In 1991 he founded Modena Design, a company that quickly gained a reputation for its pioneering use of advanced composite materials in the development of high-performance products. In 1998 he gave birth to Pagani Automobili, the brand under whose aegis the Zonda project came to life: a supercar with a highly innovative design and a body made entirely of carbon fibre, regarded by many respected critics as one of the world's best cars. Today, 138 Zondas exist worldwide. In March 2011 Pagani Automobili introduced the universally acclaimed successor to the Zonda – the Huayra

The interview with Horacio Pagani is over. Before saying goodbye, Pagani disappears for a moment. He reappears holding a small, worn-out paperback book. This book, he observes with a smile of genuine affection, has accompanied him throughout his life. Written by fellow Argentinean José Ingenieros in 1913, it is titled *El Hombre Mediocre* (The Mediocre Man). He turns to one of the first pages, and translates from Spanish a passage that, he says, has been a perpetual source of inspiration for him: 'When you point your visionary bow towards a star and spread your wings to reach an unreachable height, thirsty for perfection and rebellious against mediocrity, you have within yourself the mysterious spring of an ideal' (*Cuando pones la proa visionaria hacia una estrella y tiendes el ala hacia tal excelsitud inasible, afanoso de perfeccion y rebelde a la mediocridad, llevas en ti el resorte misterioso de un ideal.*) Seldom has a quotation found a more apposite reader.

It is a typically searing summer morning in the flatlands of northern Italy when we drive to the headquarters of Pagani Automobili, just outside the city of Modena, in the Italian region of Emilia Romagna. To motor sports enthusiasts, this area can only be described as the Garden of Eden. Within just a few square miles, the likes of Ferrari, Maserati, Lamborghini, Ducati and obviously Pagani were founded. To this day, this is where they still shape high-powered dreams.

The Huayra, the first successor to the quasi-mythical Zonda, was

revolves around this.' To Horacio Pagani, the personality, thoughts
and works of Leonardo have been more than an inspiration. They
have been a life-changing revelation, and this will be the leitmotif of
our conversation.

'Since I was a boy, I have had a certain talent and attraction for all
things manual: drawing, crafting, woodwork. I have always felt the
need to touch the material, to make things with my own hands,'
Pagani observes, gently closing his hands to underscore the instinctive
nature of this longing. 'I must become a friend of the material I work
with,' he muses.

'I was very lucky in one respect,' he adds. 'By the time I was 12,
I had a firm idea in mind as to what I would do: design cars. I used
to spend time making models in balsa wood and any other material
I could lay my hands on. I did wonder, however, about what kind
of studies would take me there. Would it be art? Or mechanical
engineering? I was actually fascinated by the aesthetics as much as
I was intrigued by technical aspects.'

At that time, in Argentina, Pagani recollects, there was nothing
that could provide the best of both worlds. 'One day I came across a
magazine that my father used to read. There was an article on the life
and works of Leonardo. What struck me was not the "Mona Lisa"
or other masterpieces, or his inventions. It was rather his conviction
about the unity between art and science. That was the one answer
I had been looking for.'

'I don't think I've invented anything,' he points out. 'I have simply
been faithful to Leonardo's principles. And as time goes by, I am
increasingly convinced that if these were followed and taught at
schools and universities, there would be a seamless connection
between all creative, development and industrial processes.' He
suggests that it is the Japanese who appear to be applying this
approach today. 'They succeed in creating things where form,
function and style can hardly be separated.'

Pagani is against much of the conventional wisdom about Leonardo. 'There's a lot of received wisdom, even gossip. Most people know nothing about what is truly fascinating about him – his way of thinking. His ideas were four centuries ahead of their time. Wood, iron, textiles: that's all he had available, and, still, he perfectly understood how they could be used in the best possible way. Today, we are familiar with countless sophisticated materials. We can predict their behaviour. Through computers, we are faster and more accurate. And yet, we completely miss the culture of *manual intelligence.*'

This concept is dear to Pagani, who interprets it as the essence of craftsmanship. 'The mind thinks and imagines, but everything must go through the heart; ultimately, our hands express all this love and passion, be it through a musical instrument or a stonecutter's tools. Look at Italy, an open-air museum. These treasures weren't crafted just by the hundreds of artists we know, but also by thousands of unrecorded, passionate craftsmen. This shows that manual intelligence was much more widely diffused than it is today.'

When asked about the difference between craftsmanship and art, he admits the lines are blurred. 'I would say that the craftsman tries to follow the rules to perfection, while the artist reshapes them, and adds something new. This is another way of seeing manual intelligence.' He hints at the view that an artist should also be a craftsman, while the opposite is not necessarily true.

'Over the coming years, I would like to leverage my public profile to diffuse this concept, which was the cornerstone of the Renaissance. Of course, I don't believe it could ever trigger a second Renaissance: as individuals, combining science and art in all we do requires a greater effort, and we live in a society that is dull and inertial. Yet, I'm sure it would generate a significant evolution.'

Manual intelligence is not the only inspiration that Pagani finds in Leonardo. 'He was a man who never stopped observing and

wondering. And that requires a special humbleness. Which, to me, is a kind of daily re-set. It is about constantly questioning what you know and, especially, don't know. It is about wanting to learn more. For instance, there's a passage in his writings where he recounts the patience, perseverance and even stoicism required to study the human body. Yet, he was propelled by a dream. He wrote dozens of groundbreaking books on the subject, and, as he says himself, was stopped only by time. He wasn't in it for the money, as he could have spent that time working for, and earning from, patrons. These are the things the world should know about Leonardo.'

These observations have meaningful consequences for Pagani. 'I'm very responsible and cautious about the way we spend and invest money, but making money has never been the goal. Money isn't something emotional for me. My job is, because of its combination of art and science. The sheer happiness we share with our customers is really the ultimate reward.'

Pagani's relationship with money is a peculiar one, he suggests. 'Saving is always much easier than earning,' he jokes. 'My duty towards the company is to invest in research, innovation and design, which is a way of transforming money into a source of social wealth. That is the one thing I'll never save on. I'll rather fly economy and choose from a restaurant's menu by looking at the price column first.' This, he emphasises with a mixture of pride and affection, is part of the logical mindframe of 'someone who started from scratch and whose possessions, upon arriving in Italy, amounted to a bicycle for himself and one for his young wife.'

So what does luxury mean to the man behind cars that have often been ranked as the best in the world? 'The term "luxury" is highly subjective. You know, today it stands for almost anything – even the time to have a coffee with a friend,' he reasons. 'We need to categorize the concept. To begin with, I guess we should distinguish tangible luxury from spiritual luxury.'

We discuss the former. 'Be it about a handcrafted object or the result of an industrialised process, I see tangible luxury as combining the absolute best in everything. The best craftsmen. State-of-the-art technology. Extraordinary materials. The best combination of design and function. The utmost effort in terms of imagination. All of this stems from a form of extraordinary care, stretching from creativity to production. Every single detail of the Huayra is created with this care. From the outset, we dreamed it would be recognised for embodying just that – once again, art and science.'

However, he adds, 'the cars we make here are not just the result of how we conceive them. We strive to interpret and deliver through our work those objective and subjective phenomena that trigger an emotion. It is only by creating something that fulfils someone else's dreams that we reach an achievement. This is authentic luxury.'

When discussing what Pagani instinctively calls 'spiritual luxury', we inevitably switch to a more personal level. 'I always tend to embark on long-term projects. Not just the seven years it took to develop the Huayra, but even things such as my own home. And yet, I cherish every moment. I live for visions, but enjoy every step towards them. It's my daily dose of energy. This prevents life from being a long wait for something which then, suddenly, overwhelms you. You know, your hands can only hold so much water,' he thoughtfully explains. 'That is probably why luxury to me is about a simple thing like waking very early in the morning, and watching the birth of a new day. Sensing its freshness, breathing its scent, listening to the blackbirds singing outside. My cat and dog being there. Starting to write things down. All of this is simply beautiful.'

Born in 1963 in Disentis, in the Graubünden canton of Switzerland, Simon Jacomet studied art in Florence, supporting himself by working as a ski instructor trainer. An architect and artist, in the Nineties Simon worked as a product developer for Völkl and Salomon before co-founding zai in 2003 in his hometown. zai skis are individually handcrafted and stem from the pioneering use of materials and innovative manufacturing techniques, as well as extensive research into human movement. The company's goal is to provide customers with an unparalleled ski experience, as well as unique longevity. In 2011, zai was chosen as the official ski of the FIS World Alpine Ski Championships in Garmisch-Partenkirchen.

When in 2003 Simon Jacomet founded zai, he sought the help
f Leo Tuor, a celebrated author known for his novels in the local
omansh language. Jacomet wanted him to express in a concise
nd lasting way the guiding vision of his endeavour. The outcome
ventually took the shape of a poem, which, Jacomet proudly says,
olds the answers to all of our questions. If in and between those
nes we can't find a convincing reason for doing something, then we
ouldn't do it.' A story that provides an enthralling answer to many
f our questions, too.

It is a crisp, sunny day in Disentis, a small town in the Swiss
anton of Graubünden known in Romansh as Mustér, or
nonastery' – a reference to one of Switzerland's oldest religious
ommunities. The Benedictine abbey dominates the picture-
ostcard town where Simon Jacomet grew up before leaving for
lorence to study art, and where in 2003 he was back to found zai.

'There is a strong artisan heritage in this area,' Jacomet observes,
 deep know-how, especially when it comes to woodworking. I have
ften heard people who work with me say, "If I leave work and I'm
ot completely happy with the way things have been done, then I

unique appearance, but that is not the primary reason. Performance is. That is what really guides us.'

Performance is an all-encompassing concept for zai, whose brief, effective name, he explains, means 'resistance' in Romansh. 'It has to do with longevity,' Jacomet explains. 'Of course, when we started, this was something we could only promise. Now, we are proving it. And besides that, every one of our skis can be serviced back to mint condition, because we can rework every single component.' Performance is also about these skis' unparalleled lightness and flexibility, 'two aspects which we constantly strive to improve.'

'And then there's design, of course,' Jacomet adds, caressing the surface of a half-finished ski. 'However, design is never for the sake of design itself. It must improve the performance. That is also one reason why we are confident to leave our exterior designs unchanged for several years.'

When we visit the workshop, we are patiently introduced to an impressive wealth of learning and anecdotes on materials and techniques, as we watch uniquely skilled workers crafting what are arguably the world's best skis. 'We make no compromise. No compromise on how long it takes, how difficult it is, or how expensive it is. When I create prototypes, I never stop and think how much it is going to cost. I just look for completely new solutions, and in that respect I am passionate to the extent of appearing slightly radical,' he admits. 'We are often told that our skis are too expensive. I disagree,' he says. 'I believe it's other makers' skis that are too cheap, which is often enabled by making profit on other products. Pressure on margins prevents innovation and the use of high-value materials.

'When we first set out to make high quality skis, we were greeted with a degree of scepticism. We even had difficulties in securing supplies for the small quantities we needed,' Jacomet recollects. 'Eventually, we proved we could make great products. Today,

whenever suppliers come up with new ideas, it is us they share and experiment with, as they know how focused we are on innovation. It is only by trying things out ourselves that we get insights into how to improve, and that's why we are so keen to be in charge of the whole process.'

Materials are indeed meaningful to Jacomet. 'As a principle, we like our products to show the material they are made of, although we make exceptions on request.' Throughout its history, zai has often introduced totally new materials to the world of skiing, such as local stone. 'Having something which is over 50 million years old at the heart of some of our products is extremely inspiring. Again, though, this must improve performance. In this case, stone defies conventional wisdom in the impact it has on weight reduction and dynamic reaction.' Being a first mover, Jacomet notices, is at once a burden and an advantage. 'When we toy around with completely new ideas, the reaction of some partners is often "impossible". Therefore, we literally have to invent a way of doing things, and I can assure you we make many mistakes. But this helps us create a unique wealth of know-how, which we must preserve as a unique asset.'

Trials are then a quintessential part of the innovation process at zai. We ask how the impact of minimal differences in weight, profiles or materials can be measured. Jacomet smiles. 'Up to a certain point, it's a question of measurement. Beyond that, it's a matter of sentiment, and even university professors will agree. What is really important is to understand and record what you are doing, and learn from that. Cause and effect.'

People, of course, are a crucial part of the zai endeavour. 'We place a great emphasis on the responsibility and sense of ownership of each person working here. We are happy when our customers come over and meet them – we know how important this closeness to the product and to the people who create it is, as is the aura created by the fact that no two skis are identical – although, of course, their technical performance is.'

In its time, zai has designed skis for the Bentley and Hublot brands. 'These partnerships have never been about just placing a logo on a pair of zai skis,' he explains. The Bentley skis, he tells us, derived from an in-depth study in product design and ultra-advanced materials, resulting in a mutually enriching exchange of competences between the small Swiss firm and the illustrious car manufacturer. 'One customer openly told me he was very critical of that project – and, by the way, this implied a great respect for our brand, which pleased me. I felt I had to explain to him what it was really about. This shows that you really need rock-solid motivations behind everything you do.'

Being challenged is something that Jacomet gives specific importance to. 'We have a duty to be able to respond to anyone challenging our work. If we can't justify what we do, how we do it and why – well, then we shouldn't be doing it in the first place. Besides, I have always believed in the value of working with people who are at least as good as I am – and preferably even better. It's probably more difficult, but it's important. You must never be afraid of being challenged.'

Jacomet began skiing as a very small child, and went on to become a ski instructor, which, he remembers, 'was also a way to pay for my education.' To him, skiing is about 'movement, freedom and being immersed in nature. It is a way to express yourself and to tame danger. We create skis that enhance those feelings, help find new limits and make the experience truly unique.' His love for skiing, he recollects, was certainly the first driver behind the creation of zai. 'Beyond that, we saw an opportunity in the fact that there were examples of excellence across many industries, but not in ski making. In my previous experience in the industry, I had to live with far too many compromises on quality. I felt there definitely had to be another way.'

'Originally,' he says, 'I thought I would leave the industry to go back to painting or pursue my passion for architecture. Then this

idea came up, and I knew it was going to be a full-time effort. I have no regrets, though. I love what I do, and I love the fact that it combines function *and* art. I've always tried to look into the depth of things.'

To Jacomet, 'luxury is being in a condition to do what you're deeply passionate about. However, you should also be aware that this requires a keen determination. It is a struggle that is by far outweighed by its rewards. When some observe that what we offer is expensive, I like to tell them everything about the hard and passionate work that stands behind it.' The strain caused by the will to create a new, outstanding product can be considerable, he explains. 'When developing a new product, there is a moment when I am incapable of communicating my ideas. I'm alone, in a way, and under pressure. I then get to a point where it's almost done, but there's that one per cent which still escapes me, and which I know is really going to make the difference. I'm on the verge of succeeding – or not. There's a lot of adrenalin in this process.

'Nowadays, we seem to embrace a concept of luxury which seems to want to distract us – to help us forget,' Jacomet reflects. 'To me, on the contrary, real luxury is about remembering the true value of what you have. Living in a place like this, for instance, is a form of luxury. Early in the morning the other day, while coming to the workshop, I was struck by the way in which that mountain top was dressed in sunlight, as the morning fog was lifting. I took a picture. Someone observed that must be the hundredth picture I have taken of that mountain. "Yes," I replied, "and I hope I'll take a thousand more, so that I can really understand why I love it so much."'

Jacomet objects to 'the idea that luxury is being able to buy T-shirts for almost nothing thanks to the fact that people elsewhere are underpaid. Do we really need the poverty of other people and the low-quality products? Perhaps there can be a different balance, where people are rewarded for, and proud of, creating good products.'

We conclude by discussing the future of zai. 'I'm always very much aware of the risks of trying to do too many things. We have to look at opportunities to leverage our knowledge, but must stay focused. We have experimented with several ideas, but felt they weren't reflecting our spirit and *raison d'être*. Whatever we do, we must make sure it's zai. And for that, of course, we have our poem ...'

Chapter V

Focus

'Mira quel cerchio che più li è congiunto;
e sappi che 'l suo muovere è sì tosto
per l'affocato amore ond'elli è punto.'[i]

Dante

It is fascinating to note that of the three spatial dimensions, it is the concept of depth – traditionally identified as the third dimension – that is commonly used in Western cultures as a metaphor for intellectual value; specifically, it relates to the notions of thoroughness, wisdom and even liveliness itself, to the extent that it is now no longer a metaphor, but an actual and proper synonym. We use the image of depth to describe the most authentic qualities of a person, of a piece of work, of an insight – or even of an emotion.

Interestingly, depth is also the one dimension that is most closely associated with discovery. Whether from a physical perspective or in an abstract sense, it is the one facet that is not immediately revealed. Not by coincidence do we owe the term 'unfathomable' – relating to something which is enigmatic and beyond understanding – to the *fathom*, a unit of measure predominantly used in relation to the depth of water. Depth is all about qualities that do not meet the eye; those that not merely are visible but must rather be looked for; those that cannot be seen by all but can be understood only by a few.

There is a strong nexus between the concept of depth and the idea of unique achievement – and, more specifically, as we shall see, the paradigm of meta-luxury. That nexus is provided by *focus*.

This Latin term has acquired several multidisciplinary meanings, but in its more general sense it can be defined as the 'centre of interest or activity' or the 'act of concentrating interest or activity on something'.ⁱⁱ As such, it describes an overall approach that is strictly related to, and interested in, depth, not breadth or surface. The act of focusing on something relates to knowing, doing or pursuing much of a little, not a little of much. Focus is about a stern limitation that is self-imposed in the interest of an excellence of some kind. Ultimately, focus is the unifying principle behind specialisation, concentration, expertise and proficiency.

Focus in Relation to Knowledge, Purpose and Timelessness

In different ways, focus is quintessentially linked to the concepts of knowledge, purpose and timelessness.

One of the keys to *knowledge* as a form of intellectual wealth and, therefore, as a unique and valuable resource, is indeed focus. Our limitations as human beings – chiefly, in terms of time, physical and mental power, and talent – create a trade-off between the depth of our skills and their latitude. With rare exceptions, which are not by coincidence illustrious – Leonardo da Vinci and, perhaps to a lesser extent, Marie Curie being epitomes of these – we all have to choose between trying to be *extremely* good at something, or *relatively* good at a wider spectrum of things.

The very idea of *purpose* is reflective of focus, to a degree where the two terms are quasi-synonymous. When speaking about an 'expert', we are unconsciously making this connection. We are, in fact, using the past participle of the Latin verb *experior* – to experience, try or test. We are referring to someone who has devoted a considerable amount of her or his time to the pursuit of a specific purpose, and has

acquired expertise in the process. After all, focus is either a substitute or an enhancing factor of talent. On being hailed as a genius, Pablo de Sarasate, a violin virtuoso of the 19th century, was quoted as replying, 'A genius! For 37 years I've practised 14 hours a day, and now they call me a genius!'

As a result, *timelessness* tends to come from focus. Again, with few exceptions, allowing for instance for the role of serendipity, the great advancements and milestones in all fields of human endeavour stand as the results of relentless effort concentrated on one, or a limited number of, specific disciplines. The works of art that stand the test of time are not the output of amateurs, but of more or less formally educated individuals who spent the best part of their lives creating art. Scientific breakthroughs that have changed our way of understanding, and interacting with, the world and the universe around us were the brainchildren of people who concentrated their time, energy and talent on a specific field, acquiring and expanding their knowledge. Historically, being known and celebrated was the consequence of being good at doing something in particular – interestingly, and frustratingly, a pattern that is less true today.

In summary, the strong relationships and affinities that focus has with knowledge, purpose and timelessness make it an essential ingredient – in fact, a necessary condition – in the successful pursuit of unique achievement. As a natural consequence, focus is one of the defining foundations of the paradigm based on the idea of unique achievement – meta-luxury.

Focus and Meta-luxury Brands

There is one universal denominator between all organisations across all kinds of industry, and that is the mere fact of existing to do something definite. Whether this meaning is formalised or not, any company is defined primarily by 'being good at', or at least 'being in the business of', something. This comes even before the company sets out to codify how to do it, according to what values and philosophy, for which ultimate goal, and so forth.

Of course, such a specific radius of action may be identified in very different ways. In some cases, a brand may be strictly related to one category. Think, for instance, of the automotive sector, where different brands within different groups, from BMW to Citroën, from Volkswagen to Maserati – albeit strongly differentiated in terms of their customers, their ethos and the benefits they prioritise – ultimately concentrate on making and marketing engine-propelled vehicles. That is, in essence, their line of business.

In other cases, an organisation is rather defined by a unique combination of competences and technologies that converge into an array of different categories. This is true, for instance, of an organisation like Samsung, which applies its skills to develop and design electronic components, interfaces and systems to address entirely different needs, which range from communication to cleaning, and beyond; or Disney, whose competences centred around family entertainment cause it to compete in nominally different sectors, such as theme parks, cinema, publishing and toys.

The span of yet other organisations is defined by the potential range of products through which a recognised or celebrated creative blueprint can manifest itself. That is the case of multi-licensed fashion brands, such as Dolce & Gabbana or Calvin Klein, operating directly or indirectly across a bundle of categories, such as apparel, fragrances, accessories and leather goods.

Entire libraries have been written on subjects such as the definition of markets and industries, corporate strategy, brand positioning and core competences. We do not wish to encroach on these territories except with the goal of making the following point: it is easy to conclude that any organisation – and in fact any brand representing it – is focused by definition, and defined by a certain focus. Hence, why should focus be exclusive to, or even merely typical of, meta-luxury? In what ways is our concept of focus different from the general notion of corporate focus?

While in general, for any kind of organisation, defining the business on the basis of a certain category, skill set or taste is a prerequisite, in

meta-luxury focus is a cornerstone of the value-creation process. It is not merely an automatic, must-have factor, but a thought-through and relentlessly executed philosophy. Focus is not simply the answer to the question, 'What do we do?'; it is the rock-solid conviction about 'what we can uniquely excel in'. Most importantly, in meta-luxury focus is not a long-term strategic choice: it is a proven, unquestionable truth.

In meta-luxury, focus can be defined as *the deliberate limitation of scope over time to a field where proven excellence can be further pursued and an unblemished reputation protected*.

Within this definition, it is key to notice that focus is never an *ex-ante* desire, but an *ex-post* fact. Original intention is necessary, but not sufficient; focus is not the initial promise, but its proof over time.

Being loyal to the boundaries of a brand's original *raison d'être* coincides, more often than not, with a question of refusal rather than choice. It means sacrificing the potential for growth in the name of excellence – something that cannot be replicated through arrogance or improvisation but is built over time through modesty and determination.

After all, most of the brands known today as luxury brands originate historically from the founder's vision and dream to represent the absolute pinnacle with regard to a certain field. This is an almost stereotypical trait but, noble and true as it may be, it is not a determining element. The difference is, in fact, between those brands for whom this commitment to excellence is merely the past, and those for which it is the constant future.

From the outset, stemming from the passionate engineering and design talent of Sir Henry Royce, Rolls-Royce was dedicated to creating milestones in aircraft engine development and outstanding, record-breaking cars. To this day, under a different ownership, the brand retains that focus and has refrained from widening its offering to include other products inspired by an undoubtedly profound and universally recognised heritage.

Several brands, despite not having set out to become undisputed leaders, have succeeded in keeping alive and cultivating their initial specialisation, striving over time to transform it into an excellence, and deliberately refusing tempting opportunities to widen their offering. In time, the nurturing of these skills builds into a unique, unsubstitutable set of competences, a solid reputation and a strong sense of continuity – a process that is, in a way, reminiscent of the aging of wine, creating a unique meaning for and influence on customers. This is the story of many craftsmen originating from the cities of Europe, once (and sometimes still) honoured suppliers of royal families. Some of their names are now respected global brands, many others unique and revered centres of gravity for the circles of those in the know: from tailors to watchmakers, from goldsmiths to winemaking *domaines*, attracting the discerning connoisseur.

For meta-luxury brands, focus is therefore, first and foremost, a core principle, around which the brand's entire existence revolves and evolves, along with the skills of those who bring it to life. It is the dedication to nurturing excellence, concentrating on what they have always been unique at (depth) rather than seeking exploitation for opportunistic growth (breadth).

It is a mission, in the noblest sense of the term and outside of trite corporate jargon. It is at once a scope and a pursuit that is proudly passed on from one generation to the next, or possibly from one owner to the next, in much the same way as the Olympic torch is handed over from one city to another.

Focus as a Driver of Demand

In meta-luxury, focus is a powerful driver of demand; one, in fact, that can prove decisive in customer choice.

In the first decade of this century, traditional luxury brands were described by many commentators as the brands with the highest extension potential. Rightly so, in fact; that was a fair and sensible assessment at that time in history. Between 2001 and 2008, global

luxury brands appeared to be invulnerable icons, standing for a pure customer experience and a lifestyle that transcended a factual, historical excellence. Such 'experience' – a widely used term in those days – could manifest itself across virtually any product, service or environment. Those were the years when, for instance, the idea of extensions into hotels and resorts directly or through licensed operations (as in the cases of Armani or Bulgari) or the creation of specifically branded mobile phones in partnership with global manufacturers (Armani, again, or Prada) looked like a completely logical move, aimed at creating a new touchpoint along such an experience chain. Because of their ability to stretch their significance far beyond their origins, it was presumed that luxury brands had an impressive potential to diversify and, thus, a lower risk profile. Consequently, a number of relatively young brands tried to jump on the bandwagon, self-proclaiming their luxury status and therefore their legitimacy to brand virtually anything – even in the absence of any form of excellence or proficiency.

The 2008–9 crisis caused an evaporation of a considerable amount of wealth worldwide and shattered many of these convictions, at least in Western markets. The attitude towards luxury brands changed dramatically, bringing back authentic, dedicated capabilities as a fundamental driver of demand. An immediate explanation for this lies in the desire to invest resources, which are now more limited, on objects with a higher intrinsic value. Focus ensures such value by proxy: reputation in one field gives credibility to a brand's offering in that field. At a time of forced, but also pursued, sobriety, it seems more sensible to invest in the result of brand extensions that appear less legitimate.

However obvious and logical this explanation may be, we feel that this rediscovery of the value of focus is part of a broader transformation – one for which it would be worthwhile to take a step back.

We now live in a world where intellectual capital seems to enjoy and offer higher and more stable returns than financial capital; in all possible senses. The inexpensive, ubiquitous and barely controllable flow of information worldwide has a much greater power to shift

attitudes and opinions than mere economic funds. As individuals and communities, our aspirations are increasingly changed and fulfilled through thoughts and ideas that circulate with unprecedented speed; less and less by the power of money.

On a broader scale, from a collective standpoint, this transition is a Copernican one. We are completing the move from societies that serve ideologies to ideas that can serve societies. Political and social shifts affecting entire regions are more easily driven by the availability of information than by the availability of economic resources, as the result of a cloud society with no centres – or, perhaps, countless centres. An example of this is the unrest in several North African countries in early 2011, triggered more by the circulation of ideas than funds.

At an individual level, too, our quests and realisations seem to be shifting in an analogous direction: they appear to be no longer about affording economically, but rather affording intellectually. Desire seems to be concentrated less on gaining access to other consumers' lifestyles, more on appropriating the secrets of the masters. It is less about being part of a club and more about being the sorcerer's apprentice.

At heart, meta-luxury is about knowing, not about showing. Focus – once again, *the deliberate limitation of scope over time to a field where proven excellence can be further pursued and an unblemished reputation protected* – is what gives brands the permission to attract connoisseurs rather than consumers; and, therefore, to share with customers unique skills and passionate perfectionism, sometimes incorporating the knowledge nurtured and accumulated across generations. Meta-luxury is ultimately about trading knowledge with customers who are willing to reward it adequately.

Focus and the Business of Excellence

Focus is a pre-requisite for making a decisive difference: for being in the business of authentic excellence as opposed to being in the more

blurred industry of luxury. And by no means can this distinction be drawn by self-appraisal or a pompous self-definition: it can only be an objective, *de facto* status.

Being in the business of excellence has a straightforward meaning. It implies, quite simply, that an understanding of the skills that lie behind the brand's offering is a fundamental driver of choice, impacting in a measurable way customers' demand and desire. It means that customers perceive the brand's uniqueness to lie not in its mere exclusivity or momentary popularity, but in the unparalleled expertise it embodies. In other words, the reason why customers desire the brand is the unquestionable expertise it represents. That goes on to create a fundamental reason for choice and, consequently, the brand's competitive barrier and weapon.

This has crucial business and economic implications. If demand is chiefly driven by a customer's quest for excellence, then the latter is providing a considerable portion of the economic profit created by the brand, through revenues and margins. In other words, this driver of demand is responsible for a major portion of the value created. This, in turn, means that the business is providing a quantifiable return on the investment in excellence, including the opportunity cost of not diversifying. The pursuit of a unique achievement – the meta-luxury paradigm – is being made sustainable.

De-focus

Are we suggesting that abandoning focus will necessarily ruin a brand or a company? Not automatically or immediately: that would be a radical and unrealistic stance. What we do maintain is that a deliberate and persistent turn in this direction will mark a disengagement from the paradigm of meta-luxury. It is, after all, reasonable to assume that an aggressive stretch into directions that are not born of the same heritage of knowledge and skills will tend, in time, to dilute the credibility of the brand's competences. By definition, generalists are deemed less worthy of an economic reward for products that require a high degree of competence and specialisation.

As a consequence, the generation of economic value will no longer be based predominantly on knowledge that is deeply rooted in the brand's DNA and striven for by customers; it will rather depend on elements such as self-image, style affinity, general market trends and the specific appeal and success of individual products – the traditional, stereotypical 'luxury' model.

This, in time, may prove a riskier platform, as these drivers are much more volatile: they are much easier to replicate and to compete with. Even at a time when people and information can circulate as never before, distinctive competences are still among the most complex resources to imitate, replicate or surpass.

A deliberate and ongoing de-focus strategy may indeed have, in the short and medium term, commercial returns: it is undeniable that brands with a significant reputation enjoy a potential for extension beyond their underlying core competence. Generally they can count on a significant following of aficionados and enthusiasts who may be instinctively fascinated by diversions into unfamiliar territories. However, in time these brands may find that they have eroded their own potential to continue competing on the invulnerable turf of an unparalleled *savoir-faire*, and to face opponents who were previously unthinkable. In the final chapter, *The Economy of Meta-luxury*, we discuss how meta-luxury brands tend to create and enjoy a virtual monopoly, becoming in effect unsubstitutable. De-focus tends to erode such a virtual monopoly in order to pursue wider revenue opportunities. The brand leaving its ivory tower may be a convincing analogy, conveying the opportunities and the perils of de-focus.

Technically speaking, the brand's role in securing demand[iii] will tend to decrease, as a result of the extension of the offering to include products that require competences that it can less rightfully claim, or that are more commoditised. In other words, a brand that was formerly unique in its core, historical offering accepts the stigma of substitutability in other offerings where its heritage of excellence is less, or not at all, influential. As a result, the brand's overall status and role is, to a certain extent, reduced.

De-focus is a compromise between consistent excellence and primacy and stronger commercial opportunities – a sometimes sound compromise from a purely monetary perspective; yet, a compromise nonetheless.

It should be noted that focus is not merely a matter of *what* is being done, but, perhaps most importantly, of *how* it is being done. The same set of skills or recognised proficiency may easily be displayed across different product categories. In the case of de-focus, the question is not just 'How far is the new category from the brand's core category?' but 'In what ways does the new category leverage the expertise that makes the brand virtually irreplaceable in its core category?' Focus is not just a blunt refusal of diversification. It is simply the pride in, and the centrality of, the *métier* that the brand embodies.

De-focus is always a choice between additional revenues generated by the brand and the reduction of its substitutability. The diagram below is a conceptual representation of this.[iv]

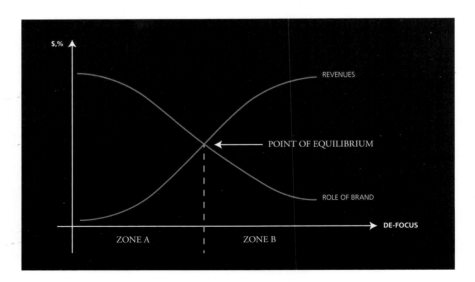

Up to a certain point, in zone A, the additional revenues counterbalance the reduction in the brand's overall substitutability. This is typically the case when the brand extends into categories that

leverage the same expertise, or categories that the brand approaches with the same philosophy as its core categories – hence, with a negligible impact on the brand's overall role.

Somewhere along the diversification process lies a point of equilibrium, after which the immediate economic advantage tends to be outweighed by the erosion of the brand's overall role. Because the new additions to the brand's offering no longer stem from a unique expertise, the brand's role in driving demand for such categories tends to decrease, with an impact on the overall role of brand.

Beyond the point of equilibrium, in zone B, the pursuit of additional revenues through diversification tends to decrease the brand's power to drive demand. This is not necessarily a 'wrong' or economically disadvantageous move, but a change in paradigm, whereby the brand – and the unique competence it stands for – is no longer as central to the value-creation process.

Focus and Style

Throughout this chapter, we have looked at focus as being defined by those areas of activity where the brand does more than compete – where it excels. It is an extremely strict definition. For this reason, it is important to underline that it refers to meta-luxury, not to what is traditionally known as luxury.

In fact, a widely observed evolution path sees brands with a strong core of skills and recognised excellence in one category grow a constellation of ancillary products along the axis of 'style' or 'lifestyle' rather than along the axis of their expertise. In these cases, their extension is guided by the recognition of taste, rather than the pursuit of excellence, as the unifying theme of the brand's offering. Whilst not consistent with the notion of focus described thus far, this model is often a very successful one – and, in many cases, it marks the transition from the paradigm of meta-luxury to the paradigm of luxury.

Salvatore Ferragamo retains an unblemished reputation that stretches back to the life, the times and the amazing story of its eponymous founder, who became known as the 'shoemaker of the stars'. Combining bold innovation, an extraordinary taste for multicultural references, and original elements (such as the *'gancino'*, or little hook, buckle), Ferragamo's creations stand as milestones in the history of modern fashion, and as a testimony to the unique skills and the innovative edge that this brand represents in shoemaking. Today, whilst retaining its celebrated heritage in this field, the brand is also present in other categories, including apparel, silk accessories, bags, fragrances, eyewear and watches – the last two marketed through licensing agreements.

When asked about the duality and the common denominator between the original category and products that do not leverage the same *savoir-faire*, the company[v] observes that:

> what stay as the fundamental elements are the value of being made in Italy and the consistency with the codes and the values of [our] style. The Ferragamo family has always played a key role in defining those principles and values that represent a reference for [our] management and partners. Such principles, inherited by the founder, Salvatore Ferragamo, still constitute [our] guidelines, albeit made relevant to today's needs. They are principles that are based on both tangible and intangible 'codes'. Tangible ones such as quality and innovation, as well as experimentation in all directions, from product to communication to distribution; the values that have established the greatness of being 'Made in Italy' – inventiveness, creativity, comfort and colour. Intangible codes include boldness, meant as acting with confidence and consistency; the will to communicate through our products both a service standard and a lifestyle; the care for individuals; and our respect for their needs.

The company's perspective on the dilemma between focus and diversification, and on striking the right balance between the two, is that:

> this balance is perpetually moving. The company has always managed diversification carefully, with the goal of not diluting the brand but rather preserving its core values. The Salvatore Ferragamo brand represents our story, our legacy and our heritage – but also our continuity for the future. On the

one hand, concentrating on the Ferragamo brand is a structural aspect – our way of conceiving our company. On the other hand, we believe in a strategic diversification policy of our product portfolio, which positions itself on high-end customers. Such a policy has led us to leverage opportunities that are consistent with the Ferragamo world, refinement and lifestyle. We take extra care in not diluting our brand, and that is why we have not given the Ferragamo brand to our diversified activities, wanting them to be appreciated for their intrinsic value and not for the Ferragamo brand. In 1995 the Lungarno Collection was developed to transfer to the real estate and hotel businesses the style and quality canons that distinguish Ferragamo products, as well as the brand's culture, experience and creativity.

Thus, as can be seen, Ferragamo, despite having a unique heritage in terms of skills and innovation, defines its focus not through that expertise in the strict sense of the term, but through a wider commitment to quality and style that goes beyond shoes and embraces other items that can be worn. The company recognises more distant areas, such as real estate and hotels, as being definitely out of its focus, and hence not in a position to operate under the same brand.

This is an example of an outstanding brand that has successfully translated its heritage of unrivalled competence in shoemaking into the power of its style and of the signature itself – a move that allows for a much wider reach, as it is free from the boundaries imposed by specific skills; and, on the other hand, a move that results in a *raison d'être* that is rooted more in an interpretation of quality and style than in the hard competences developed by the founder. It is a trade-off between breadth and depth, resulting in a brand that retains its legendary status in the core part of its offering – shoes – and necessarily faces broader competition in adjacent categories, where its distinctiveness and uniqueness are less tightly connected to its unique expertise.

Focus versus Halo and Diversification

Focus being a choice resting on principles, it is impossible to suggest a credibly objective measure of the extent to which a brand reflects an

organisation's focus. It is, however, sensible to at least try to put into perspective different degrees of focus, each progressively more distant from the idea of a unique achievement and, therefore, meta-luxury.

This exercise is meant to provide an intuitively qualitative, or judgemental, scale that can help understand the essence and implications of this pillar of meta-luxury. It is of the essence to notice that this is *not* a ranking, but an attempt at categorisation. Consistently with the way we look at the other three pillars – craftsmanship, history and rarity – we have chosen to consider focus itself as the vertex of the scale.

I. Focus Brands

Brands here are keenly concentrated on a field that they have always been, and still are, able to dominate, shape or influence, thanks to unique competences and expertise. These brands have not attempted to extend their offering beyond their core skills and mastery, staying focused on the pursuit of unique achievements in the area where they prospered in the first place.

We have mentioned the example of Rolls-Royce[vi] previously in the course of this chapter. The term 'icon' is frequently misused in the world of brands and marketing; yet, if there is a handful of brands globally that deserve the title, this automotive marque is undoubtedly among them. To this day, focus has been one of the mainstays of the story of Rolls-Royce. The brand has consistently remained concentrated on the creation of romantically evocative cars with a characteristic design DNA, resisting the temptation to move into other spots within the automotive market or to otherwise leverage the brand's heritage and celebrity.

Rolex can be readily cited as another example of focus. The brand's field of action remains strictly aligned to the spirit and the competences of the company's origins. Despite embodying a global status symbol, and acquiring the broader significance of the celebration of accomplishments in life, the brand has confined its operations to watchmaking, a field where it can boast a history of

authentic skills and innovation – two traits that contribute to the desire and the demand this brand generates in markets worldwide.

As mentioned earlier, focus is a distinguishing component of meta-luxury only if it is a principle that is consistently respected over time, not if it is a mere starting point or declaration of intent. Therefore, it can only be judged over time. There are, however, some brands that, although having a much shorter history than the aforementioned brands, seem to have embraced focus as a guiding principle. One example within this set is Vertu, the company founded in 1998 by Finnish mobile phone manufacturer Nokia and specialising in handcrafted mobile telephones and smartphones using 'exotic, rare and naturally durable materials.'[vii]

Ultimately, the consequence of staying within the focus class is the constant pursuit not just of achievement but of unique achievement.

II. Halo Brands

Brands included in this set are those that are still regarded as the *ne plus ultra* in a certain category while having ventured into ancillary categories. The original expertise is not under discussion. On the other hand, these are no longer brands with a pure focus, in that they accept being less than the best in other categories.

At times, the additional offering of the brand may be deemed as being in the interest of the core offering. That is, for instance, a typical reasoning related to the world of fragrance, whereby brands that are out of reach for most turn to this category to create a highly visible point of contact and reward the desire for the brand in a way that does not dilute its status, nor its mystique.

Brands within this cluster are brands that pursue and represent a unique achievement in the core of their offering; however, they add to that core offering extensions that may be achievements but cannot claim the same uniqueness. What is lacking here is not the achievement component, but – in the peripheral part of the offering – that of uniqueness.

Such brands represent a deliberate strategic shift away from the paradigm of meta-luxury and into a more traditional concept of luxury. From a business perspective, it is a sensible choice that provides these brands with growth and relevance to a wider global target; and one that implies that the role played by the pursuit of a *unique* achievement – embodying knowledge, purpose and timelessness – in securing demand has a lower relative weight than the role played by more imitable, less defendable and shorter-term factors, such as self-image and the pure aesthetics of individual products. In financial terms, the return on investment that the brand generates on the unique depth of competence accumulated in the course of the company's existence is comparatively lower.

An example in this area would be Montblanc. Founded under a different name in 1906 but trading as Montblanc since 1910, the brand has become one of the best known and most celebrated makers of writing instruments. Over time, the brand's scope has stretched to leather goods, jewellery and, most recently, fragrances. The brand's website clearly states this transition upfront:

> Montblanc has been known for generations as a maker of sophisticated, high-quality writing instruments. In the past few years, the product range has been expanded to include exquisite writing accessories, luxury leather goods and belts, jewellery, eyewear and watches. Montblanc has thus become a purveyor of exclusive products which reflect the exacting demands made today for quality design, tradition and master craftsmanship.[viii]

It has been a successful venture from a commercial standpoint. The new categories represented a veritable engine of economic growth for the brand, now part of the Richemont Group, in the years leading to 2011. From a branding perspective, this de-focus strategy has led the brand to compete in additional categories, where its legitimacy in claiming unique skills is possibly less strongly supported. The addition of other sections of the offering suggests that this historical brand may struggle to claim the same degree of uniqueness in categories such as leather goods and fragrances.

III. Diversification Brands

Brands in this cluster are those that are no longer, or only weakly, associated with their original area of excellence, as a result of a constant anxiety to spread into new categories. As a consequence, they can no longer credibly claim a uniqueness at anything in particular.

An example of a highly diversified brand is Pierre Cardin. An influential and widely known fashion design brand since the 1950s, Pierre Cardin has progressively opened up its extent to a vast number of licensing opportunities in very different categories – a policy that is antithetical to the concept of focus, both because of the magnitude of the extension and because of the high leverage of third parties' skills. As a result, the brand can hardly be seen as symbolising the pursuit of unique achievement – nor, in many cases, of an achievement as such. The logic behind meta-luxury is, in a way, reverse-engineered: rather than the brand being based on knowledge, purpose and the quest for timelessness, its name is used for a wide, and not selective, number of individual endeavours, whose common denominator appears to be the signature (form) rather than a specific excellence it may signify (substance). This, again, is a choice that sees breadth prevail over depth.

Ultimately, brands in this cluster have voluntarily abandoned the pursuit of uniqueness as well as the quest for a unique achievement. Theirs is not necessarily a negative choice from a commercial perspective, but it is a long way from a deliberate limitation to excellence – and a philosophy based on the passing of knowledge across generations, a sense of purpose and the quest for timelessness.

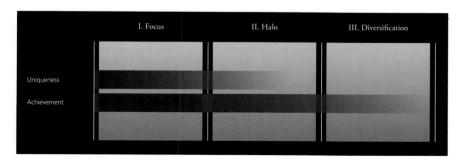

Focus versus Halo and Diversification

Summary

Focus, as defined in this chapter, is very often *the* pillar that distinguishes meta-luxury. It is often what brands that are otherwise soundly based on craftsmanship, history and rarity have ceased to maintain.

It appears as a highly restrictive and even counterproductive condition; on the surface, it looks like the rejection of potentially rewarding business opportunities. And yet, rather than being about pure radicalism, focus is simply about not compromising. It is the logical consequence of a culture of excellence: it means holding the pursuit of unique achievement as the constant, and subjecting even the brand's sphere of activities to that quest. Beyond that, it means ignoring short-term gain for the benefit of the long-term preservation and enrichment of the brand asset.

And yet, focus should not be seen merely as denial and limitation. The choice between excellence and nothing at all does not necessarily lead to stasis: in many cases, it is a formidable springboard for innovation, leading brand custodians to apply their unparalleled knowledge to virgin territory, pursuing excellence in new fields, rather than simply claiming it.

[i] 'Behold that one circle which is nearer to that point; / And know that its movement is this swift / because of the ardent love that spurs it on.' (*Paradise*, XXVII, 43–5).

[ii] '1. The centre of interest or activity; 2. The point of origin. From Latin "domestic hearth."' (OED).

[iii] The Role of Brand Index is a component of Interbrand's Brand Valuation Methodology. It measures the portion of the decision to purchase that is attributable to brand – this is exclusive of other aspects of the offer such as price or features (Interbrand Best Global Brands 2010).

[iv] For the sake of clarity, the diagram is purely conceptual. The offer's extension (represented on the X axis) is not a continuous variable, but a discrete one, likely to give rise to discrete 'steps' in both revenue and the Role of Brand Index (Y axis) rather than to actual curves. Similarly, the actual relationship is between the positive delta in revenues and the negative delta in Role of Brand Index. The diagram may be given precise significance and full brand management relevance through Interbrand's Brand Valuation methodology supported by primary research and advanced statistics.

[v] Exclusive quote by kind submission of Salvatore Ferragamo S.p.A.

[vi] We refer here to the automotive brand.

[vii] Source: www.vertu.com.

[viii] Source: www.montblanc.com, as of June 2011.

Paolo Fazioli

 Pianist and engineer, Paolo Fazioli is the founder of piano manufacturer Fazioli. Born in Rome in 1944, into a family of furniture makers, he demonstrated from an early age a gift for music and a keen interest in the piano. Within the period 1969–71, he graduated from the University of Rome with a degree in Mechanical Engineering and in piano performance at the G. Rossini Conservatory in Pesaro and attained a Master's degree in Music Composition at the Academy of Santa Cecilia. His unique skills as an engineer and pianist inspired his desire to create a better piano. Having brought together a team of mathematicians, acoustic physicists, wood technologists, piano makers and pianists, to 'define the process for the construction of a conceptually new piano', Fazioli realised his dream in 1981 with the establishment of Fazioli Pianoforti s.r.l.

It is a wet, dark morning in Milan as we set off for Sacile, a Renaissance town known as 'the Garden of la Serenissima' nestled not far from Venice in the north-eastern corner of Italy. Sacile may not be afforded the same global renown as its famed neighbour, but its significance resides in something that, in the history of music, is held in sacred regard – wood. Sacile has a prestigious history and tradition in woodworking. True to its sacred heart, it is now home to what is considered by some of the leading musicians as the best creator of pianos in the world. This seemingly sleepy town belies a resonant past and present.

We almost overshoot the perimeter of the town twice, before hitting upon the sinuous road that leads to the Fazioli piano factory. The morning is fresh with a hint of rain as we look across at this stunning white modernist structure of stone and glass, set against a steel-grey sky. We meet Paolo Fazioli in his office. His face animates as he talks passionately about the company that he founded 30 years ago. He is one of those rare individuals whose smiling eyes have the ability to capture and captivate your attention in seconds.

Fazioli's company was born of a long-held dream – to design and build 'a new piano with a superior sound'. And that is what he did, combining his unique achievements as both musician and engineer to test the boundaries of piano design, construction and performance. His family's furniture design business, also based in Sacile, came to play a critical role in research and development. Over time he brought together experts in acoustics, wood technology and piano craftsmanship to form the company that we know today.

A humble smile emerges as he talks fondly about how his dream began. 'This year we celebrate our 30th anniversary. The idea has always been with me, since I was a child. This instrument, this magic box that emits these beautiful sounds; it's always been a fascination. In Rome, when I was a child, there were these street musicians with a street cart with these small pianos. I was enthralled by this box from which these sounds would come out. They were

capable of producing so many different sounds – sometimes sad, sometimes sweet, and sometimes brilliant – but overall they gave a feeling of happiness. I was fascinated. I started studying the piano, and I always kept thinking about creating instruments that both would be beautiful objects and could create beautiful sounds. I was convinced this degree of attention did not exist – there was a strong sense of business rather than respect. I had studied piano, I had studied engineering, my family had a furniture business – I thought I should try to start something up. For me it had to be about creating a product that would not be driven by business, but by the desire for excellence. We started as a very small team and then grew, but we always had the vision to try to create something excellent. I am not sure that we've achieved it, nor that we will ever achieve it. Our philosophy is about never being sure about the result. Which is also true – I don't think anything can ever elevate itself beyond criticism.'

The pursuit of excellence is a recurring thread throughout our conversation. And it is no surprise, as this is what fires and inspires Fazioli. 'This is a challenge that we aim for every single day: reaching our ideal, this kind of "hyper-uranium". This is a good thing. This is something that enriches us all and forces us to improve ourselves. I've always thought about real luxury as something that must have a sense and an aim. Take gold, for instance, the stereotype of luxury. Gold is not negative in and of itself, but it should be about more than mere ostentation. It has to be about more than gold for gold's sake. We do use gold, in the lacquer for our frames. Brass undergoes oxidisation; it blackens and looks dirty. We choose to use a gold lining, which prevents oxidisation, and we make sure that an object is beautiful, but a beauty that lasts, a beauty that endures. This is not luxury; this is a form of excellence.'

Fazioli reacts quite negatively to the word 'luxury'. 'It has always given me a sense of emptiness and even of something negative. Luxury in the current and common understanding is ephemeral – something which is very different from what is, all in all, my

philosophy, which is about excellence.' There is a quiet gravitas to what Fazioli says as he goes on to explain what the pursuit of excellence means in his business.

'You can't imagine the time we spend doing things that have nothing to do with excellence,' Fazioli complains, 'yet what we always focus on is to do things in such a way that the result is better, not that the process is simpler or cheaper. You see, profit is simply the means to do what I love,' he observes. 'Safeguarding quality with big numbers might not be impossible, but it is certainly very difficult. This is why we create only the number of pianos that can allow us to ensure the quality that we look for in each of them. And of course, every single one of them is different, and has unique characteristics.' We ask if he has his own favourites. 'Yes, I have a few whose sound I particularly warm to,' he smiles.

The subject of the relationship with excellence and time yields an interesting debate. 'If we look at some masterpieces from the past, there time doesn't count. Saint Peter's in Rome, for instance. Take Bach – he doesn't belong to time. His work doesn't become old – it's a milestone that stays there and becomes part of humanity. Taste may change. But that is different. Excellence is outside time.'

He goes on to talk about his sources of inspiration and their importance to the quality of sound of his instruments. 'There have been composers that have inspired me to seek depth and vastness of sound. We have to think of Chopin, Schumann, Liszt, Gershwin and Rachmaninoff. They tried to pull out the most amazing and luminous sounds from this instrument. Bach's music, for instance, is not something that is expressed through an instrument – that's why I said he's outside of time. It is a sound architecture, it transcends the individual instrument. Even Beethoven or Mozart – instruments are simply a tool to express the immensity of their music. The same, however, cannot be said, for instance, of Chopin – Chopin doesn't exist without a piano. Chopin *is* the piano. He's more earthly, perhaps even more human, while others were giants, super-humans.

'Of course, anyone can debate this – this merely is my truth.
Mozart and Beethoven are excellences that are outside the
parameters of time. Time does not touch them. Then there are those
examples of excellence that are imbued with and linked to their
time. Debussy is excellent but it is an excellence related to the time
in which he expressed himself – Impressionism and a particular
way to conceive sound. Maybe we can conclude, then, that the truly
exceptional excellences are beyond time.'

There is a natural segue from the composition of music to the
rendition of music. 'What we look for in a great pianist is that in
his or her interpretation there is always a form of added value.'
Fazioli explains. 'After all, music is written on pieces of paper. It's
like a picture where shapes and colours are defined. But then it is a
question of bringing it alive. If you think about it, today, a computer
can play these scores. Through advanced sampling, you can get
a flawless execution, without the mistakes that even the greatest
pianists may make. But of course it's something else when one of the
greats brings a piece alive – he or she gives meaning and life to it.'

The engineer in Fazioli makes for a compelling discussion around
the interpretation of music. 'I always see music in an architectural
or structural way. All the themes weave into the values they have
within the whole. The interpreter must harmonise this architecture
convincingly, to deliver the composer's message in the right way.
Here, too, there is no limit – anything can be improved. The great
pianists are never satisfied, they always question their conception of
a piece, think about different ways in which it can be played.'

This detailed understanding of music and its structures
and possibilities, and of the quests for excellence and unique
achievements of composers and pianists through history is infused
in every touch of the Fazioli process, not least the quest for a
'beautiful sound'. 'When we create a piano, there is a mix of things
we look for. There are many parameters: the timbre of sound, first
and foremost. That is something that is not objective, so you have

to look for judgements. However, interestingly, I have learned that these, when collected in certain numbers, always distribute themselves along a Gaussian normal curve. Of course the dispersion of this curve may change according to the sample you choose. But there is always a concentration of judgements around what is thought to represent beauty.

'It's not only about timbre, of course,' he adds. There are also 'the features of sound – the richness in harmonics, the length of the sound, the power of the sound, the dynamic range – a wide range of nuances to great sonorities; even what I call the elegance of sound, which, yes, is subjective. I can't describe this, but when I listen to two pianos, I will likely say that I find one of them to be more elegant than the other.'

Fazioli draws an interesting parallel between music and culture and the extent to which our understanding of sounds is dependent on our language and culture. 'Our idea of sound is influenced by the sound of our language. Take the Chinese: they have an average tone that in terms of frequency is higher, and a more structured use of frequency levels. I am certain that the sounds that one uses in everyday life influence one's appreciation of sound. The Chinese language has a more percussive sound, and so the Chinese are more attuned to the more metallic and acute part of sound. We are less attuned to this. You refer to *cantabile* or "Italian sound" and think of Italian tenors – we have a different understanding of sound. It is culture'.

As our discussion draws to a close, we are invited into the inner sanctum of Fazioli. A door is opened to reveal a room of grand and concert grand pianos. The experience of meandering amongst these pristine Fazioli creations is nothing short of hallowed. Eyes bright, Fazioli emits a warm smile as he watches us survey the room. Running his hand over one of these beautiful instruments, Fazioli explains how only a small part of the wood is suitable for the construction of the soundboard – what he refers to as 'the "heart"

of the piano'. 'We need wood that is strong and at the same time has a high degree of elasticity. For the quality of the sound we need absolute regularity in the grain'. The wood used for Fazioli pianos is red spruce, specific to the Val di Fiemme mountains in Trentino. It does not come as a surprise when he goes on to explain that it is the very same forest from which, in the 17th and 18th centuries, Stradivari violins were made. The words of painter, sculptor and writer Sven Berlin – 'Speak of stone with gentleness and respect' – come to mind when Fazioli speaks of the qualities of wood. There is a profound gentleness and respect for this material.

There is a heartfelt humility coupled with an indomitable determination in Fazioli's parting words to us: 'The future of our company is not easy. In an idealistic way I will endeavour forever to build this vision of excellence for the people around me and after me.'

Francis Kurkdjian was not born in Grasse; neither is he the son of a perfumer. As a child, he studied the piano and classical ballet. At the age of 15, he decided to become a perfume maker and dedicated himself to attending all the right classes to take him to ISIPCA, the International School for future perfumers. In 1995, at the age of just 25, he signed his first fragrance: 'Le Mâle' for Jean Paul Gaultier. He went on to create many more fragrances for the worlds of fashion, beauty and luxury. In 2001, while he continued to work for international fragrance houses, he opened his own workshop for custom-made perfumes. He went on to work closely with other artists, signing a number of joint projects and, since 2006, several olfactory installations. In 2009, he was made a Chevalier des Arts et des Lettres and in September of that year he opened the Maison

A small plant, on a shelf by his desk, catches the attention of
Francis Kurkdjian. He runs his long pianist's fingers through its
leaves, smells them, picks one and offers it to us. 'Patchouli,' he says.
'It will become stronger as the leaf dries,' he adds, as we immediately
sense the profoundly intriguing scent of one of the most widely used
ingredients in fragrances for centuries.

Today, having been the signature behind many of the most
successful fragrances from the best known brands in the world,
Francis Kurkdjian is the living soul of the Maison Francis
Kurkdjian, which he created in 2009. A considerable change in
many respects. 'I like consistency. It is a part of my personality.
In working in this business you always end up switching from
one brand to another. And yet, I loved and nurtured the idea of
building something over time, working as part of a team. Acting
as art director for one brand would have been an option. And yet,
I kept challenging myself. "Is it not your time?", I thought. "Are
you not good enough? Are you too loud with your opinions?" On
the other hand, I didn't want to wait. Everything around me told
me this was the right moment to launch the Maison. Many things
in my life came to me because of "no's", and I hated the possibility
that this *might* happen; this *had* to happen this time,' he smiles. 'La
Maison owes its name to many of these feelings – the idea of not
working alone, the will not to dramatise my own name, a sense of
establishment.

'I think luxury has changed so much over the past 30 or 40 years.
Since this notion of "masstige" arrived, the term "luxury" hasn't
had the same meaning, *resonance*. It's the same with many words
today. What is a star now? What is glamour today? We know
these concepts, but do they last? Do they change? We have to
accept change, and the same must happen with luxury,' Kurkdjian
emphasises. 'When you think about it, this idea is always about
a distant past that no longer exists. Of course, it is a human
inclination to say it was better before, and to be nostalgic in our
view of the past and turn it into the measure of things.

'A few years ago I was involved in an art project for Versailles,' he recalls, 'and I had the opportunity to work with leather artisans from Hermès. Glove makers. When I voiced my impression that glove making was better before, they rejected this view – and went on to explain to me how and why that is simply not true. Yes, luxury has a tendency to look too much to the past. It's like the typical adult observation about youths: yesterday's always seem to have been by definition nicer than today's.

'I wonder – in a world where the next target is to go to Mars – is there a real value in handcrafting? We have to admit that sometimes mechanics are simply better. If I go back to my own craft, my scale, which is fully mechanical and mechanically made, is much more reliable than the free weights used a century ago. I guess what enhances precision and perfection becomes part of luxury or at least helps to achieve it.

'Luxury', he concludes, 'is about know-how and how you do things – and admitting you can't do everything. The illusion of the opposite – a shift which dates to the Seventies – has damaged the world of luxury, because it was merely pretending, after all. Which does not mean', he points out, 'that you can't bring in new expertise and successfully link it to what you already do, in order to help bring your vision and history to life. Again, Hermès does more things than many other brands, but I would still say it perfectly embodies luxury as I see it.'

This leads to the one concept that Kurkdjian sees as being inextricably linked to luxury: legitimacy. 'Luxury is very much about the legitimacy to do something. In real luxury, creations are marketed. Whereas fake luxury is about creating marketable things.' Smiling, Kurkdjian ponders, 'that sentence definitely sounds better in French. Anyway – it really comes down to being offer-driven, or demand-driven. I believe that the idea of legitimacy is dispelled by the feeling that something is being just marketed, in a very overt way.'

Legitimacy, Kurkdjian ventures, is the road to excellence. 'Legitimacy is a question of expertise, which is the path to perfection. And expertise is about culture, too – all that is linked. You know and you can judge, and you have the talent to do it. Talent with no sense of history is about being an artisan. The artist has a vision – is able to push it a step further.' This is where the line between craftsman and artist is to be drawn, and, interestingly, it is again a question of past and future. 'The craftsman's knowledge is based on history, but art is founded on a vision. Look at Picasso's early paintings, for instance. They're not so different from those of a very good student from art school. But what happened was that, quite early, he was able to absorb controversy and bring in a vision.

'The sense of perfection is ultimately what makes luxury. Luxury was originally for the aristocracy. You see, this is the real problem: today we have a problem to admit the existence of social classes. We don't want to oppose the rich and the poor. Yet, this is how luxury came to be. Luxury is really not democratic at all. Jean-Louis Dumas used to differentiate between expensive and costly – *cher* and *couteux*. There's a huge difference.'

Kurkdjian develops this point passionately. 'It is a matter of responsibility and honesty. We must learn to be responsible not just about the product itself, but about the philosophy and the honesty behind it – to pay the right amount of money for people's work and materials and, ultimately, have people pay the right price for the right product. I was in Florence the other day, listening to a friend telling me about the illegal workers, mostly Chinese, in the area of Prato. When I raised the question about the difference between something made by Chinese labourers in Italy or in China, he suggested that the point is not about nationality, but how fairly they are paid. I agree with that perspective – it's not a discussion about who, but about ethics. Our era is all about communication and awareness. We get to know more and faster, and that really changes the way we ask questions, challenge convictions, fight our battles and, of course, choose and buy.'

To Kurkdjian, there is a deep connection between luxury, value and time. 'Luxury is not a question of price, but of ratio between price and quality. And … of timing. Take a bottle of Krug, which I consider as one of the best champagnes in the world: serve it at the wrong temperature and … you see, it's more about preciousness and timing than anything else. Time and space are a key part of the idea of luxury now, I believe, and it wasn't the case just a few years ago, when we weren't surrounded by computers, iPhones, Blackberries, Facebooks and Twitters. Time, specifically, is no longer about where you spend it, but how. To me, for instance, it is about losing access and disconnecting.'

The association between time and luxury comes back, in Kurkdjian's words, in the idea of heritage. 'That's one of the reasons behind my own choice of the term *Maison* – I wanted it to be suitable for a succession in the same spirit. The names of those that I would consider as being real luxury brands are much more important than the names of the creative individuals behind them. The spirit of the House should prevail over time, enabling evolutions, not continuous revolutions, and ensuring timelessness. Timelessness is reassurance.

'Time runs faster and faster,' he goes on. 'That's the paradigm of these years – needing things instantly. Fashion, in a way, is collapsing because of collection after collection, trying to make people buy more. I was a shopping addict myself, mind you. But I believe this is now gradually changing. Buying more and more is not making us happier, and luxury now is going to take back its real meaning. I would challenge the need to coin a new word. Let us call it by its name. Luxury. *Basta.*'

When discussing the notion of rarity, Kurkdjian remembers with a smile that 'my philosophy teacher used to say that a horse with one eye is very rare, but not very expensive. Rarity for the sake of rarity feels somewhat old hat … The ugliest things can be rare. Artificial rarity in itself is just a question of snobbery and privilege.

The equation would rather be what may or may not lead to it – the know-how, the materials, the capability of sparking a dream, the quality, the design. This would probably be the equation.'

We ask in what ways Kurkdjian's musical background influenced his accomplishments and approach. 'Music to me has that sense of perfection I was referring to – after all, everyone can physically play something on the piano. But not all will play well or, even less, be able to compose. Anyway, the decision to go into perfumes actually came as a sum of negations,' he recounts. 'I wanted to attend ballet school, but was not accepted. I tried with fashion school. Same. I was more successful with perfume school, and this became my work. However, I couldn't call it my one passion. I do it with extreme commitment, I love what I do – but there are things in life I love even more.'

And yet, the dots between music, fashion and fragrances do connect clearly in Kurkdjian's thoughts and feelings. 'Perfume is very close to fashion. And fashion is very much like being on stage. It is a very logical sequence to me. When in fashion you create something new, it is like going on stage in a beautiful costume, and I know that beautiful thrill very well from my ballet days. Perfume is an emanation of all that.'

The analogy with being on stage stretches to the idea of an ultimate performance. 'You should think of each single project you undertake as the one that is going to be the best. Creating the best perfume ever is not possible, I think. But you should indeed aim to deliver the best response to that unique situation.'

Sound and scent share a fascinating common trait, Kurkdjian notices. 'Perfume reaches your nose in very much the same way in which sound comes to your ears. While colours blend and change, sounds and perfume ingredients combine without mixing. Think of the vibrations of sound – they go together, combine, but do not melt into one another.'

We go on to ask what are the challenges in creating bespoke fragrances. 'There has to be a common passion. I have to grow passionate about my clients; and they have to be passionate about perfume, and committed to me creating it for them. I have to love something about my clients, even though sometimes it is very difficult with people I barely know,' Kurkdjian explains, adding, 'and besides, do we ever get to really know people?' This makes the art of creating a customised perfume 'something you cannot do *à la légère,* lightly. Making a pair of shoes requires physical measurements. What I have to measure is totally emotional, and if you don't get an emotional response, then you can't do anything. Not for a moment do I worry about how the fragrance will sit on his or her skin. It's not a physical response I'm after.' Personal interactions are not critical, Kurkdjian reveals. 'It is a question of commitment. I am currently creating a perfume for a customer whom I've only seen twice so far, and yet he enthusiastically provides me with frequent and intense feedback. He's emotionally there.

'I once came up with a sentence that sums this up: "*le parfum est l'art qui fait parler la mémoire*"; perfume is the art that makes memory speak. This is also why, contrary to what most people imagine, I don't have to ask my customers any specific question – let them speak about perfume, and they'll actually talk about themselves. Just press the button, and let it flow. It's very easy – and fun.'

When we ask what excellence is in the world of fragrance, Kurkdjian uses a compelling metaphor. 'Think about ice skating. There is both a technical and an aesthetic evaluation. You may be very technical, do the right figures but lack grace. On the other hand, you may be extremely graceful but miss something in terms of technique. To be a really good skater, you need to score ten on both criteria. It's the same in perfume. Technique – trail, diffusivity and so on – is the foundation. Then you have the artistry: the capability to find new signatures. You need both. What makes the Pyramid

of Cheops the achievement it is is this marriage between statics and aesthetics. As in cooking,' he laughs. 'You need good tomatoes, but that won't be enough.'

When we touch on the invisibility that characterises fragrance, Kurkdjian recognises that 'one of the challenges is indeed making fragrance visual. More generally, perfume needs a revolution. Badly. The dematerialisation of information, for instance, changed that industry. Perfume needs something like that, and this is my ambition – expressing perfume in a different way. When you think about it, the only innovation this business has experienced in a century is the spray. A breakthrough must come.'

As we go on to discuss the process of creation, Kurkdjian observes that 'for me, there is an intimate bond between words and scent. I just can't work on a perfume if I don't have at least a code name. It's not that I refuse to – I simply can't. It's like playing without a score.' When we ask whether the process is led by intuition or rather by a process of trial and error, he smiles, opens a drawer and picks up a voluminous file. 'This is the work on my latest fragrance,' he comments, running through hundreds of pages of notes, forms and formulae. 'They are like different versions of the same painting. In this case, the final result is one out of over three hundred trials. These are the existing variations – there have been many more in my mind. You may have an intuition, but if you don't work on it, it amounts to nothing. I begin by defining what I am after,' he explains. 'Then reality must be faced, and I have to find the right way of realising what I imagine. And it goes on through combinations of ingredients, suppliers, quantities. A good perfumer will always have the idea lead the materials, never the other way round. You should never be satisfied with something that just smells good.'

Chapter VI

History

'Time present and time past
Are both perhaps present in time future,
And time future contained in time past'[i]

T.S. Eliot

Deriving from the Greek *historia* ('narrative', 'history'), the word 'history' is defined as *'the study of past events; the past considered as a whole; a continuous record of past events or trends'*.[ii] Those definitions find one of their earliest confluences in a work that is regarded as one of the seminal works in Western literature, *The Histories* of Herodotus. Written from the 450s to the 420s BC, it constitutes an expansive cultural, geographic, political and social record of the age. The work is now segmented into nine books, each named after one of the nine Muses. Above all, it was seen to have established the genre and study of history in the Western world. It is a world-renowned mark and marker of a truly unique achievement.

Heralded by many as 'the father of history', Herodotus was a singular individual who created a paradigm in the course of history, in its study and telling. As the visionary behind and creator of a unique achievement, it is apposite that, in the course of *The Histories*, Herodotus singles out exceptional individuals and achievements. Special note is made of 'firsts', of inventors, of striking buildings or cultural achievements. Those firsts may not have been seen to constitute meta-luxury in today's paradigm, but it is no less true

that Herodotus both heralded and hailed the value of unique achievement.

Meta-luxury holds sacred the heritage of the past in the present, maintaining relevance across generations, while heralding a passion for innovation and the promise of new discoveries to come. As such, the aforestated definitions of '*historia*' would seem to afford a particularly relevant triptych within which to contemplate the temporality of meta-luxury as we examine the idea of unique achievement in the context of knowledge, purpose and timelessness. The trajectory of history far transcends the notion of 'time past'. It is a question of how a brand captures and cultivates its history, maintaining absolute clarity, consistency and continuity over time.

History in Relation to Knowledge, Purpose and Timelessness

As we have stated, meta-luxury is about knowing, not showing. Having an authentic history is intrinsic to meta-luxury brands, and integral to an authentic history is *knowledge*.

In terms of '*the study of past events*', history is about knowledge at its most elemental and fundamental. It is the act of discovery and learning. It is about understanding the past to better inform the future. For the creators of meta-luxury, the past lays out a blueprint of what was possible ... and, by definition, of what is now surpassable. It is about the culture of craftsmanship, the passionate cultivation of artisan knowledge, to be transmitted from generation to generation.

In meta-luxury, knowledge is a virtuous circle. These brands understand the value of knowledge, its place in history and in the future. There are some beautiful examples of brands in meta-luxury that have invested in foundations, museums and a host of philanthropic initiatives, in the name of the preservation of history and the perpetuation of knowledge. Hermès is a case in point, having established the Fondation d'Entreprise Hermès in 2008 as a

commitment to the promotion of artisanal *savoir-faire*, education, contemporary design and sustainability. Affording residencies to exceptional new and upcoming talent, the Foundation has as its premise to stitch the threads of Hermès' history, knowledge and skills into the fabric of the future.

In terms of '*the past considered as a whole*', the notion of meta-luxury is an integral one and runs counter to the fractal denominations of luxury as they exist today. This is where history and *purpose* converge. It is about the protection and preservation of history. History in meta-luxury is the cultivation of excellence through time past, pursued obsessively and consistently through time present for the creation of time future. Meta-luxury brands have a unique sense of self, certainly, for it is one that is at once *of* and *beyond* the self, intrinsically entrenched in a sense of their unique place in history and at the same time of their role and responsibility within it. It is a thread and threading-through-time of tradition and legacy.

For Fazioli Pianoforti, the quest for perfection in a piano is one endemic not only to the 'time present' and 'time future' of Fazioli but also to the time-honoured tradition and continuous timeline of piano craftsmanship. There is something deeply resonant in the self-knowledge and the unparalleled historical knowledge inherent in brands that speak with such reverence: 'Working traditions, intuition and continued testing have made possible the piano's development down the centuries. Today this wealth of experience is supported by the modern methods of scientific investigation employed by Fazioli in its own Research Centre. In this way new and valuable elements serve to enrich the knowledge and further the evolution of the piano'.[iii]

Finally, a sense of history in terms of a *continuous record* is more than the mere luxury of a prestigious timeline. It is about brands that have been able constantly to preserve their past while inventing their future: a strong DNA that allows the brand to evolve without losing its strands along the way. It is about *timelessness*, the ability to stand the test of time. In the words of Goethe, it is a sacred understanding of '*Dauer im Wechsel*' ('permanence within change'). These are brands that strike a delicate and dedicated balance between iconic origin and seamless relevance.

When asked about the meaning of history and tradition, Prada, a brand that despite a century's history seems to be constantly looking ahead, suggests that:

> our real strength has always been the notion of contemporaneity, which we see as the ability to observe and understand the present and infuse in our creations a sense of the moment, anticipating society's trends. This approach and the sensitivity to look ahead through the lens of history, are Prada's key values, and they have characterised the brand since its birth. To Prada, the ideas of tradition (by which we mean the knowledge and keen understanding of history) and innovation are not antithetical, but complementary.

While art and culture in general are part of the brand's DNA:

> they are not used as marketing or communication tools. The Prada Foundation's initiatives have, and will have, no commercial link with the company. Art, architecture, cinema, philosophy and culture in general are intellectual stimuli, and serve as moments in which to reflect and broaden horizons, allowing for collaboration and debate with the most respected interpreters of our time.[iv]

History and Meta-luxury Brands

History is about origins. It is about where we come from, our heritage. It is part of our own narrative, the 'story' we tell of ourselves. As children, we grow up with fables and fairytales, enchanted by stories passed on to us, from generation to generation. It is this mythology that is intrinsic to true luxury brands. They export us, seductively, in the scent of a fragrance, in the fastening of a clasp of a watch, in the stitching of a piece of leather, to a place and time that is 'beyond'. In meta-luxury, these are stories of humble tools in the hands of the most articulate artisans.

Transforming history into a driver of demand and choice means a deep-rooted understanding of the intrinsic nature of origins, authenticity and enduring value. History in meta-luxury affords the absolute in authenticity: *authenticity of origins*, uniqueness of knowledge and craftsmanship, and sincerity in the telling of their story.

Authenticity in meta-luxury is about origin and depth. The ubiquitous 'since ...' speaks to timeline, while 'made in ...' establishes provenance. Locus and focus.

As we have stated, there is a seduction to history: being part of tradition and mythology. For consumers, this is the very principle of desire in meta-luxury. Whether or not a consumer has ever set foot in Florence, or indeed may ever do so, their buying into a piece of Ferragamo leather is buying into a piece of Florentine history.

The Relevance of History

With consumer trust at a record low, consumers are increasingly looking for a deeper notion of value. Brands are being held to account and transparency is demanded of brands as never before. Moreover, in times of deep economic, social and moral crisis, as well as rapid, unforgiving change, as human beings we tend to anchor ourselves to certainties – and within this context, heritage and history exert a powerful role. Enduring roots generate enduring value.

Analogous to gold in times of strong financial volatility, meta-luxury brands represent safe personal investments. This explains the rationale behind diverse brands' campaigns such as Gucci's 'Forever Now' or Louis Vuitton's 'Core Values' campaigns in 2008–9, which focused on re-stating these brands' status as long-standing classics.

History breathes life into brands, transforming them from inert trademarks into icons that are dear to our feelings, not simply relevant to our choices. It is thanks to brands' histories that we are capable of associating them with people, times and places that are meaningful to us. It is in this way that they acquire a significance that transcends the merely commercial.

Ultimately, through their history, brands are no longer just 'makes'. They become powerful metaphors. In remembering John Barry, composer of the best known James Bond scores, friend and fellow musician David Arnold was widely quoted as saying, 'You could

be stuck in a traffic jam on the M25 in a Ford Fiesta, but if you're playing a John Barry score, you're in an Aston Martin.' Part of the strength of this affectionately humorous tribute is in the use of two brands that perfectly encapsulate two antithetical worlds.

Likewise, it is inevitable that the desirability of Riva yachts stems not just from their inimitable, cultivated design and sophisticated materials, but most importantly from the wake behind this brand: a veritable journey through time, encompassing the entrepreneurship of Pietro and Ernesto Riva in the 19th century and the days of Federico Fellini and the heyday of the Côte d'Azur.

History beyond Time

In meta-luxury, history is much more than a mere recollection of the past. It is about being remembered in the future. In order to be relevant to customers and drive choice, history cannot simply be a question of longevity. The fact of having been around for a long time is not significant in itself – age does not necessarily drive preference. What is relevant is the fact of having left a mark through unique achievements. The brand's influence and track record is what drives demand by creating differentiation or even uniqueness.

So, ultimately, possessing a history is not in itself an achievement – rather, achievements build history.

For this reason, when looking at history as a pillar of meta-luxury, we see that time is neither a necessary, nor a sufficient, condition. There are many veteran brands that definitely do not belong to the realm of meta-luxury. In contrast, there are many brands that, despite being in their infancy, are perfect examples of the paradigm of meta-luxury.

This book includes conversations with the likes of zai, Fazioli and Pagani, all relatively young brands. How can history be a driver of choice for them?

Meta-luxury brands like these immediately show the will and conviction to emerge from the flow of time by an uncompromising cultivation of excellence. They all stem from the principles of knowledge, purpose and timelessness. They share the pursuit of unique achievement. Their youth is more than compensated for by the vision of their founders – their sense both of making history and of forerunning – which sets these brands apart. History, here, is about bringing the future alive in the present.

Longevity is nothing but a consequence. Our commentary on Chateau d'Yquem in Chapter VII takes us to a time pre-dating the birth of the Sun King. Here, history drives choice not just as a pulsating effort, but also as an extraordinary result. History, here, is about bringing the *past* alive in the present.

So, ultimately, what history means to both young and old meta-luxury brands is the ability to live beyond the moment – and to represent more than their present. To these brands, each moment is naturally placed within the context of things gone and things to come. The present does not exist for these brands. Sustained by the pursuit of unique achievements, they navigate through time with a clear course, consistently embodying where they come from and where they are heading to. As such, they never seem to feel decay. It is this very sense of eternity – history passed on and history to come – that translates into value for their customers.

History and Origin

Let us zoom out, for a moment, to a wide-lens view. Let us look at the relationship between the origins of brands and how they tie in to our cultures, to our identities. A paper written in 2009 by Dr Juergen Häusler,[v] entitled 'Brands Create Nations', affords a telling and compelling argument. It subverts the associations that we make between countries and brands – namely that countries are the birthplace of certain specialist crafts and skills. Thus, Germany conjures associations with expertise in automotive manufacturing and watchmaking. With Italy we associate the cutting edge of fashion and

design. What Dr Häusler posits, by contrast, is that brands are not born of nations, but that national identity is at least in part shaped by brands. If it were not for the early development of brands such as Vacheron Constantin and Patek Philippe, would Switzerland have acquired the peerless status to which it lays claim today in watchmaking? Entire regions in France have become synonymous with specific types of wine as a result of pioneering brand champions that continue to pave the way. In this way, meta-luxury brands are integral to our cultural identity. These are the brands that set the tone and create the standard.

'Made-in' by Prada affords an interesting perspective on the debate on origins. The collection, launched in 2010, was sourced from the best in artisanal techniques around the world, from tartan in Scotland to embroidery in India. The labels in the garments read 'Prada, Milano, Made in Scotland', reinforcing the quality of the brand's origin, while celebrating the local heritage of each specialist craft. Woollen tartan is sourced from Scottish artisans with an age-old heritage, alpaca wool is knitted in Peruvian workshops, and Indian embroidery uses the ancient Chikan art, which can be traced back to the third century BC. It is a telling testimony to a brand that understands the intrinsic importance of relevance to the global consumer, while remaining true to its roots, true to the original, inspiring vision of founder Mario Prada, whose relentless pursuit of rare and remarkable materials took him on travels to every corner of the earth. As the company tells us:

> back in 1913 Mario Prada, during his travels around the world, was already on a constant quest for refined materials, textiles and leathers, as well as for sophisticated craftsmen to bring to life his creations. From Alsatian and Austrian leather, precious objects and accessories in turtle or ivory [and] walking sticks in rare woods, to Bohemian crystal and the work of English silversmiths, he was driven by the spirit of the sophisticated, curious and observant gentleman – a connoisseur who would recognise the unique materials and skills [required] to craft a product to perfection. True to this spirit, in various countries in the world, Prada has identified niches of absolute excellence with whom to collaborate to create unique segments of the collection. These segments are deeply rooted in local legacy, craftsmanship, fine materials and manufacturing and combined with the brand's strong identity and modern, innovative style. This has enabled us to push the quest for excellence beyond boundaries which are not merely

geographic, in a visionary journey which has absorbed and sublimated what would otherwise have been thought of as barriers.' vi

Storytelling

Establishing history in meta-luxury is much more than being firmly rooted in strong values; it is about leveraging them to tell your story – a clear and compelling story of who you are, where you come from and where you are going (time present, time past, time future). Great brands take the customer on a journey; whether they make a unique purchase or a series of repeat purchases, it becomes a relationship for life.

As stories are recounted to us through time, they often lose something in the telling, or in the translation. It is the province of meta-luxury to exert and exercise supreme clarity, control and consistency of the messaging around a brand. As such, there is a meticulousness to the language used by meta-luxury. Moreover, meta-luxury brands invariably can be seen to mark themselves out by the very absence of the term 'luxury'. They have no need to self-proclaim.

Today, access to history and to knowledge has never been more immediate. With the incandescent ascendance of Facebook and Twitter, the narrative of brands has a new narrative with which to contend – the personal 'brand'. Stories of the self are framed and re-framed on a daily basis. Brands are fast coming to terms with a new dynamic of dialogue.

Burberry is a powerful example of a company that has understood the value of storytelling at a time when stories can be told and shared across social media platforms as never before. Word-of-mouth has always been a powerful tool but never more so than at a time when stories may be created and circulated within seconds. One example that stands out is the Art of the Trench – a website set up by Burberry in celebration of and dedication to one of their most famous assets and achievements – their quintessential trench coat. This is a brand with a compelling understanding of the power of social networks.

History and DNA

There is also an inimitable quality to history in meta-luxury. It cannot be replicated. Competitors may try to come close, and some come closer than others, but meta-luxury brands protect their DNA – their unique code.

The analogy between history's role in meta-luxury and DNA seems particularly appropriate for a number of reasons. Like DNA, a brand's history cannot be altered. Equally, as indeed with DNA, it is one's endeavour to make of it what one can. Second, DNA does not appear; it shows. The same applies to meta-luxury brands, where history not merely is communicated but is the 'invisible hand' guiding the brand's further development in time. Third, like DNA, history cannot be created artificially; rather, it defines the brand as a living entity at a given moment.

Its unchangeable nature makes history a driver that cannot be managed tactically but must be respected and perpetuated in each and every decision, no matter how difficult. The role of history in securing demand rests on this sense of consciousness, consistency and long-term vision.

Hermès' extension into China under a new brand is indicative of their, perhaps, unprecedented level of protection of every aspect of their brand. Shang Xia, launched in China in 2008, specifically for the Chinese market, operates separately from the main Hermès brand. It is no accident that the name chosen, Shang Xia, means 'up' and 'down' to 'reflect the flow of energy from the past through to the future'.[vii]

History in meta-luxury is about enduring value. Where so much of luxury has come to be defined by overstatement, excess and extravagance, meta-luxury would seem to afford the ultimate in the simple articulation of statement and sustainability. These are products that, in every sense, are designed for life, destined to be passed on from generation to generation. Meta-luxury is a true test of time.

A design aesthetic that has the ability to hold its relevance from one generation to the next is rare and precious. There are products in the portfolios of meta-luxury brands launched over 50 years ago – in some cases, over 100 years ago – whose relevance to today's market continues to fire, inspire and *ensure* demand and desire for them. As the iconic Birkin and Kelly bags are to Hermès, so the Calatrava is to Patek Philippe, and the Daytona and Oyster to Rolex.

Writing History

We have spoken of brands whose footprint has been etched in history. Not only have they celebrated the unique achievement of sustaining a business over milestone anniversaries, but they have created milestones along the way, ones that continue to be seen to set the standard.

As we look to time future, the question arises of the future of meta-luxury. The very self-sustaining premise of meta-luxury is such that the brands whose names have already resonated across centuries will continue to do so for centuries to come. It is for this reason that we have chosen to define the pillar of history as *a sense of eternity, stemming from a brand's ability to remain constantly relevant by perpetually embodying its own past and future*.

But which brands are in such a process of making history? There are brands that, like truly great wine, need to age. Their story, albeit recent, is an authentically captivating one and will constitute the 'roots' to which they will turn with pride in a few decades. Time will be their ultimate proof.

There are brands in their ascendant whose unique knowledge and unquenchable sense of purpose are laying the foundations of new eras.

Among meta-luxury brands in the making, a number of compelling names are emerging – luminaries that are breaking new boundaries in their respective territories, applying their unique knowledge to

established categories to create things of which we will speak and tell stories in decades to come.

As we have seen in the chapter on focus, the inception of meta-luxury brands invariably derives from the absolute and obsessive pursuit of doing one thing exceptionally well. For Elie Saab, auteur of haute couture, the thread of the red carpet is interwoven into the very DNA of the Elie Saab brand. His specific milieu is the world of the evening, of nocturnal glamour. His creations live and breathe in the world of showcase and spectacle, but they are born of a singular focus on the artisanal skills of haute couture.

Ikepod is a ten-year-old company specialising in watch – and more recently, clock – design. The name behind Ikepod is none other than the eminent designer Marc Newson. World renowned for his work across a wide range of disciplines, Newson has created everything from furniture and household objects to bicycles and cars, aircraft, yachts, and architectural and sculptural commissions. Many of his unique creations having gone on to acquire the status of modern design icons, his work is present in many major museum collections, including the MoMA, the V&A, the Centre Georges Pompidou and the Vitra Design Museum.

In terms of unique achievement, without doubt the most fascinating product in the Ikepod portfolio is Hourglass, a creation that fuses time past and time future in exemplary form. Not only has Newson succeeded in rearticulating one of the most ancient forms of time telling in the world, but he appears also to have seized on something with which no others in the industry have perhaps (dared to) engage. Hourglass is a beautiful statement in the art of supreme simplicity, belied by an underlying complexity that almost defies belief. Comprising a single piece of borosilicate glass, filled with 8 million nanoballs, Hourglass marks the passing of time by the hour. A more recent version has been developed, to mark time's passage at ten-minute intervals. As time itself, perhaps, has become one of our most precious assets, it seems apposite that Newson has designed a teller of time that marks its flow not at the rate of seconds and split-seconds, but at the more sedate pace of minutes and hours.

As Newson himself puts it, 'it says more about time than any other object I can think of'. 'Hourglass is not a purely functional object but is also something more poetic and talks about time in a more philosophical way'.[viii]

History versus Longevity and Temporality

As with the other pillars of meta-luxury, we have sought to classify the different extents to which history can play a part in igniting desire and securing demand.

In comparison with the classification of craftsmanship, focus and rarity, the exercise is far more complex, on account of the more composite and impalpable nature of this driver. As mentioned earlier, in meta-luxury history is not just a question of age but of sustained achievement in time; that is what has significance and value for customers. Hence, the prominence of history as a driver of choice is not proportional to how old the brand is, but rather to the extent to which the brand has been, and still is, capable of producing excellence over time.

With this in mind, we have identified three clusters, each progressively more distant from the idea of unique achievement and, therefore, from meta-luxury: from history itself, which is relevant to the paradigm of meta-luxury, to degrees in which brands' relationships with time and achievement are more diluted.

I. History Brands

This cluster comprises brands that combine a glorious past with a clear vision for the future, remaining consistently relevant and influential – a delicate balance between preservation and innovation, and a combination of endurance and achievement. These are the brands that are truly timeless, and that deserve the otherwise abused term 'iconic'. Their influence on the market is such that without them, their market and category would be different. They convey to their customers a sense of eternity; their value is beyond discussion.

These brands do not necessarily have a long story from a strictly chronological point of view – some brands have proved capable of unique achievements in a relatively short space of time and have a clear course set for the future; their history is glorious despite their youth. That said, as with good wine, aging is clearly an asset. Brands whose track record reaches deep into the past have indeed reached timelessness, and exert a unique attraction to discerning customers.

For brands in this cluster, history is a vital asset – one that must be protected and respected.

The owners of these brands would be defined as brand guardians, custodians of an asset that transcends time present, to be nurtured and treasured for generations to come. In the case of meta-luxury, this is about more than claiming history. It is about a reverence for history: the brand's search to prolong its own history in perpetuity, its search for perfection by the second and its striving constantly to maintain its relevance for time to come.

As Patek Philippe states: 'As a family-owned company, we are the only guardians of this quality.' The notion of *guardianship* is telling. It implies complete control, certainly, but also a sense of care, protection and legacy.

The incessant pursuit of excellence, the quest for the exceptional, is the catalysing force that drove the business then and that continues to propel every one of its 1600 employees today. In the words of Patek Philippe's President, Thierry Stern: 'We are constantly concerned with our quest to increase the quality of what we do and to achieve perfection.' 'Our work is about beauty, passion and history. That's why it has to be perfect'.[ix]

As such, Patek Philippe requires its craftsmanship to meet not one but two standards of excellence. The first of these is the Geneva Seal, a certification of quality that has been granted since 1886 to the élite of horological craftsmanship. The Geneva Seal requires compliance with 12 exacting criteria 'that can only be fulfilled by craftsmen who perfectly master micromechanical engineering, hand finishing, assembly and precision timing regulation skills.'[x] Not content with

external accreditation, meta-luxury sets its own standards. Patek Philippe has also created its own hallmark of quality – the Patek Philippe Seal, an emblem of excellence that covers everything from the movement, case, dial and hands to the strap and clasp. In meta-luxury, it is not the industry that sets the standard, but the brand.

History in meta-luxury is about enduring value. That sense of enduring value in its products is something that the Patek Philippe brand has drawn on, consistently, in its communications, celebrating its family tradition as a marker of milestones. This is a creator of time that cherishes time. Indeed the current 'Generations' campaign celebrates the precious relationships between father and son and between mother and daughter, underlined by the simple statement: 'Begin your own tradition'.

Patek Philippe would seem to exemplify this very notion of time present told through time past and held sacrosanct in time future, to be passed on from one generation to the next. The very premise of a Patek Philippe watch is to cherish, over time, to hand down from one generation to the next.

That notion of enduring value in meta-luxury is one that is not only embraced but also celebrated. Whether in the development of foundations, residencies and awards, as incubators of innovation, or of museums as showcases of knowledge, craftsmanship and expertise, it is about perpetuating the thread of history.

We see this exemplified in the Patek Philippe Museum, which opened in 2001 in Geneva. True to the brand's DNA, the building selected to house the collection has a long history dedicated to all things horological, having housed gem cutters and jewellers such as Ponti Gennari and Piaget, and specialists in watch cases and bracelets. As a testament to the tenets of meta-luxury, this is about more than the legacy of a name. It is the legacy of an entire history of watchmaking. It is a preservation of time past for today and for generations to come. The museum not only houses the entire Patek Philippe collection from 1839 – featuring one of its own milestones, the Caliber 89 (the most complicated timepiece ever made) – it also tells the story of over four centuries of watchmaking, featuring the

world's earliest watch. This is about a passion that at once celebrates the brand and transcends the brand. It is about itself, yet has an objectivity that looks out across the world.

Patek Philippe's DNA is entrenched in its very sense of history – a sense of history that calibrates self-respect with a respect for the watchmaking legacy of which it is a part. In the words that resonate from one campaign to the next: 'You never actually own a Patek Philippe; you merely look after it for the next generation.'

This is about legacy over generations, legacy through history and generations to come. Time present in time past and in time future ...

II. Longevity Brands

Some brands have time on their side. They have lived and prospered across generations. However, history is not a prominent driver of choice for them. This may be because they have failed to reach (or not pursued) a unique achievement; or because, having indeed reached unique achievements in the past, they have allowed their significance and relevance to be diluted over time, so that these are insufficient to illuminate the present or set the course for the future. As a result, these brands can claim longevity from a chronological standpoint, but they cannot be ascribed to the realm of meta-luxury.

Not counting on history as a driver of choice is not necessarily an indication of failure. There are plenty of brands that, while having considerable longevity, deliberately play a different game, and set out to win customers on the basis of other elements. It is, once again, a question of philosophy and paradigm, with no right or wrong, better or worse – just differences.

Sometimes, however, brands in this cluster are the result of a misconception: that stereotypical communication about the brand's history (celebrating anniversaries, using black-and-white pictures) is all that is required. Of course, perceptions can be steered, and that is a fundamental point of branding. However, in meta-luxury, history is much more than an emotional coating painted on a brand; it is the

immediately apparent track record of a long-standing conviction that informs every aspect of the brand. It doesn't work outside–in, but exclusively inside–out. Only then does history become a powerful creator of economic value and not just an age datum.

III. Temporality Brands

This cluster is populated by brands for which neither time nor the concept of achievement over time are part of their culture. These brands are based on a focus on the present; to them, their past and their future are neither guidelines nor assets, but just what stands before and after this moment.

To brands in the History cluster, the past is a crucial asset, and therefore a constraint for the future. To brands in the Longevity cluster, the past can be a powerful reinforcement. To brands in this cluster, the past is virtually insignificant.

Again, it is a question of philosophy and perspective. Many fashion and retail brands, for instance, see their constant self-reinvention as the key to enduring success. Their lifecycle does not evolve along a straight line, but rather through a series of changes in direction.

It is a perspective that is opposite to that of meta-luxury. While in meta-luxury the brand's past is relevant to customers as a driver of choice, for many fashion brands it appears to represent an obstacle.

The three degrees of history

Summary

The thread of history runs straight through the eye of knowledge, purpose and timelessness. The knowledge that these brands have acquired and continue to build upon is unique and unparalleled. Their purpose and path is clear. They tread respectfully in the footsteps of others, while their passion and ambition propels them to discover new ground. Their reason for being is the fulfilment of an original dream – one that, in their eyes, may never fully be realised. Their quest for excellence is an eternal one.

Meta-luxury brands may, perhaps, be best described as those that look through both mirrors and windows. There is an introspection and self-scrutiny inherent in these brands that cause them constantly to reflect on what they are doing, how they are doing it and how they will sustain it (knowledge, purpose, timelessness). They assess and reassess. They examine and re-examine. But time spent on introspection and self-reflection is counterbalanced by time spent looking out, ahead, into their future and the future of their craft …

What is fascinating to observe is history in the making, the meta-luxury brands of tomorrow. These are the new luminaries whose modern quest for the 'blue flower'[xi] propels them with an indefatigable sense of purpose, whose knowledge acquired along the way is harnessed to inspire their next achievement and whose creations will be touchstones for generations to come.

In the words of Jean-Louis Dumas, the former CEO of Hermès, 'time is our greatest weapon'.[xii] Brands that have created value across generations are more than commercial propositions: they are a valuable part of our culture, they set standards and become emblems and ensigns of excellence – and our world would miss them if they ceased to be.

[i] 'Burnt Norton', *Four Quartets, Collected Poems 1909–1962*, Faber and Faber Ltd.
Excerpt from 'Burnt Norton' from *Four Quartets* by T.S. Eliot. Copyright © 1936 by Houghton Mifflin Harcourt Publishing Company; Copyright © renewed 1964 by T.S. Eliot. Reprinted by permission of Houghton Mifflin Harcourt Publishing Company. All rights reserved.

[ii] OED.

[iii] Fazioli, www.fazioli.com.

[iv] By kind submission of Prada S.p.A.

[v] *Best Global Brands*, Interbrand, 2008.

[vi] By kind submission of Prada S.p.A.

[vii] www.shang-xia.com

[viii] *Luxury Culture* (2011), interview with Marc Newson.

[ix] *Raconteur Media*, 9 June 2011.

[x] Patek Philippe.

[xi] The 'blue flower', as cited in Novalis's *Heinrich von Ofterdingen*, came to be recognised as the symbol of Romanticism.

[xii] 'From Hermès to Eternity', *Vanity Fair*, 2007.

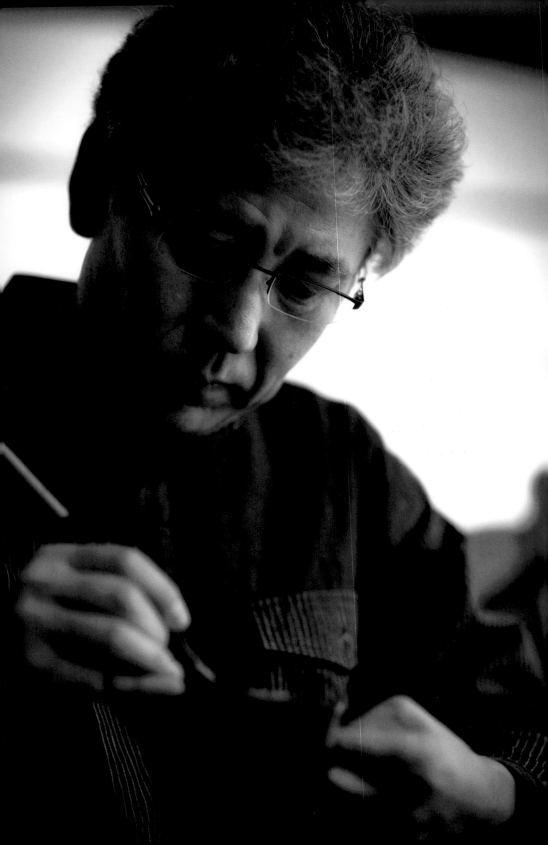

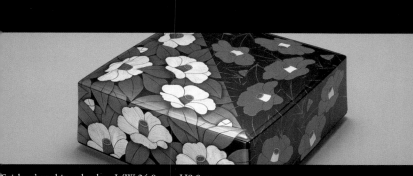

'Saishun', makie raden box L/W 24.0cm x H9.0cm

For many Living National Treasures, their dedication to their art form is a family business. This is no less true of Kazumi Murose, whose father was an urushi artist and whose workspace was his playground as a child. It was in the early 1960s, during Japan's period of highest economic growth, that Murose decided upon his vocation – a brave decision in an era that shunned the very notion of tradition, embracing instead a future of bullet trains, expressways and technology. In 1970 he entered Tokyo University of the Arts, graduating with a specialism in urushi art. Having held his first solo exhibition in Tokyo, he went on to exhibit at a number of world-leading events, including the 22nd Japanese Traditional Arts exhibition, 100 Selections of Contemporary Japanese Craft in Paris, and, most recently, Crafting Beauty In Modern Japan – Celebrating Fifty Years of Japanese Traditional Arts and Crafts, at the British Museum, London. Murose has played a pioneering role in the championship of urushi art, particularly through his restoration work at the Tokyo National Museum and the establishment of the Institute of urushi Research and Restoration. In 2008 he was presented with the Purple Ribbon Medal and designated a Living National Treasure.

The warmth of the wooden house is abundant as we enter Kazumi
Murose's workshop, treading softly on floorboards accustomed to
the footfall of soft sunlight. There is an immediate sense of serenity
in this place, as if it were imbued with the unique mystique of *urushi*
art itself. The silence is broken only by the faint hum of *urushi*
polishing, being carried out in the room below by his apprentices.
Workshop and home are inextricably linked for Murose, the two
wooden structures living and breathing side by side in a quiet corner
of the Mejiro district in Tokyo.

In Japan the title of Living National Treasure is awarded in
recognition and support of the culture of excellence. Murose is
one of 114 such Treasures,[i] exemplars of everything from the art of
urushi and ceramics to *koto* playing and performance arts such as
kabuki and *kyogen*.[ii]

An important part of the role of Living National Treasures is to
ensure the preservation of their art form. It is indeed telling that
they are otherwise known as 'Holders of Important Intangible
Cultural Heritage'. It is about much more than preserving the
memory of these skills. As gatekeepers of intellectual property these
exemplary individuals are tasked with the guardianship of their art,
which involves the transfer of knowledge to generations to come.

Murose speaks with a quiet passion about the special material
that forms such an integral part of his life. '*urushi* is a truly
amazing material. Known as Japanese lacquer, it is a natural
material obtained from the sap of trees. If a tree is cut, it oozes
out just like human blood, and then hardens due to the water and

aqua regalis, it will be totally unaffected.' His astonishment at
why the world doesn't take greater advantage of this formidable
material is evident – not least because it represents the ultimate
in sustainability. 'And because it is organic matter, if it is exposed
to ultra-violet rays it goes back to being soil. There is no natural
material as ecological as *urushi*. I am totally in love with *urushi* as a
material, and it is something that can express the pride and beauty
of Japanese people and culture.'

Indeed, this sense of the pride and beauty of Japanese culture
causes us to reflect on the essence of what is celebrated in the very
notion of a Living National Treasure. Curiously, although not
surprisingly, it seems to embody the very principles of meta-luxury
– knowledge, purpose and timelessness. As the denomination *Living*
implies, it is about the preservation of knowledge for generations
to come. As *National* suggests, it is about a wider purpose, the
pursuit of a unique achievement and a sense of cultural identity and
knowledge transfer. As *Treasure* signifies, it is about timelessness.

Knowledge is a sacred thread running throughout our
conversation. For Murose, the development of his art is a continuous
circle of learning. 'I believe that the *act* of learning is one way of
honing a skill.' He recounts three main ways of learning.

First and foremost is learning from people. 'Of the many things
that I was told by the now deceased Gonroku Matsuda, a Living
National Treasure and my master, [the most important] was that
learning is wealth above all else. You have to think for yourself
every day, and there is nowhere else to start except from with
learning. In my 20s, when I was assisting the people who were my
teachers at that time, I got to learn about the method of expression
and the technique for applying the finishing touches. If you don't
have the foundation, you can never apply it to anything higher. In
particular, in the field of *urushi* art, it's not about mass production
so the period until you really acquire an amazing technique may be
three or five times longer than that of the techniques learned in an

average business. Being able to create one object does not amount to being able to create ten. Simply, in order to know how to do ten, you have to do ten. It's an unavoidable fact that it is going to take a long time.

'Although we learn from people, we can only learn from people who are alive at the same time as us. Whether it is a role model or a teacher, at most, we can only learn from the previous two generations. So, in the 1960s, to which I was just referring, although my teacher was born in the *Meiji* Era (1869–1912), the teachers who were born in that era learned the technique from the latter part of the *Edo* Period (1603–1868). That means that at best you can only possibly learn the techniques, ways of thinking and senses of value from the last 100 to 150 years or so.'

Murose goes on to articulate the importance of the second element of learning – 'from arts and works'. 'Thankfully, there are types of *urushi* art today that have been around for more than 1300 years. *urushi*, as an art form, actually dates back to the *Jomon* Period (145th century BC to 10th century BC); Japanese people first engaged with *urushi* some 9000 years ago. There are many still in existence because *urushi* does not deteriorate. Basically, these things remain true to the cutting-edge techniques that enabled their creation. If it's an art of the *Heian* Period (794–1192), things that have drawn to the fullest extent on the cutting-edge art of that Period remain today in the form of national treasures and cultural assets. There are works remaining from the *Momoyama* Period (1573–1603) that are imbued with the cutting-edge techniques and sensibilities from that era. Through learning from creations of the past, one is able to learn things from a long time ago that far, far exceed what one can learn from a teacher.'

In a culture where ceremonies are dedicated to the beauty of cherry blossoms, and where snow-viewing windows are installed to enable people better to appreciate the pure beauty of nature, it is not surprising to discover that the third element is that of 'learning from

nature'. 'Nature changes in the same way, and because *urushi* is a gift from nature, this is where learning starts. You need to be highly sensitive to learn from nature.

'Learn from people. Learn from things (arts and works). Learn from nature. These three elements are the ways of learning that I was taught. When we put these into practice, we grow.'

In looking back, Murose is constantly looking forward. 'Although "tradition" tends to be thought of as an old word, the truth is that it is an expression of the most vanguard emotions of that era, of the individuality and idiosyncrasy of that era. The characteristics of that period are evident in the design, in the creation of new things. With *urushi*, whatever the period, the sense of value at the heart never changes, namely to 'express the personality of *urushi*'; so when we look back, we can express *urushi* art as 'tradition'. Traditions are not something that we should keep, rather something that we continually create. Although what we have now might appear to be cutting-edge, in a hundred years' time it will be a tradition.'

Murose makes an interesting distinction between the active nature of 'tradition' and the passivity of 'inheritance'. 'In Japanese, the words are strikingly similar. The fact that they couldn't be more different needs to be understood. So, inheritance is often mistaken for tradition. I think that it is a mistake to translate inheritance as tradition. "Not changing and being passed on" is inheritance, while tradition continually takes on a different shape. That is why the word "tradition" means the creation of new things.

'There are new discoveries with every restoration that I do. There are all sorts of techniques and materials from the *Edo* Period. These are, rather surprisingly, not passed on by people. They are conveyed to me by the types of art themselves. Put simply, each generation comes up with new ideas. Techniques are developed, and take on new shapes, and this becomes innovation. Tradition is innovation repeating itself.'

He tells us that the first ever patent applied for in Japan was for *urushi* paint for the prevention of rust on boats, which he discovered on meeting the Director-General of the Patent Office. 'The Director-General still has the patent certificate in his office,' he smiles. 'The rust prevention technology of *urushi* actually predates this patent, [*urushi*] having originally being burned onto armour and helmets during Japan's Warring States period, around the 15th and 16th centuries. Each item of armour and helmet used *urushi* to prevent the iron from rusting. What's more, the armour was adorned. It was not a case of simply pursuing something for its function. Indeed, I think people sought beauty in the outfits worn by Japanese men fighting in battle.'

An interesting debate ensues on the correlation between form and function, between beauty and the culture of excellence and indeed luxury. 'This is the history of the Japanese people, pursuing both function and beauty. In Japanese, the word "beauty", despite only being one *kanji* [Chinese character] can also be interpreted as luxury. When I talk about these definitions, they are about a sense of depth. Superficial prettiness is not beauty. Beauty is the set of values from deep within.' Beauty, for Murose, is a profound emotional driver. 'In the absence of beauty, however expressive you may be, you won't be able to really move people.

'The level of sensitivity and subtlety towards beauty in the Japanese culture is manifest in so many things. For instance, Japan has names for 700 to 800 varieties of colour. In the same way, I believe that it is necessary to be discriminating towards not just techniques, but also towards beauty. *urushi* gives a different sheen to lacquer, a different texture, a different nature; and within this, I believe, lies the beauty of *urushi*.

'Also, alongside beauty, I think that the personalities of materials could be called elements of luxury. In my case, while I am expressing beauty through the material of *urushi*, this simple resin taken from a tree changes shape into something incredibly beautiful through the

hands of humans. If you were to create something without making use of the personality of the material, to ignore its characteristics and prioritise self-expression, I think that there would be no point in using *urushi* to create something. Technique is about maximising the peculiarities and characteristics of a material to the fullest, it is about bringing out the personality and beauty of materials. To do this, intimate understanding of the materials is important. Only when man gets as close as possible to the material of *urushi*, and to expressing something that is totally and utterly faithful to *urushi*, will he or she be able to imbue it with some element of his or her own individuality. Only then can their creation enter the realm of beauty.'

The characteristics of *urushi* that Murose admires most are its unique properties of adhesiveness, lustre and transparency, attributes that he seeks to develop through his technique of *Makie*,[iii] which is something that has developed in its own right in Japan.

We ask what the role and title of Living National Treasure means to Murose. Telling the story of *urushi* and maintaining its relevance for today's world and for generations to come is a responsibility that runs very deep with him. 'Since being certified, I have recently come to think about how *urushi* can be communicated and appreciated outside of Japan. With this in mind, over the last two or three years I have been involved in activities around the world to raise awareness of the value of *urushi*. In turn, an appreciation of *urushi* helps to create a greater understanding of Japan, of our culture.

'The "appetite for learning" and "passion" for the material of *urushi* are for me something unchanged from a long time ago, irrespective of becoming or not becoming a Living National Treasure. I have been saying the same thing for the last ten, twenty years, so I don't feel that I have changed or that I was "reborn" in any way. The only thing is that more people listen to me now,' he laughs.

Clearly, the world has been listening. He tells us the story of how he was approached recently by the telecommunications

specialist Vertu to collaborate on the creation of a set of four mobile phones. Christened the 'Kissho Collection', these unique phones were created using *urushi* with the special technique of *Makie*, incorporating particles of gold or silver into the *urushi*. True to Murose's emphasis on the importance of 'learning from nature', each handset corresponds to one of the four seasons. It seems to be a beautifully virtuous circle on which to conclude our conversation.

[i] The title is afforded once a year, by the Japanese Ministry of Education, Culture, Sports, Science and Technology, with no more than a total of 116 Living National Treasures in existence at any one time.

[ii] A *koto* is a stringed musical instrument; *kabuki* and *kyogen* are traditional forms of Japanese theatre.

[iii] *Makie* is the specialist art of *urushi* decoration with metal powders.

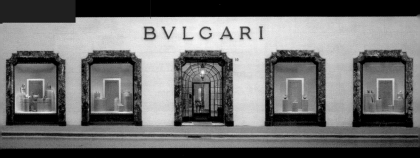

Francesco Trapani became Chief Executive Officer of Bulgari in 1984, a point at which Bulgari was starting to expand internationally. With qualifications in Economics (University of Naples) and Business Administration (New York University), Trapani brought to the company both financial planning and a long-term strategy based on product diversification, global distribution and professional organisation. In July 1995, Trapani successfully led the listing of Bulgari S.p.A on the Italian Stock Exchange, with the Bulgari family as majority shareholder. In February 2001, Bulgari announced the creation of Bulgari Hotels & Resorts, a join venture between Bulgari and Marriott International/Ritz-Carlton. As a result, the Bulgari Group has become a major success story. In March 2011, Bulgari and LVMH Group joined forces through an agreement that provided LVMH with the majority shareholding in Bulgari S.p.A., while the Bulgari family became the second largest family shareholder of the LVMH Group. Trapani became a member of the Board of Directors of LVMH. In July 2011, Francesco Trapani was also appointed President

'The Italian architect and designer Giò Ponti used to state that elegance is the absence of decoration. I totally agree with him, because the whole point is always in those details which can make a big difference, rather than the mere fact of sheer abundance,' Francesco Trapani observes.

This remark could apply to the entire history and quintessence of Bulgari, the 127-year-old brand behind many legendary jewellery masterpieces. Primarily inspired by Greek and Roman art and aesthetics, they have in turn influenced the canons of preciousness and elegance to our days. Often used with excessive generosity, the term 'icon' is unquestionably appropriate when used to describe Bulgari and its creations.

The importance of such individual details is, in many ways, the guiding principle that also inspired a more recent endeavour in the story of this brand, the Bulgari Hotels & Resorts chain – one of the first and most successful examples of a hospitality brand originating from an extension. 'When you consider their architectural design, in fact, it is extremely reduced,' Trapani notes. 'It is virtually weightless. It completely relies on the extensive use of rich materials and finishes, such as marbles, stone, wood and metal, which are so powerful within themselves that no other decoration is necessary.' The idea of weightlessness also inspires the way in which 'both are perfectly integrated into their original landscapes. What I believe is extremely captivating is also that subtle balance between spatial rigour and the overall atmospheric suggestion, something which is obtained through carefully orchestrated textural juxtapositions and

We simply look at the final result we want to achieve. And without any doubt,' he concludes, 'the Bulgari Hotel in Milan and the Bulgari Resort in Bali perfectly mirror my own idea of how luxury should translate into a physical place. They have a strong energy and vibrantly contemporary feeling, but offer true luxury quality and features. These, to me, manifest themselves through a consistent quest for impeccability in every single detail – and that is also about the ability to cater to all needs,' Trapani observes. To that extent, an integral part of the experience lies in the level of service. 'The uncompromising level of the staff allows for the best of both worlds – a highly personalised service delivered in an informal and relaxed manner.'

The notions of service and needs are, to Trapani, essential components of the offering of those brands that he feels represent true luxury. 'I believe excellence has a lot to do with being able to really anticipate customers' needs, and to then transform that deep understanding into the basis for an impeccable execution in terms of service. This, along with quality and distinctiveness, is what luxury should ultimately be about.' This combination, reasons Trapani, is especially true in the post-crisis world. 'Now more than ever before, luxury means self-indulgence and self-reward. And this can be embodied by a made-to-order item or by an absolutely exclusive service or treatment. Luxury has gained a more individual significance, ideally allowing each of us to choose his, or her, own meaning and way of experiencing it: and that can be interpreted as a desirable item as well as a state of extreme comfort.'

To Trapani, this sense of comfort and bliss has diverse personal meanings. 'Very often, having time for myself, and particularly time to spend with my family is a form of luxury. It is something that cannot be bought,' he adds, 'and it is never enough.' To a more tangible, but consistent, extent, 'I would say that, yes, owning a personal jet or a yacht represents a form of luxury in one sense – they make you feel completely free in time and space. They enable you to reach the places you belong whenever you want, and in

full accordance with your mood and the company you desire to be surrounded by. In fact,' he adds, 'if you ask me what luxury is *not*, then I would say it's haste. Because luxury requires time to be produced, in terms of craftsmanship, and time to be experienced and appreciated.'

For a brand that has played a fundamental role in defining the aesthetic canons of jewellery across several decades, the concept of time acquires a special resonance, creating a constant echo between origins and the future. 'We are very proud of our history and heritage, since they shaped our identity and are still today the source of inspiration for our creations. They are a sort of "fil rouge" [red thread] between present and past,' Trapani passionately observes, 'and it is incredible to see the great deal of inspiration coming from our archives. The founder of the company, Sotirio Bulgari, was a Greek silversmith, and in fact a fundamental characteristic of Bulgari's creations is their ability to reinterpret themes and motifs of art and architecture, mainly from the Greek and Roman ages.'

This is not merely a source of inspiration, but translates into a consistent element of discovery. 'In our creations you can always find a sense of volume, a passion for linear and symmetrical forms which are the precious legacies of these roots. At the same time, Bulgari is a brand that in well over a century of existence has contributed to writing the history of jewellery through a strong and constant innovation in style and design: we introduced daring colours and material combinations, such as the mix of precious and semiprecious stones, or the use of ceramics and antique coins. Bulgari has always striven to find new ways and schemes to express its creativity, following the absolutely new concept of a jewel that could be worn all day long, "at a ball or at a picnic", as my uncle Nicola loved to say,' Trapani remembers with affection.

'As a matter of fact, this concept was in line with the evolution of women's role in society starting from the 80s, which saw them established in the world of business and therefore requiring jewels

that suited their working lifestyle – from a board meeting to a cocktail party. A perfect example of this thread between past and present is our jewellery line Parentesi[i], whose motif is inspired by the travertine joints typical of Roman roads. This line features a strong innovation, which is modular jewellery. An element of a well defined shape, free of unnecessary ornamentation, can be reproduced in series and combined to form a variety of homogeneous designs,' he explains. 'Another effective example is the Serpenti[ii] line, where the snake motif – a symbol of knowledge and eternity which wound its way through the history of jewellery design from Hellenistic times to the present – is applied to the revolutionary Bulgari craftsmanship technique called "Tubogas", consisting of a flexible band of sleek and polished contours produced without soldering. In this way, the snake jewels, which are a reinterpretation of the past, become modern and timeless ornaments.'

The ideas of craftsmanship and history, Trapani notes, 'are intertwined. Craftsmanship implies a unique care for detail. History, in turn, is important for a luxury brand because it results in the authority of a long experience in the ambit where it operates.'

For Trapani, these notions of timelessness and culture are part of the same concept. 'Luxury products entail the ability to convey in a sophisticated manner the real essence of a brand, which is ultimately made of its history, heritage and style. Yet this concept of culture also implies an in-depth knowledge and understanding of people's values, ideas and attitudes in the age you live in, which are aspects that influence the evolution of a brand and, at the same time, its power to keep the flame of its own values burning within this evolution.'

We go on to ask about the boundary between craftsmanship and art. 'Craftsmanship becomes art when a creation conveys a sense of perfect, unquestionable and timeless beauty,' Trapani suggests. When discussing the concept of meta-luxury, Trapani indicates it as being applicable to 'the highest expression of human

capability in doing something, a drive for excellence, the search for perfection through a flawless execution.' A notion that leads on to the idea of unique achievement, which, 'in our world, is embodied by a recognisable style which marks a new concept in creating, thinking and living jewellery, and is at the same time inimitable. As for Bulgari specifically, that lies in the wearability and flexibility of jewels, the colour combinations, the inspiration from art and architecture which originates motifs of a timeless elegance.'

There is one final point to which Trapani warms when summing up his personal notion of luxury. 'All in all, luxury is about something that is not necessary but that is able to improve the quality of life through the emotions it arouses and/or through the desires it fulfils. You see, a luxury brand must, in the first place, be coveted.'

[i] 'Parentesi' translates from Italian as 'brackets'.

[ii] 'Serpenti' translates from Italian as 'serpents' or 'snakes'.

Chapter VII

Rarity

'Heard melodies are sweet,
but those unheard are sweeter'[i]

John Keats

The fascination for the 'rare and remarkable' was widely exploited in Renaissance Europe, in what became known in England as cabinets of wonder or cabinets of curiosities, in Germany as *Kunstkammern* or *Wunderkammern* and, in France, as *chambres des merveilles*. Creators of some of the world's most renowned 'wonder rooms' included Francesco I, the first Medici Grand-Duke of Tuscany, and Peter the Great of Russia. The collections comprised an encyclopaedic array of objects of untold rarity, fable, intellectual virtuosity and beauty, and the 'rooms' that housed them were the precursor to today's museums.

The notion of rarity is elusive but it is, by definition, exclusive. True to the spirit of Romanticism, the quintessence of the quest for the elusive is the quest itself, as emblematised and exemplified by the 'blue flower' of Romanticism. Rarity is the expression of the 'beyond' in every sense. It is beyond the grasp of everyone 'else'. It is beyond the skills of others who have gone before. It is beyond, in some cases, the realms of possibility.

It is no surprise to discover that the semantic origins of the word 'rarity' encapsulate not only the elusiveness and infrequency of the

appearance of these rarefied objects, but also the overwhelming sense of wonder and awe that they inspire.[ii] The 'infrequency' of rarity delineates the necessary timeline of the pursuit of a 'unique' achievement. In meta-luxury, rarity is a consequence of the nature and process of the remarkable. Rarity is, quite literally, the exception and the exceptional.

However, in the world of exponential change we have experienced over the past decade, the question of rarity has, perhaps, never been more challenged. The generation growing up today enters a world of the immediately available, of the instantly accessible. A single touch of a phone, tablet or laptop can transport them to anywhere in the world at any time of the day or night. Increasingly, there are no limits, no limitations. Everything is available … found in a matter of seconds, purchased and dispatched in a minute. But are we necessarily the richer for this newfound immediacy? Certainly, it has quelled, at a fundamental level, the quest, the simple act and anticipatory pleasure of discovery.

In counterpoint to the near vertical trajectory and explosive pace of technological change, what is interesting to observe is that a softer curve has emerged – as manifested, for example, in the rise of 'slow' movements. So frenetic has the pace of change – and life – become that a reactionary trend has evolved, giving rise to movements such as 'slow food', to concepts whose very premise is to attenuate the pace of our lives and to appreciate those things that take a little longer in the making.

This sense of the value of time is the very essence of meta-luxury. Indeed, the sweet spot of the connection between rarity and *knowledge* resides where the process of ideation and creation is inextricably intertwined with the journey required of that process and the intricacies involved along the way. When it comes to this connection, the question is about the extent to which rarity is linked to the time and economic constraints resulting from the need to inject knowledge into the conception and creation process. Meta-luxury, by virtue of its very nature, is slow in the making.

A single component of a Fazioli piano, for example, may be three years in the making. Meta-luxury takes time. It sets its own pace

and will not be rushed. But the very premise of meta-luxury is that it is *worth* the wait … This is not about the transitory 'hit' of instant gratification. It is about the enduring nature of lifelong satisfaction.

In terms of *purpose*, is rarity the inevitable consequence of the pursuit of excellence? Purpose speaks to the specification of materials, skills, workmanship and processes that will lead to the pinnacle of performance across different criteria. Salvatore Ferragamo encapsulated beautifully the obsessive vision in meta-luxury that fuels an incessant pursuit: 'There is no limit to beauty, no saturation point in design, no end to the material.'

The creation of a unique achievement in history is contiguous with the rare and remarkable. In some cases, this is articulated in the form of a singular, wondrous achievement, a one-off. In others, it is a question of a very limited number of creations. In either case, these are achievements that stand the test of *time*.

Rarity and Meta-luxury Brands

The concepts of luxury and exclusivity are often confused and set in a contradictory relationship. Exclusivity is in itself a relative concept and, moreover, the concept of luxury has come to be curiously coupled with the idea of accessibility.

There are two facets to rarity. The first is *quantitative*. While greater volumes clearly provide economic rewards, rarity remains the quintessence of luxury. It is unfair and untenable to draw comparisons between brands that create unique pieces and brands that address millions of 'consumers'. This is one of the fundamental contradictions arising from the use of the term 'luxury': how can these completely different models, scales and value propositions be bundled under the same label?

Rarity, however, also has a *qualitative* aspect. Exclusivity is also about perception – the degree to which a certain brand is a widespread experience rather than an almost mythical discovery

and epiphany, sharing its uniqueness with the lucky few or even an individual. It is no surprise that substantial layers of secrecy and mystery surround many of the brands we are talking about.

The dual value of rarity – quantitative and qualitative – resonates with the idea of being, at once, *rare* in numbers and *remarkable* in manifestations.

Thus, in the world of meta-luxury, availability is replaced by attainment, both economic and intellectual; exposure, by discovery. The policy of brands in meta-luxury is to elude and exclude, rather than to produce and adduce. Some brands work specifically and single-mindedly on small, if not single, numbers, treasuring their rarity, manifesting themselves as dreams more often than as a physical presence. Some afford a high level of customisation, resulting in truly unique pieces.

In the context of this inherent sense of discovery, it is particularly telling that the aforementioned concept of the cabinet of wonder, along with the term 'wonder', was seized upon by Selfridges, in their inauguration in 2008 of The Wonder Room, a 1800-square-metre quadrant dedicated to the elusively exclusive, hosting and showcasing brands such as Bulgari, Cartier, Hermès and Vertu. When Henry Gordon Selfridge opened the doors of the world-famous department store in London, in 1909, his vision was to showcase things whose novelty and uniqueness would delight and excite his customers. Selfridges was a locus and focus for 'firsts', for the unseen. Indeed, it was in Selfridges that Scottish inventor John Logie Baird demonstrated history in the making with the first public showcase of television. Thus Selfridges' naming of The Wonder Room was not only relevant to the original vision of the brand but also in clear and distinct reaction to the dilution of the term 'luxury'.

Rarity as a Driver of Demand

Rarity, by its very definition, is a divider of social groups. It draws a definitive and indeed finite line. 'Accessible luxury' has become a statement of the collective. Overt and extravert, these badges of

accessible luxury are often toted as totems of a tribe. Whereas the
narrative of accessible luxury is one of overstatement, by sharp and
delineating contrast, that of meta-luxury is the ultimate in the art of
statement, or indeed, understatement.

Indeed, the very quest for the rare, for the truly remarkable, is
driven by a desire to be a part of something that is truly apart. To be
one of the select owners of these ethereal creations is to be a part of an
exceptionally exclusive 'club'. But whereas the ownership of 'accessible
luxury' is driven by a desire to display that badge of membership, the
privilege of ownership of a rare creation is more analogous to that of
the protectorate of a secret society.

As we have stated, value comes only with rarity, and unique
achievements are, quite simply, priceless. For meta-luxury brands, profit
ensures the sustainability of the company's culture of excellence over time.

There is a clear corollary that we, as consumers, draw between rarity
and value. The more rarefied the object in question, the greater the
value we attach to it. Intrinsic to rarity in meta-luxury is this notion
of discernment, of connoisseurship, where knowledge becomes the
province of the consumer. It is the notion of being part of a 'sect', of
a highly select set of individuals. Beyond the parameters of economic
affordability, it is this unique and privileged position, of being 'in the
know' that drives demand. Rarity is the ultimate 'collector's item'. It
is beyond desire. It becomes a question of necessity.

Rarity and Excellence

There is one fundamental misconception about rarity that we feel
should be dismissed. It originates partly from the widespread, and
somewhat frustrating, use of words such as 'exclusive' and 'exclusivity'
in the way in which some so-called luxury brands introduce
themselves and their offering.

Nothing is more distant from a culture of excellence than forced,
artificial rarity. Series that are limited for the sake of being limited

are an extremely ephemeral means of trying to increase the value of an object. Likewise, prices that are high for the mere purpose of creating exclusivity are nothing if not an example of rarity imposed as an economic distortion – and such distortions can last only in the absence of transparency, a circumstance which typically occurs when the customer can afford a certain product from an economic, but not from an cultural, point of view.

The paradigm of meta-luxury is based on knowledge, purpose and timelessness and is therefore free from such distortions. In meta-luxury, it is not pursued value that drives deliberate rarity, but inevitable rarity that drives subsequent value: rarity is the natural consequence of the devotion to excellence, regulated purely by the unique materials and skills requisite to the process of creation and sustained by the value that it commands.

This does not imply that there is anything ethically wrong in commanding a price that is disproportionately high in comparison with production and supply costs, as in the case of some branded cotton T-shirts. After all, brands are central to free societies, and represent freedom of choice. The 'fairness' of a price is something that only the market has the right to establish. What we do mean, however, is that in the paradigm of meta-luxury, price is not a distortion, but a consequence. We will discuss this in greater detail in Chapter IX, *The Economy of Meta-luxury*.

Ultimately, in meta-luxury rarity is never a decision. It is always a consequence, a logical implication of the pursuit of unique achievement. As a result, in meta-luxury, the pillar of rarity can be defined as being ***the limited accessibility imposed by intrinsic value, ultimately making demand subject to discovery and affordability, both economic and intellectual***.

The Degrees of Rarity

As discussed, the pillar of rarity is born of the observation of the notion of unique achievement in the context of the 'Who?'

perspective. In this chapter we have discussed the ways in which rarity represents a unique achievement along the 'Who?' axis. Following the same logic that was adopted in the previous chapters, we have sought to define two other degrees along the same axis.

I. Rarity Brands

The very principle of infrequency would seem to run counter to the models of many businesses, where production lines are constant, nay incessant, and where quantities can be increased at the touch of a button. The balance of supply and demand is based on the premise of availability and accessibility. It is product by replicable numbers. Rarity, however, is about a business of small numbers.

This tension around the current business models of luxury is evident in some recent debates. As stated by François-Henri Pinault, Chief Executive of the French conglomerate Pinault-Printemps-Redoute (PPR): 'Over the past decade or so, the luxury industry has focused on developing derivative goods – like lower-priced accessories – to make a brand and its products more attainable to a wider audience. This business model can and should be challenged.'[iii]

Instead of producing greater quantity of product, Pinault argues, luxury companies should gravitate to 'high luxury': concentrating on 'individualisation of the product [...] personalisation [...] and more adventure and risk.' Within the paradigm of meta-luxury, 'individualisation, personalisation and risk' is the very premise on which some of the greatest brands in the world were born, and on which they continue to grow. That growth may not be at the exponential rate of other brands in the luxury sector, but, vitally and valuably, it is one that self-sustains.

For piano specialist Fazioli, the notion of quantity is, purely, one of quality. In the course of a year, no more than 120 pianos are created. Having celebrated only its 30th anniversary last year, Fazioli was born of a single desire: to build a better piano. Each instrument is handcrafted, to the most exacting specifications in design and technology. It is a process that takes time. The first phase in constructing a piano

consists in forming the rim, which, at Fazioli, is still shaped in the time-honoured manner, leaving the wood in clamps for days to allow it to adapt naturally to its new shape. The rims are left to rest for a minimum of six months before the next stage of assembly can commence. The soundboard is left to rest for at least three years in a climate-controlled room to maintain the ideal conditions of humidity and temperature. This patient process and the profound respect for the natural tendencies of the wood are what will ensure the stability and longevity of the piano. Rarity is the pure and inevitable consequence of the daring and dedicated dream of the perfect piano.

The Pagani Zonda made its debut appearance in 1999, a new name in the elite history of supercars. Within a mere decade, the Zonda emerged as an exceptional performance player, rivalling the historic names of Bugatti, Ferrari and Lamborghini. The production line of the Zonda ran at under 20 cars per year before giving way to the Huayra in 2011. Limitation of numbers is driven by the eternal quest for excellence.

At Vacheron Constantin, the composition of a watch is a time-intensive process. The movements of each watch are composed by a team of artisans, in the company's assembly workshop. The attention to detail is such that each step of the process is afforded the dedication of an artisan, specific to that area of the watch. Founded in 1755 in Geneva by Jean-Marc Vacheron, the business is one whose heart has always been the pursuit of the remarkable. The words of François Constantin, who joined Jean-Marc's grandson in 1819 to create the company we know today, resonate: 'Do better if possible, and that is always possible'.

This is the foundation on which unique achievements are created. In 2005 the company celebrated its 250th anniversary with a rare and remarkable achievement, creating the most complicated double-faced wristwatch in the world. The Tour de l'Ile watch comprises a unique combination of 16 complications and astronomical dials. Its exceptional calibre of 834 components involved Vacheron Constantin's designers, engineers, constructors and watchmakers in over 10,000 hours of research and development. The number of timepieces produced? Seven.

As current CEO Juan-Carlos Torres states: 'Our goal isn't to present several new sensational items each year. We want to offer the complications that connoisseurs expect from a manufacture such as ours […] All of this, naturally, takes time.'

The confluence of time and excellence are the very lifeblood of such brands. When it comes to history, Château d'Yquem's has the makings of an epic. This illustrious wine has a no less illustrious heritage, spanning over four centuries, including a period of regal ownership by the King of England (who was also the Duke of Aquitaine at the time) and immortalisation in countless works of literature. Time operates here as a central organising principle: 'Château d'Yquem can only be understood within the framework of time. Life seems to pass very slowly at Yquem, reflecting the chateau's history and traditions handed down from generation to generation over more than four centuries. At every moment in its life, Yquem is above all an affair of time and, therefore, patience.' iv

As we have seen, the principle of rarity rejects anything that endangers the promise of quality. At Château d'Yquem, there is not even the remotest notion of compromise. In inclement years, entire vintages have been rejected. As a former guardian of the brand, Count Alexandre de Lur Saluces, put it: 'we can only win across the board if we accept the risk of losing everything'. Rarity here is an organising principle and it is a practice that continues today under the aegis of its current brand guardian, Pierre Lurton. The reward of that risk is evident in the level of desire commanded by this brand. So sought-after is this wine that a bottle of 1811 Château d'Yquem recently set the record for the most expensive bottle of wine not bought at auction.

We have talked previously about craftsmanship as a form of indirect customisation; rarity exemplifies the ultimate in the art of the truly personal. The custom-made has become an intrinsic component of some of these unique businesses. Maison Francis Kurkdjian, in Paris, alongside its unique range of fragrances, has a division dedicated to custom-made perfumes. With a history of a mere 15 years, Kurkdjian has some natural aging to do in terms of

the paradigm of meta-luxury, but already he has emerged as one of the leading lights in the fragrance industry and has been lauded with the title of Chevalier des Arts et des Lettres. From signing his first fragrance, 'Le Mâle' for Jean Paul Gaultier, in 1995, he went on to create fragrances for world-leading fragrance houses and laboratories, including a reconstruction of one of Marie Antoinette's fragrances: 'Le Sillage de la Reine'. His latest creation is a new perfume for the couturier Elie Saab. His inspirational creations for luminaries in the industry are unique achievements, but it is his dedication to go beyond that reaches into the realms of rarity.

II. Exclusivity Brands

As we have stated, the notion of exclusivity has become ever more elastic – as a result of more expansive offerings, of a breadth that runs counter to the depth of meta-luxury. This cluster of brands falls under a wide definition and includes those that, whilst being off-limits to the majority of the public, belong to a more ordinary experience.

While retaining a highly exclusive core offering, these brands make their products available to a wider audience, perhaps – but not necessarily – through alternative categories. These brands may be highly desirable and respected, and a Chanel handbag or a piece of Louis Vuitton luggage might indeed represent an *achievement*. It is not, however, a *unique* achievement in the sense discussed in this book.

The principle of rarity has often been used, or rather misused, as a management tool for luxury brands, in the guise of artificial exclusivity. Over time, the increased availability of Chanel No. 5 led to the iconic perfume being widely available and even distributed in everything from department stores to drugstores. One of the initiatives undertaken in the mid 1970s to reinvigorate what, by then, had become an ailing brand, was to limit access, thus removing it from places in which it should not have been made available. When luxury and rarity are debated today, this, invariably, is the context in which the two concepts are understood. It is far-removed from the principle of rarity in meta-luxury.

III. Accessibility Brands

Some brands that could have been called luxury years ago have, over time, become accessible brands. Brands in this cluster are managed on the basis of a strategic choice – the deliberate compromise on rarity aimed at achieving a wider customer base. Very often, this provides the brand with fast economic growth as well as considerable profitability. The brand's business model is no longer based on the pursuit of a unique achievement, and is therefore not consistent with the paradigm of meta-luxury.

Armani, through an articulated architecture of sub-brands, has now become a relatively less exclusive brand. While the company operates through different sub-brands, some of which are distinguished by limited quantities and exposure, the portfolio is endorsed by the Armani masterbrand, threatening to dilute over time the overall perceived exclusivity of the entire offering. This does not prevent Armani from being a highly successful and desirable brand, consistently admired for the sheer beauty of a variety of creations. Simply, rarity is possibly not a driver of choice for the brand, nor does a part of its demand stem from the pursuit of discovery and discernment, but from other elements. Overall, the brand succeeds in a strategy that is different from meta-luxury, and that has a subsequently different risk/return profile.

Veuve Cliquot is a global benchmark when it comes to brand management. At once audacious and sagacious in its innovative use of touchpoints and dynamically consistent use of its identity, this brand ensures that it remains highly relevant. The brand's business model is undoubtedly based on focus and history, but it can hardly offer a sense of discovery and individualism. The sense of a unique achievement has been diluted along the way through wider availability.

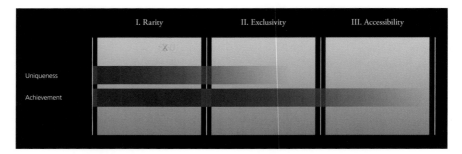

The three degrees of rarity

Summary

As we have seen, in the conversation with Dr Michael Scott, rarity has taken on a plurality of forms over the course of history, but the enduring constant throughout is that value comes only with rarity. And rarity comes at a price. In meta-luxury, as we have seen, it is rarity that drives price, never the reverse.

Rarity is an issue of brand management – the result of an untiring pursuit of excellence that commands a uniqueness in materials and demands a uniqueness of technique, the result of whose convergence is a truly unique achievement. For some brands, that translates into a limited number of pieces, for others, into singular creations.

Rarity's relationship with knowledge, purpose and timelessness renders it a cornerstone of the meta-luxury paradigm. The quest for perfection, for the ultimate, for the 'beyond' has no limits. In such a pursuit of quality, the only natural and necessary constraint is quantity.

[i] Extract from *Ode on a Grecian Urn*.

[ii] '1. The state or quality of being rare; 2. A rare thing.' (OED).

[iii] Speaking at the *International Herald Tribune* Luxury 2006 Conference.

[iv] www.yquem.fr.

Dr Hans Peter Danuser von Platen

Dr Hans Peter Danuser von Platen was CEO of the St Moritz Tourism Board, Switzerland, for 30 years. Before, alongside and after this he worked for three other global brands: Nestlé (coffee), Deutsche Bank and the Swiss Army. Today he co-owns two consulting companies, continues to work for Deutsche Bank, is on several boards of directors and lectures at the Swiss Federal Institute of Technology in Zurich (ETH) on brands and brand management.

Like a sapphire set at the heart of the majestic mountains of Upper Engadin, Lej da San Murezzan, also known as Lake St Moritz, shimmers in the sunshine. Early on a May morning, its northern shore offers a rare experience: absolute stillness, and a perfect silence, broken only by the whispering trees, caressed by a beautifully fresh wind. It is hard to reconcile this sense of immobility with the liveliness of the summer and winter season peaks, when St Moritz becomes one of the most sought-after destinations in the world, graced as it is by a quasi-alchemical combination: the town's dynamically cosmopolitan atmosphere, and the pristine magnificence of the surrounding landscapes.

The hotel tea room where we meet Dr Hans Peter Danuser von Platen has large windows embracing almost the entire lake and the town – an ideal context for a conversation that will draw much from the spirit of a place shaped by a unique blend of nature and society, history and innovation, sports and culture.

Dr Danuser's insights take the form of a delightful stream of vivid anecdotes, combining a brilliant sense of humour with a keen taste for discovery. 'For a brand, it is always good to be able to borrow a well known name,' he observes. 'Mauritius was a Roman officer who became a martyr in AD 285 for his refusal to fight Christianised Germans in this region. He is a prominent Saint in German religious culture, and the town's name is a tribute to his deeds. However,' he adds, 'archaeologists have found evidence of settlements dating back to almost 3500 years ago, around the local springs, and the first recorded mention of the place is dated AD 1139. So yes – the name is old, but the community is even older,' he smiles.

It is fascinating to learn that even what can be described as the modern period of this constantly in-vogue resort goes back over 150 years. 'The birth of contemporary St Moritz is associated with the opening of the Kulm Hotel by Johannes Badrutt in 1856. Interestingly, that happened to be located at 1856 metres above the sea level,' Dr Danuser notes. 'The Kulm was the first deluxe

establishment in the high Alps. Mr Badrutt was more than an amazing entrepreneur – he was an innovator, or, I would rather say, a true pioneer. To give you just one example, the first electric light to be switched on in Switzerland wasn't in Zurich or Lugano but, yes, right here in St Moritz, at the Kulm. Badrutt had seen it at the World Expo in Paris and had immediately decided to adopt it. Badrutt's importance, however, goes beyond his role as the owner of the hotel. He was the initiator of St Moritz as we now know it.

'Badrutt established three principles which influenced the entire offering of the place. The first one was quality. His vision was to offer the same level of quality and comfort that visitors were used to in, say, Paris or London. The second principle was of course innovation, and I'll tell you more about this in a moment. Finally, he had from the outset what we would call a truly global approach; when you think about it, luxury was not an intrinsic part of Swiss culture at the time,' he points out.

'Anyway, let us go back to the point of innovation. Because the summer season was too short to secure a good return on investment, Badrutt literally invented the concept of winter holidays in the mountains. The story is well known, but worth mentioning. Getting to St Moritz in the wintertime was a real adventure then. Still, in 1864 Badrutt managed to convince some British summer guests of his to come over for the winter, also on the grounds that the weather would be sunnier and drier than in London anyway,' Dr Danuser explains with a laugh. 'He offered them a deal: if they didn't like it, he would cover all their travel expenses. And if they did enjoy their stay, they would be his guests for as long as they wanted. They had a great time, and once back home, in spring, they started spreading the news. But this isn't all. In order to prevent his guests from finding themselves in a beautiful but boring place, Badrutt showed them how to use sleighs, and went on to invent the winter sports business. Over time he established events like curling tournaments and supported the Cresta Run, paving the way for the hosting of the 1928 Winter Olympics. You may easily call it the dawn of event

marketing. Many of those events are to this day staples in the tradition of St Moritz.'

There is a thread of focus and consistency running from Badrutt's days to the present, Dr Danuser emphasises. 'When Badrutt passed away, Camille Hoffmann, a young Protestant pastor, was elected President of the St Moritz Tourist Board, the oldest in Switzerland. Like Badrutt, he was multilingual and extremely open-minded. Over the following 30 years, he refined Badrutt's vision into a clear strategy. Interestingly, even in his religious role, Hoffmann strongly advocated the value of concentrating on key competences and the importance of not losing focus. For example, when the idea of enlarging the local clinic into a huge structure came up, he campaigned against it. Holidays were what this place had chosen to be about, he argued, and that should be the path ahead. To Badrutt's principles of quality, innovation and global approach, Hoffmann added a strong sense of focus, which has been passed on to, and by, each of his successors.'

Continuity has been a huge asset for the development of St Moritz. 'The strategy for St Moritz was more or less the result of the work of two people in the course of more than half a century,' Danuser notes. 'And over the following 80 years, only three people were subsequently in charge, myself being the third, from 1978 to just a few years ago. Continuity is without any doubt part of the secret behind the success of the St Moritz brand. In fact, I was offered the position subject to one condition – that I would commit to hold the position at least for 25 years. Not an easy choice from a personal point of view, but a very wise policy from a branding perspective.'

The St Moritz brand? Precisely. 'In 1930 Walter Amstutz, the head of the Tourist Board, my pre-predecessor and a genius communicator, had the idea of conceiving, and designing, St Moritz as a brand. He asked Walter Herdeg, one of the greats of Swiss design, to create a graphic device. By 1937, variations of the now famous St Moritz Sun icon were registered as a visual trademark. We are talking about the Thirties, and here you had not only a clear

brand strategy, but also a full corporate identity, an innovation that was widely covered in the press at that time.'

From this point on, the story of the St Moritz brand intertwines with Dr Danuser's own career. 'Half a century after the registration of the design device, in the mid Eighties, we managed to protect the name and logo of the city. It was universally recognised as a step into a new dimension in marketing. We subsequently launched a licensing program with several and diverse parties, including a power company. This move created considerable streams of profit that were reinvested in growing, communicating and managing the brand.'

This leads us to talk about St Moritz's famous tagline, 'Top of the World'. 'Oh, that was heavily debated,' Dr Danuser recollects with a degree of amusement. 'Some did not understand it. Some were against it as it wasn't expressed in any of the official Swiss languages. Someone suggested it was technically false if taken literally, i.e. from an altitude perspective – never mind the Carpenters singing about "sitting on top of the world". Most strikingly, somebody ventured to say we were a resort for everyone. And this was the point I strongly objected to, because it was simply not true. You see, in steering a brand you have to make choices, the first of which is a positioning based on what you offer. At the time, more than half of our hotel capacity was four or five star. We had events like horseracing and polo, and a sophisticated clientele. All these were touchpoints celebrating and positioning the brand in a clear way. Was 'Top of the World' arrogant? Was it not politically correct? Well, it was in line with choices made decades before. Since 1987 that has been our slogan, and in a world where getting attention is indeed a form of luxury, it has contributed to creating a unique profile. It is such a clear promise. All the market research we carried out showed it is plainly the ideal statement for St Moritz.'

Along with a clear strategy, there is consistent implementation. 'Rather than investing in communication campaigns, we chose to work on events, as they would immediately bring resources back to the local community while ensuring that the press would then diffuse

the message worldwide. We also worked on several strategic alliances, such as the Glacier, Bernina and Palm Express tour services.'

The question of living up to the 'Top of the World' promise brings us to discuss the nature of excellence and luxury. 'Luxury is a very individual idea, which is influenced by time and place. Think of St Moritz. A small community. A kind of Switzerland within Switzerland, magnifying the latter's properties – space, scenery, safety, health, cleanliness and reliability. If we look at what goes on in so many places around the world, these attributes are far from being a given.' What most of Dr Danuser's friends and acquaintances seem to be short of, though, is time. 'What luxury is *really* about to me personally is taking time and living according to the weather. That's my ambition now,' he says, a gleam in his eyes. 'It is not easy, because it requires breaking a circle, and doing things which do not belong to your usual life. You need to be open-minded and optimistic – no risk, no fun.'

On a less personal level, Dr Danuser observes that 'excellence is about performance, and there are so many great brands out there – from Apple, say, to Google and Audi. But the point is, they are not rare. Real luxury has nothing to do with overavailable products. It is about things that are rare because they have to be earned and achieved, and I'm not talking necessarily about money. It is primarily a learning process. You see, luxury has to do with rarity in the sense that you need a certain education and degree of relaxation to really understand your desires. Widespread uncertainty, as well as the media, makes many people confused as to what they are really after. They have others orient their needs, tastes and behaviours. Few are self-confident enough to know what luxury means to them. Luxury is a question of culture, not lifestyle,' he adds. 'It means being part of certain circles, not of certain clubs. Otherwise, you are still following others.'

'Luxury is very much about conviction,' Dr Danuser concludes towards the end of our breakfast. Minutes later, as we pass a vintage poster of St Moritz, it is harder than ever to challenge the idea.

Chapter VIII

The Pillars of Meta-luxury in Summary

In the past chapters we have looked in depth at what we have called the four pillars of meta-luxury – craftsmanship, focus, history and rarity. These pillars define the meta-luxury paradigm by driving its dynamic of offer and demand. They are the threads that run between them.

Before going any further, we feel that a recapitulation will be helpful. Let us take a step back and look briefly at the bigger picture.

Based on the notions of knowledge, purpose and timelessness, we have identified meta-luxury as the quintessential manifestation of a culture of excellence, embodied by the pursuit of unique achievement. We have subsequently explored and challenged this concept from four fundamental perspectives – How, What, When and Who.

Along each of these axes, we have sought to define the way in which unique achievement is pursued. This is how the four pillars are identified.

The first question related to the manner in which the concept of unique achievement is reflected in a certain way of doing things ('How'). We maintain that the answer is **craftsmanship**, defined as *the creation of individual objects that are unique and non-substitutable due to tangible and intangible, rational and emotional qualities deriving from the predominant use of human judgement, skills and techniques in their conception and execution.*

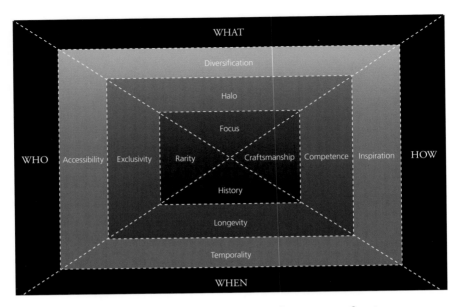

Along the 'What' axis, we have looked at the notion of unique achievement in the context of latitude, or scope. We suggest that essential to the pursuit of a unique achievement is **focus**, defined as *the deliberate limitation of scope over time to a field where proven excellence can be further pursued and an unblemished reputation protected.*

When considering the 'When' axis, we have seen unique achievement as having undying relevance over time. We have thus defined this pillar as **history**, describing it as *a sense of eternity, stemming from a brand's ability to remain constantly relevant by perpetually embodying its own past and future.*

Along the last axis, 'Who', we have assessed the notion of accessibility. We have identified **rarity** as being the natural implication of the pursuit of a unique achievement, and have defined it as the *limited accessibility imposed by intrinsic value, ultimately making demand subject to discovery and affordability, both economic and intellectual.*

A meta-luxury brand is thus defined by the *concurrence* of all four pillars – or, in other words, by the fact that it embodies a culture of excellence, from *all* perspectives. The reason for adopting a restrictive definition of meta-luxury – that is, one requiring all four pillars to be an

integral part of a brand's model – is that these pillars are not a collection of discrete principles, but different reflections of the same principle: the pursuit of unique achievement. If the latter is in place, then the pillars are the logical consequences, inspiring creation and driving demand.

The diagram opposite summarises the overall logic, including the various 'degrees' discussed in relation to each of the pillars.

A simpler way of illustrating meta-luxury as the combination of its pillars is by using the Venn diagram shown below, which is the only way of representing all the possible combinations of four sets. The added value of this graphic interpretation lies in the possibility of plotting individual brands in a specific region, based on whether they can claim one, two, three or all pillars. Brands that can be placed in the 'core' of the diagram are meta-luxury brands, inspired by, and desired because of, the four pillars.

This exercise provides an intuitive way of drawing the line between meta-luxury brands and other brands, allowing for a rationalisation of the pillars that draw each brand closer to, or more distant from, meta-luxury. Most interestingly, it is an effective way of determining why a given brand cannot be called a meta-luxury brand.

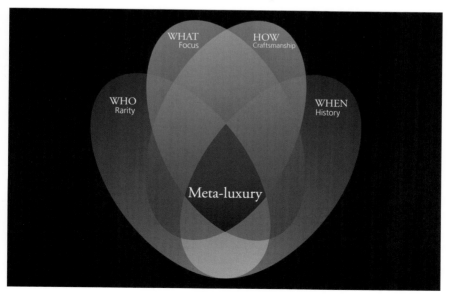

In summary, craftsmanship, focus, history and rarity are the principles that bring together the creator and the customer under the aegis of a culture of excellence.

From the brand owner's perspective, these four pillars are the consequence of the pursuit of unique achievement, as well as of the underlying concepts of knowledge, purpose and timelessness; they are, essentially, the canons guiding the creation of meta-luxury.

From the customer's perspective, they act as drivers of choice; they are what customers ultimately look for in these products and what they recognise as being truly valuable. Hence, they generate demand and desire for meta-luxury.

As we will see in the next chapter, this interaction between supply and demand has extremely fascinating, and at times paradoxical, economic implications.

Chapter IX

The Economy of Meta-luxury

We have discussed in the previous chapters the key drivers through which meta-luxury brands create demand: craftsmanship, focus, history, and rarity – the translation of the concepts of knowledge, purpose and timelessness, and the reflection of the pursuit of unique achievement. We have also looked in detail at the different degrees to which brands pursue those qualities. It is now time to look at the business and management implications of meta-luxury.

In everyday language, the notion of 'luxury industry' encompasses extremely different economic realities, ranging from global conglomerates to local workshops, from listed giants to small, family-owned businesses, from licensing operations to highly integrated manufacturers. Widely divergent business models are bundled together under this label, and meta-luxury is often one of these, regardless of its distinctive traits.

There is not only a culture of meta-luxury. There is also an economy of meta-luxury, and one reflects the other. What sets meta-luxury brands apart is not simply a set of principles, but a well defined business model.

The goal of discussing such a business model is not to prove or suggest that it is a 'better' one, but simply to outline its features. And this is better done by contrast – that is, by observing the differences between meta-luxury and the so-called premium or luxury brands.

At a first glance, there are several top-line criteria according to which meta-luxury brands generally fail to perform as well as so-

called premium or luxury brands. Seldom, for instance, do they produce larger revenues, or show higher growth rates. In many cases, they do not achieve equally high levels of profitability. So, is meta-luxury a fascinating but somewhat irrational paradigm, where some form of romantic conviction defies business common sense?

The truth is that to look at the performance metrics of meta-luxury brands through the same lens adopted for the vast majority of brands is not just misleading – it is fundamentally wrong.

There are at least seven features that define the economics of meta-luxury. They encapsulate both our observations and the content of many of our conversations. As such, they should not be taken as a finite set of discrete laws, but rather as tightly entwined economic implications of the cultural significance of unique achievement. They are the following:

1. Meta-luxury is about sustainability, not profitability.
2. Meta-luxury is based on a balance sheet approach rather than a profit and loss approach.
3. Meta-luxury brands tend to build a virtual monopoly.
4. In meta-luxury, long-term growth is provided by limitation, not expansion.
5. Meta-luxury is about effectiveness, not efficiency.
6. Meta-luxury is based on a long-term vision, not short-term opportunism.
7. Meta-luxury is focused on mitigating risk, not maximising returns.

Let us look at these features in detail.

1. Meta-luxury is about Sustainability, not Profitability

The first distinction that characterises the economics of meta-luxury brands and companies lies in its very nature. In the vast majority of businesses, the goal is completely or predominantly economic (how many times have we heard the 'creating long-term shareholder value'

mantra?). In meta-luxury, economics are a means to an end. Radical as this may seem, in meta-luxury it is never the business that drives the brand, but always the brand that drives the business. Some of the conversations reported in this book – most notably those with Paolo Fazioli of Fazioli Pianoforti and Simon Jacomet of zai – offer compelling testimonies to this principle.

Meta-luxury brands embody the pursuit of unique achievement. Both at an ownership and at a management level, the hearts and minds behind these brands are concentrated entirely on this quest, which is the exclusive reason to be part of the enterprise. All else follows, and that includes economic performance.

Of course, this does not mean that revenues, costs or profit are irrelevant. What it does mean is that they are a means, not an objective. Profit is not important *per se*, but only inasmuch as it makes the pursuit of unique achievement economically sustainable. In other words, the paradigm of meta-luxury does not revolve around the idea of profitability, but around sustainability.

This might sound philosophical or abstract. In truth, it has extremely pragmatic and down-to-earth implications. In every single decision, profit will be sacrificed for the benefit of excellence. Equipment, materials, people, processes – in the management of meta-luxury brands, the question will always be, 'What is their effect on quality and value?'; their economic impact will follow. It is not about 'How much will this cost?', but 'How will it make things better?' This criterion will endure until the erosion of profit begins endangering business continuity – and this, precisely, is what marks the threshold of sustainability, whereby demand no longer justifies, and remunerates, supply.

2. Meta-luxury is Based on a Balance Sheet Approach Rather than a Profit and Loss Approach

A fundamental difference between meta-luxury brands and other brands lies in the economic perspective adopted by the business. Although it may be a simplification of reality, there is a degree of truth

to be found in the profit and loss statement – revenues, costs and profits, and their respective evolution in time. These are the central performance indicators, which constitute the framework of multi-year business plans. As can be seen, these are flow measures that refer to a specific year in a firm's existence.

Profit and loss items are fundamental requisites for the operation of any firm; they record its natural activity. However, meta-luxury brand management revolves around a logic that is typical of a different financial statement – the firm's balance sheet, and specifically its fixed assets segment, populated by resources that benefit the company's operations over more than one year. Meta-luxury revolves around the construction and nurturing of an asset that can liberate substantial value over time. That asset is the brand.

In meta-luxury, the brand is the nucleus of the company. It translates knowledge, purpose and timelessness into a proposition that satisfies four specific drivers of demand – craftsmanship, focus, history and rarity. In doing so, the brand reduces the offer's potential substitutability through uniqueness, creating and securing demand, and ultimately generating revenues and profit.

It should be clear that this is not a question of profit and loss *versus* balance sheet accounting, but simply a question of priority within the owners' and management's mindset. In meta-luxury, revenues and profit are the consequence of a powerful asset, whose health and protection is vital. The strength of the brand asset drives profit. It is a radically different approach from that of global financial markets, where the priority is placed on revenues and profit – sometimes, in fact, to such an extent that the asset is endangered or damaged as a result of chasing immediate performance.

3. Meta-luxury Brands Tend to Build a Virtual Monopoly

Because it is inextricably linked to the culture and the creation of excellence, the business model of meta-luxury has positive competitive implications.

Of course, the entire notion of branding is centred on the *reduction* of substitutability by available alternatives and the consequent higher competitive potential. However, what distinguishes meta-luxury brands is their tendency to *eliminate* substitutability, thus creating what can be defined as a virtual monopoly.[i]

The reason for this stems from the nature of the drivers through which meta-luxury brands generate demand. There is one feature that is common to each of them, and it is the ability to create an *inimitable* offering – one that is not seen as being substitutable by alternatives in the marketplace.[ii]

A company's or a brand's history is by nature unique. If it is successfully employed as a key driver of choice, then the brand's power to attract and secure demand rests on an element that cannot be replicated or changed.

Consider craftsmanship. Competing on this driver means relying on a wealth of expertise that is impossible, or at least extremely difficult, to replicate. In turn, the value that customers attribute to that brand's offering is largely dependent on a set of skills that are unlikely to be identical to those possessed by a competing organisation or individual.

Focus is, of course, imitable if interpreted as a mere scope of activities or categories. However, if considered in the wider sense explained in Chapter V, and hence as a driver of choice, it ensures that the brand will operate on a turf where it is less likely to face rivals.

Within the remit of rarity, a brand whose offering has limited availability is of course a less imitable brand. The ultimate here is the unique, singular piece.

The combination of four drivers that are each individually hard to challenge necessarily creates a formidable competitive barrier. If choice of a brand is driven primarily by its craftsmanship, focus, history and rarity, it is fair to say that no competitor will be a substitute, but at best a distant proxy.

In conclusion, while the business model of meta-luxury is typically characterised by a relatively small demand potential, it is also based

on a lower, or non-existing, degree of direct competition. Rather than competitive arenas including several brands, what can be observed are individual brands building their own exclusive arenas.

Over the years, Armani has adopted a strategy that has seen its extension into new territories. This extraordinary brand has both gone for considerable diversification – an example being Armani Casa, the highly successful furniture and interior design venture – and targeted entirely different audiences, creating a host of different sub-brands, from the tailored offering of Armani Privé to the denim of Armani Jeans. As a result, the brand has been stretched beyond what could be defined as its original focus. It has also sacrificed rarity, the Armani name now being prominent on products owned and sported by a vast number of heterogeneous customers.

This strategy has allowed the company to be hugely successful and the brand to be consistently among the most valuable global brands.[iii] Yet, it has steered Armani away from meta-luxury, towards the adoption of a different model, based on far larger numbers but also, potentially, on a higher degree of substitutability.

Arguably, what drives the demand for Armani products may no longer be found in the recognition of a unique achievement, in the value of craftsmanship, in consistently focused skills, in history or rarity, but rather in the aesthetics of individual collections, as well as other more imitable associations the brand elicits – Italianness, 'exclusivity', and so on. Such drivers might tend to make the brand more easily substitutable by competing fashion brands. The idea of a virtual monopoly has been traded successfully for otherwise unreachable growth rates.

4. In Meta-luxury, Long-term Growth is Provided by Limitation, not Expansion

The choice to generate demand through the four drivers of meta-luxury – craftsmanship, focus, history and rarity – produces an intriguing contradiction.

From a creative and production perspective, meta-luxury represents a commitment to excellence, and therefore a constant quest for pushing *beyond* limitations. However, from an economic perspective, this paradigm also implies a self-imposed restraint.

If looked at from a purely economic perspective, each of the four drivers of meta-luxury represents, interestingly, a deliberate limitation. Craftsmanship, in the sense described earlier, inevitably tends to reduce productivity and output volume. *Ceteris paribus*, it means producing less, and/or less cheaply.

Rarity is, to this extent, self-explanatory. It implies accepting to sell less as a means to preserve both the qualitative integrity and the brand's desirability to customers seeking an individually meaningful product.

Focus is, essentially, about doing fewer things. It is a more or less severe limitation in scope, and a barrier to potentially rewarding diversification policies – a restraint that is accepted and endorsed in the name of the belief in excellence as the result of a well defined endeavour.

Finally, history, while being a uniquely powerful (and powerfully unique) asset, is also a limiting condition. It inevitably influences decisions, reducing freedom of choice. A brand's past, if recognised as a driver of demand, provides guidance – but also guidelines.

Ultimately, from a purely economic standpoint, competing on the basis of these drivers means giving up growth opportunities. This sounds counter-intuitive and even penalising. So why should a company opt for this paradigm?

A first answer lies in the fact that meta-luxury is founded on a culture of excellence, which is, in turn, driven by qualitative achievements, and not by their economic outcomes. This is a reflection of what was discussed earlier – these companies seek sustainability, not maximised profitability.

Second, the limitations imposed by craftsmanship, focus, history and rarity are only such in the short run. In the long term, they are the very essence of these brands, and their engine of growth. It is only by accepting such limitations in the short term that these companies ensure the continuity of their brands' power to create a virtual monopoly, often continuing to generate demand across generations. Meta-luxury is, from an economic standpoint, a game of patience, discipline and modesty. Incidentally, this is the reason why it is always tempting to abandon this paradigm – and extremely difficult to reverse that step.

5. Meta-luxury is about Effectiveness, not Efficiency

In the vast majority of industries and categories, the dominant economic criterion is *efficiency*, that is, the attainment of maximum productivity with the minimum use of resources. Typically, efficiency is achieved through product standardisation, process streamlining, synergies between categories, and so forth. Efficiency is input-driven, whereby the quality and the properties (that is, the value proposition) of the output are adapted to allow for a given level of production cost. In this equation, required resources act as the independent variable – and quality is a function.

The paradigm of meta-luxury revolves around a different economic criterion – *effectiveness*, that is, the attainment of a certain result. Effectiveness is output-driven; the quality and the properties of the output steer resource requirements. In this equation, quality is the independent variable, and required resources are a function of this.

What this means in concise terms is that meta-luxury is never about trying to achieve more with less, but about trying to achieve the absolute best, whatever that may take. The implications of this simple innovation principle reach across every single operational aspect of the company – from design to production, from supply chain to distribution.

This does not mean that efficiency is something that meta-luxury companies refuse to pursue. What it does mean is that an increase in efficiency should never correspond to a decrease in quality. In essence, efficiency follows effectiveness.

This idea is also a reflection of the concept of limitation that was discussed above. Competing on craftsmanship, focus, history and rarity, in many cases, does not allow for production efficiency, flexibility, synergies, economies of scale and so on. It does, however, tend to create a virtual monopoly, which generates sufficient margins to cover the efficiency shortfall.

6. Meta-luxury is Based on a Long-term Vision, not Short-term Opportunism

A different way of looking at the same difference in approach is through the lens of time and outlook.[iv] Adopting a balance sheet approach as opposed to a profit and loss perspective is equivalent to focusing on a long-term rather than a short-term view. It is about measuring performance across decades rather than quarters. It is about concentrating on the prosperity and value generation capability of an asset over time rather than on the creation of economic flows that refer to a single year – never mind a single quarter. It is, finally, about pursuing achievements that can defy, and not be driven by, the passing of time. Success for these companies is not necessarily measured in percentages, nor in short-term gains.

It is not by coincidence that meta-luxury is definitely more compatible with, and more frequent within, private, or family, ownership – often reaching back for centuries – than with an ownership that can change in a matter of days on the capital markets.

These two models adopt very different scales when looking at time – the former reasoning in terms of generations, the latter, often, in terms of months.

7. Meta-luxury is Focused on Mitigating Risk, not Maximising Returns

Brands create economic value not just through the generation of greater margins, but, first and foremost, by acting as powerful risk mitigators. Operating under the aegis of a strong brand means relying on a higher degree of continuity in demand and, therefore, reducing the company's risk profile. This is the fundamental economic function of branding, no matter what the specific business model or positioning may be.

To this extent, brand value management itself may be seen as a chain of choices between different combinations of risk and returns.

Take, for instance, the evaluation of a brand extension opportunity in a completely different category. The many questions that come with this decision can be summarised as whether or not to accept a higher degree of risk vis-à-vis the higher expected returns. *Ceteris paribus*, choosing not to extend means avoiding a higher risk of diluting the brand's focus, but also giving up the pursuit of higher returns. On the contrary, opting for an extension means deciding to seek higher returns whilst accepting a higher risk due to the brand's potential loss of focus.

'Democratisation' processes, such as a decrease in the entry price of a sought-after brand, or the creation of affordable lines, can also be seen as a risk–returns trade-off. Expanding a brand's customer base may ultimately have considerable positive business impacts. Yet, it will clearly tend to dilute the brand's rarity and, therefore, its desirability to a certain audience. Somewhere along the curve is an ideal point of optimum, which is where the right – or desired – balance between returns and risk is struck.

The paradigm of meta-luxury is based on the relentless prioritisation of risk mitigation over return maximisation. This approach is the natural consequence of a long-term asset preservation perspective. Because what these brands can lose is much greater than what they

can gain, their owners will constantly tend to avoid pursuing quick wins that can endanger the brand's long-term prosperity.

In meta-luxury, economic returns and growth are not measures of success, but a means to sustain the pursuit of an achievement. Hence, no risk will be taken in order to accelerate that pursuit. Meta-luxury brands build their long-term success on a commitment to excellence – and therefore on drivers of demand that inevitably translate into short-term economic limitations.

Risk mitigation, however, should not be mistaken for stasis. Meta-luxury brands are soundly based on a culture of constant improvement and bold innovation. Reducing risk is simply about not compromising on that culture.

Two Philosophies?

The financial tug-of-war between Hermès and LVMH (the Louis Vuitton Moët Hennessy group) in late 2010 is a quasi-perfect depiction of the opposition between the two radically different brand management approaches. Of course, this is not an attempt at pigeonholing either group into one paradigm or another. Simply, it is an exercise in reading some of the respective public announcements through the lens of meta-luxury.

In late 2010, LVMH, which possesses over '60 prestigious brands' in different sectors and with aggregate revenues of over €20 billion in 2010, bought a 17.1 per cent stake in Hermès, a family-controlled company since its foundation in 1837, with revenues of approximately €2.4 billion in 2010. The reported reactions by Hermès to this hostile bid are revelatory, and capture in a compelling, real-life manner many of the notions highlighted above.

There is a part of our world that is playing on abundance, on glitz and glamour, and there is another part that is concentrated on refinement, and basically making beautiful objects. [...] We don't want to be a part of this financial world which is ruining companies and dealing with people as if they

were goods or raw materials. It's not a financial fight, because we would lose that. It's a cultural fight. (Patrick Thomas, Hermès Chief Executive)

If you tell me I have to double the profit of Hermès, I will do it tomorrow. But then you'd have no Hermès left in five years. (Patrick Thomas, Hermès Chief Executive)

Axel Dumas, a sixth-generation director of Hermès, said that his family would never sell. All the family can do, he said, is stand firm in what its members see as a battle for the very soul of Hermès. 'If it doesn't destroy us,' Dumas said, 'it will make us stronger.'[v]

A widely quoted interview with Patrick Thomas and Bertrand Puech (a fifth-generation director of Hermès) published by *Le Figaro*,[vi] included the following observations:

We're artisans; our goal is to make the best products in the world. We're not in luxury, we're in quality. (Bertrand Puech)

This culture is hardly compatible with the culture of a large group. (Patrick Thomas)

Bernard Arnault, President of the LVMH group, replied afterwards:

On the contrary, our cultures are, I believe, quite near. The LVMH group is the world's first manufacturer of extra-high-quality products. The Vuitton trunks, Dior's haute couture, Dom Pérignon, Chateau d'Yquem, among other examples, yield nothing to the magnificent Hermès saddles. We do possess a craftsmanship culture within the LVMH group. And, like Hermès, LVMH is a family group. I am convinced that as shareholders we can bring a certain number of advantages to Hermès.[vii]

It is interesting to see the dramatic cultural conflict between two companies that otherwise share several traits. Both quoted on the stock market, both French, they compete in their core category, leather goods, and are generally defined as being global luxury brands. Interestingly, the statements by Hermès' directors are not about a difference in the businesses or the products themselves, but in the businesses' philosophies.

Of course, each of these statements may or may not be agreed with; and they may or may not be taken at face value. In any case, they provide an interesting picture of the apparently divergent perspectives of an allegedly shorter-term, profit and loss-driven strategy and a declared long-term, asset-driven approach.

Managing Meta-luxury

Looking at meta-luxury from an economic perspective – and, specifically, from a risk management standpoint – provides interesting and actionable insights. Linking the four drivers – craftsmanship, focus, history and rarity – with risk means creating a brand management framework for the sustainable development of meta-luxury brands.

As we have seen, these four drivers represent the translation of the concepts of knowledge, purpose and timelessness into what drives choice and engenders loyalty. They are at the heart of the value-generation process of meta-luxury brands. In the following pages, we look at how craftsmanship, focus, history and rarity can guide brand management for risk mitigation and business performance.

As we will see, this is about the careful orchestration of facts and perceptions across every single one of the brand's touchpoints. Before going into greater detail, it is essential to note that the distinction between facts and perceptions is not in any way equivalent to the difference between what is true and what is not true, but rather between objective reality and a unique and compelling representation of it. A brand – any brand – is as strong as its ability to condense information into a compelling point of view. By doing this, it simplifies understanding and attracts preference.

History

The longevity of a brand is an objective datum. It is an invaluable asset, as it cannot be achieved other than through the passing of time, the one dimension that defies human control.

There are, however, other facets to the driver of history beyond the mere, and unchangeable, date of foundation. From a brand management perspective, there is a difference between the simple fact of having a history and the ability to transform that history into a driver of demand. Being old is a fact. Being historical is a status.

On the surface, it would be tempting to reduce the entire premise of meta-luxury to the notion of making history an integral part of the brand's messaging. There are many cases in which a brand's long existence and track record are simply not communicated, nor honoured. Several brands, at different points in time, have sought to do this in a variety of ways. Often, this takes the form of the revival of a vintage product or the rediscovery of the brand's origins. In other circumstances, it is marked by the celebration of an anniversary. In yet other cases, the addition of the 'Since …' tagline or the presence of an 'Our History' section on a corporate website are expected to be sufficient.

We challenge the effectiveness of this kind of approach – or, rather, their consistency with meta-luxury. In meta-luxury, transforming history into a driver of demand is not just a question of communication. It is to be seen in the light of knowledge, purpose and timelessness.

As far as *knowledge* is concerned, it should be asked: to what extent does the brand's history converge into a unique and unparalleled knowledge, experience and *savoir-faire*? In what terms are those skills unique and not replaceable or replicable? Even more importantly, are they an integral and authentic part and necessary condition of what is being created today?

Moving on to *purpose*, to what extent has the brand's history followed a clear path and ambition, and been the fulfilment of the founder's vision? To what extent are the contemporary principles that inspire the brand a loyal translation of the philosophy from which it originated? Is it a history with a meaning, or merely a succession of events?

And, last, has the company produced milestones that have stood the test of time, placing the brand in the realm of *timelessness*? Does the brand represent a thread that connects the customer and devotee with a time far from his own?

Through these questions, we wish to underline that what characterises meta-luxury is not the claim to a history but the ability to perpetuate it and keep it relevant. In meta-luxury history is not necessarily communicated but is left to be discovered and passed on from individual to individual in very much the way the tales of old used to circulate. It is not about the artificial transfer of cleverly copywritten information, but the spontaneous diffusion of a mystique. It is not about the mere presentation of a feast, but the creation of an appetite.

It may appear to be a paradox, but the digital revolution of the past two decades has generated substantial opportunities for brands seeking to transform their history into a driver of demand. The successful development of networks of enthusiastic storytellers enables these brands to let individuals be the ones to relay, diffuse and discuss their history with far greater conviction and impact than any traditional campaign could have.

Ultimately, transforming history into a driver of demand means breathing a meaningful past into the present, across all that is done and said. The understanding of a brand's history should be the result of a pursuit on the part of the connoisseur wanting to know more. And that, in turn, can only be the result of a form of seduction that comes from the object or work itself. Only when objects, places and people effortlessly exude the wealth of time is a uniqueness that can drive demand and desire created – and, ultimately, risk reduced. At that point, it is hard to distinguish whether the brand is selling products with a history, or, rather, selling a history that manifests itself through products.

When this is accomplished, the brand's history reduces risk by creating a near to invulnerable competitive barrier, ultimately transforming time into a crucial asset.

Craftsmanship

The concept of craftsmanship should not be taken in the literal sense of the term. It rather refers to two things: on the one hand, to the infusion of unique personal competences and passion into the creation of items; on the other, to these items not being the result of a standardised production, but of an authentic labour of love and judgement.

There are many brands that profusely use terms such as 'craftsmanship', 'craftsmen' or 'handcrafted' when describing themselves and their products. We believe that in order to become a true differentiator, the notion of craftsmanship should go deeper in terms of both its meaning and its results.

Again, reverting to the knowledge, purpose and timelessness paradigm is a good way to distinguish the extent to which craftsmanship can become a driver of demand and therefore have an impact on business performance.

First and foremost, does the act of creation derive from unique *knowledge* – from a unique set of competences and skills? Are the latter defendable over time? Craftsmanship without these is of little value, as it makes the creator fundamentally indifferent to the result of the act of creation.

Second, does this way of producing things improve the object's performance (i.e., better fulfil its *purpose*)? Is the process continuously improved upon to achieve new levels of excellence and preserve competence dominance?

Finally, is the form of craftsmanship able to create a result that stands the test of *time*? Does it represent a heritage that has persisted through generations and can be passed on to the next? Is it the endlessly evolving result of a recognisable 'school'?

It is by doing and communicating these things that craftsmanship transcends the concept of mere production process to acquire the status of a form of uniqueness. A careful engineering of the whole

experience chain – from corporate to product communication and on through the retail experience and the ancillary services – can steer the products' perceived worth, and establish or consolidate the brand's reputation as a meta-luxury brand.

To this day, for instance, every single AMG engine has borne the signature of the individual craftsman who has been in charge of its construction. That signature establishes a direct and explicit link between a rare object and a single master of skills. This makes AMG an excellent example of the transformation of a way of doing things into a reason to desire them. There is no doubt that at AMG craftsmanship embodies knowledge, as it replaces the fragmented manual intervention required at a typical automated production chain with one single multidisciplinary, all-encompassing endeavour – an endeavour that is undertaken with the clear purpose of creating an engine that is not a collection of assembled parts, but a vital, functioning organism. Finally, it is about the creation of a single piece that will stand in time and will never be substitutable.

Ultimately, meta-luxury is not based on craftsmanship as a choice, but as an inescapable prerequisite. The preservation of craftsmanship ensures the unsubstitutability of the brand by customers and its irreplicability by competitors. In this way, a virtual monopoly is created, and risk is reduced through the protection of demand continuity.

Rarity

Value comes only with rarity.

As we have seen, the concept of rarity should not be mistaken for a simple question of price. We reject the idea that high prices define meta-luxury (or even luxury, for that matter). Unjustified high prices designed to create an artificial exclusivity, have nothing to do with the principles of knowledge, purpose and timelessness.

Rather, we believe that, as a model, meta-luxury is sustainable only through prices that can be defined as being comparatively high. This, in turn, is due to the need to support the model's cornerstones and, specifically, the dominance of effectiveness over efficiency.

Remunerating the operating and capital costs of excellence is likely to require a more ambitious pricing policy: focus, craftsmanship and history come at a cost.

In other words, in meta-luxury it is not prices that drive rarity, but exactly the opposite. This is a corollary to the idea that in meta-luxury profits are a means to make the pursuit of excellence sustainable over time.

Rarity, therefore, is not merely a matter of pricing. It is a much wider brand management question, which again stems from the very roots of meta-luxury – knowledge, purpose and timelessness.

When it comes to *knowledge*, the question is about the extent to which rarity is connected to the time consumption and economic constraints deriving from the need to inject knowledge into the conception and creation process. Also, are prominence of the human component and devotion to excellence the main drivers of the limitation in availability?

In terms of *purpose*, is rarity the inevitable consequence of the pursuit of excellence, for instance due to the use of materials and processes that deliver the pinnacle of performance across different criteria?

Is rarity, finally, consistent with the intention to produce a *timeless* achievement – the result of the creation of unique items, which will stand in time as achievements that will never be replicated?

It is affirmative answers to questions like these that are intrinsic to meta-luxury brands, and that mitigate business risk by reducing numbers to sustainable levels.

Interestingly, certain brands – Ferrari, for instance – are consistently praised for showing the wisdom to limit their production despite a level of demand that would support a higher, short-term business performance. That is certainly a bold and sensible decision. We wish to underline, however, that in meta-luxury rarity is never meant as an artificial demand-creating parameter, but as a *de facto* protection of the

integrity of the supply chain, in the widest possible sense of the latter.

Take Hermès again as an example:

Because handstitched perfection cannot be rushed, royal coronations were sometimes delayed until Hermès fittings for the carriage and the guard had arrived. In this century, the waitlist for items such as the hot-and-heavy Birkin, a handbag created in 1984 for the actress Jane Birkin, can stretch to five years. One Birkin takes 18 to 25 hours to make, and the Paris workrooms produce only five or so each week; these supply Hermès stores worldwide.[viii]

Rarity, therefore, is tightly linked to the reduction of business risk in two related ways. In the first place, it reflects, and is vital to, the full control of the ultimate delivery: uncompromising excellence. Secondly, and as a consequence of such control, the brand cultivates that degree of desirability that can come only through a limitation of availability that is genuinely born of its commitment to mastery.

Focus

As we have seen, focus embodies the quest for depth rather than breadth, driving the pursuit of excellence.

Meta-luxury brands always find their roots in an original superlative skill at something in particular, and very often this specialisation remains the keystone of business success over time. In other cases, however, the initial focus may open up to a greater latitude in time. The latter is the story of many of the great global luxury brands, which today no longer stand for a specific *métier*, but rather as generalist 'lifestyle' signatures. In many cases, the historical origins of some of these so-called icons are unknown to their very aficionados. This means that focus – on being the absolute best at something specific – is no longer a driver of demand for customers, the valuing of excellence typically having been replaced by the more superficial appropriation of a status and/or by the more general appreciation of a style.

In the wake of the 2008–9 crisis, many groups and companies have resorted to investing in campaigns that clarify where their brand

comes from and what it stands for today, reclaiming the *savoir-faire* beneath the surface style.

Focus is not necessarily a value *per se*; it must be intertwined with, and constitute the celebration of, the notions of knowledge, purpose and timelessness. That is when it becomes a risk mitigation choice, and, for the customer, a reason to choose that brand.

Typically, focus is understood as being revelatory of proficiency, on the basis of the assumption that specialisation is more likely to generate excellence. Especially where trust in technical quality is concerned, concentration on a well defined range of products is usually perceived as being an element of superiority. This is why a brand's proven excellence over time is a strong but fairly rigid support – one that can be broken much more easily than it can be bent. Weakening it through an inattentive extension policy is possibly the greatest risk that can be taken.

On the other hand, focus should not be seen as a limiting, static or conservative idea. In the first place, from a latitude perspective, focus may be relative to a specific set of competences that, nevertheless, create a consistently excellent range of products. Second, from a chronological point of view, focus has nothing to do with a brand doing what it has always been doing: brands are living business assets, which must evolve over time, embracing and driving change.

Therefore, from a brand management perspective, averting risk through focus is neither about relentlessly clinging to certain product categories – which is, of course, a challenge in terms of risk diversification – nor thoughtlessly embarking on initiatives that may damage the brand's significance as a unique achievement.

It is rather a matter of evolving the brand's proposition in a way that perpetuates its DNA, making the brand relevant and sustainable through change.

This can happen through a continued and careful assessment of (a) the competences (knowledge) and (b) the vision (purpose) that can yield (c) meaningful accomplishments (timelessness) – a delicate three-

way balance of conditions that are not individually sufficient but must concur, and can be summarised through the following questions:

First and foremost, can the brand's focus be evolved in a way that reflects and builds upon the knowledge and skills that have made the brand successful in the first place? Can the brand's latitude be widened without compromise, replicating and extending the brand's unique mastery without diluting it?

To what extent does the evolution in the brand's focus manifest the organisation's intimate conviction as to the high sense of *purpose* of its original specialisation? Does the new focus reinforce and provide a new edge to that sense of purpose?

Finally, is the evolved focus likely to generate new *timeless* achievements?

Universally admired for having created unforgettable pieces of jewellery inspired by Roman and Greek Classicism, Bulgari progressively extended its focus to watchmaking, with increasing conviction, despite the fierce competition of established and much celebrated brands. Rather than doing this through the typical licensing operation, it did so in-house. A fully fledged Swiss watchmaking operation was created in 1982, and a number of Swiss companies were acquired – an ambitious combination of the celebrated artistry of the original Italian group and the newly acquired technical proficiency that aimed at transposing the idea of 'contemporary Italian jewellers' into new territory.

This is a stirring example of risk minimisation through a careful, well pondered expansion of the brand's focus; of evolution attained by avoiding an overall dilution of skills (knowledge) and by preserving consistency with the brand's overarching vision (purpose), thus building the best possible platform for the creation of unique achievements in a new category.

Ultimately, managing risk in meta-luxury through the driver of focus means carefully marking the future path of the brand – keeping it at once relevant to the times and consistent with the original brand DNA.

Conclusions

Meta-luxury is a model based on the long-term preservation and development of an asset – the brand. From a financial perspective, this implies that the net present value of the future earnings to be created by such asset is determined by risk reduction much more than it is influenced by a steep growth in returns.

From a brand management perspective, this means that, in the ongoing succession of decisions relating to a meta-luxury brand, the question should never be 'Why not?' but always 'Why?' – a question that reflects the way of thinking of customers and should endlessly echo within the organisation.

This approach can be looked at in more operational and concrete terms – and we have done so through the lens of the very essence of meta-luxury, by looking at craftsmanship, focus, history and rarity in the light of the defining principles of knowledge, purpose and timelessness.

The resulting matrix provides a general mind map that helps define priorities in brand management (see opposite). Ensuring that the questions included in this matrix find convincingly affirmative answers requires a thorough and perpetual analysis and steering of all of the brand's touchpoints, including products and services, communication, people and behaviours, environments and channels. Managing the entire experience means fighting a battle of facts and perceptions – the latter reinforcing, but never replacing, the former.

[i] This term and the related considerations were partly inspired by conversations with Mr Nik Stucky.
[ii] We are not referring to the possibility of counterfeiting, but to competitors' ability to offer a clearly distinct, but convincing, alternative.
[iii] Interbrand Best Global Brands 2011.
[iv] These considerations are partly inspired by the *Leading Luxury Brands* study, published by Interbrand in 2008.
[v] Liz Alderman, *The New York Times*, 5 March 2011.
[vi, vii] Florentin Collomp, *Le Figaro*, 2 November 2011.
[viii] 'From Hermès to Eternity,' Laura Jacobs, *Vanity Fair*, September 2007.

	Knowledge	Purpose	Timelessness
History	1. Does the brand's history converge into unique and unparalleled competence and experience that are still relevant today? 2. Are those skills unique and not replaceable or replicable? 3. Are they an integral part and necessary condition of what is being created today?	1. Has the brand's history followed a clear vision and ambition? 2. Are the contemporary principles that inspire the brand consistent with the philosophy that originated it? 3. Is it a history with a meaning, or merely a succession of events?	1. Has the company's history produced milestones? 2. Does the brand successfully connect the customer with times far from his/her own? 3. Is the pursuit of timeless achievements still at the heart of the brand?
Craftsmanship	1. Does the creation derive from a unique set of skills? 2. Are these skills defendable over time? 3. Is their impact understood and testable by the customer?	1. Does the process/way of doing things produce a true difference in performance? 2. Is the process continuously improved upon from a qualitative point of view? 3. Is output quality still dominant over efficiency of the process?	1. Does the craftsmanship create a result that stands the test of time? 2. Does it represent a heritage? 3. Is it the result of a recognisable 'school'?
Rarity	1. Does rarity derive from the time/resources absorbed by the creation/production process? 2. Is rarity due to a cultural selection of potential customers? 3. Is the proficiency in the brand's field rare, or are there comparable competitors?	1. Is rarity determined by the pursuit of excellence? 2. Does rarity contribute to driving desire and demand? 3. Does the brand's communication policy leave space for discovery?	1. Is rarity consistent with the intention to produce a timeless achievement? 2. Is rarity the result of the creation of unique items? 3. Are existing products sought-after pieces?
Focus	1. Is the brand's focus defined or definable in a way that allows for, and justifies, an evolution over time? 2. Is there a core of competences ('how') that are evident beyond the offer ('what')? 3. Is the brand consistently investing in innovation with regard to its area of excellence?	1. Is the brand's focus clear within and outside the organisation? 2. Is it linked to a higher sense of purpose? 3. Is being highly specialised regarded as a driver of choice with regard to this produce or service category?	1. Are the brand's past achievements consistent with a specific focus? 2. Can the brand's focus be broadened in directions where the original threshold of excellence will be equalled? 3. Will the brand's focus still be relevant over time?

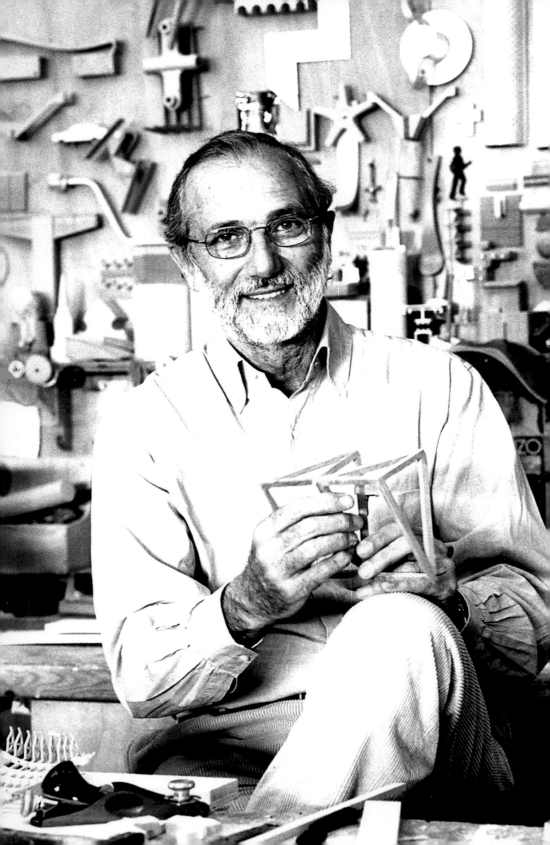

Renzo Piano was born in 1937 into a family of builders, in Genoa — a historic port city and a family profession, with both of which he developed strong attachments. While studying at the Politecnico di Milano, he worked in the office of Franco Albini. After graduating in 1964, he began to experiment with light, mobile temporary structures. Over the next five years, he travelled extensively, discovering much about Great Britain and the United States. It was in London, in 1971, that he set up the Piano & Rogers office with Richard Rogers, with whom he won the competition to design the Centre Pompidou. From there he moved to Paris, where, between the early 1970s and the 1990s, he worked with the engineer Peter Rice, sharing the Atelier Piano & Rice from 1977 to 1981. In 1981 the Renzo Piano Building Workshop was established, with 150 staff and

RPBW. A simple set of initials at the entrance to a building in he Marais, a stone's throw from the Centre Pompidou, is a discreet irection to the archway behind whose doors an arresting array of rchitectural dreams is in constant development. A hallowed hush of lent industry envelops us, as we walk into a light-filled atrium. We re in the beating heart of the Renzo Piano Building Workshop.

We meet in a glass-encased pavilion, dotted with small trees. Our backdrop is a wall of words, books and journals in pristine rrangement, from floor to ceiling. The concept of excellence opens conversation in which Renzo Piano pauses for a moment before he hrases, in almost musical intonation, four words.

'"*Luxe, calme et volupté*". These are the words of Baudelaire.[i] hey are also visualised by Matisse. "*Luxe, calme et volupté*" – they o well together. "*Calme*" we understand. "*Luxe*" is more difficult, :cause people think about luxury, money and power. But "*volupté*" what we are talking about. It's the way in which we make mething. For me, it's a feeling of lightness. And when we talk out this sense of lightness, music is perhaps the best example. Art about emotion and *every* art is about emotion. Yet music is the ost sublime. Music is light by nature.'

Music occurs and recurs, throughout our conversation, in constant

at the visible part of the iceberg. It's much more profound than that. It's beyond what you see. What is not understood is that the connection is below the surface.'

We ask whether it is the same difference that exists between luxury and excellence.

'In architecture we can talk about the measurable and the immeasurable,' Piano explains. There are things you can measure, and that is why I literally go around with this' – a tape measure emerges from a pocket. 'This is one metre, two feet, and so on. Then suddenly something different sets in. It's about light, emotion, rhythm – and even hierarchy. As in music, in architecture there's a main structure, then the secondary structure, the surface, the texture, and so on. But the good things are the things you don't measure. Music and architecture share this common need of mathematical precision. But it is inside that necessity that you build your freedom.

'When you are in the abstract world of beauty, of the sublime, you enter the world of the immeasurable. These are things you cannot measure. As a sculptor, poet, writer, artist, architect, certainly as a musician, you have this notion of beauty. Yet, it's something you never reach. Your arms are too short.' He reaches up with his arms and his eyes smile with knowingness. 'Beauty is a kind of constant desire. In some ways, it's difficult to talk about, because it is so unreachable.

'It's easier to talk about beauty as an architect if you look at it in the [Ancient] Greek way, where beauty is about ethics, where beauty and good go hand in hand. Beauty was both an aesthetic and an ethical commitment. And this is not just true of Greece, it is also the case in Africa. In Africa the word "beauty" doesn't exist alone. Beauty only exists in the context of good. But if we only look at beauty in this way, then, of course, we are missing *volupté*.

'It's one of those things that you don't even talk about,' he reflects. 'It's almost private. It's between you and yourself. As a musician, it's between you and your instrument. For me, my Stradivarius is my pen. I would give everything up, but I would never give up my pen.' A white pen appears in his hand, as if from nowhere – almost as if this inanimate object were an extension of himself. 'What you are looking for is that sense of the unreachable. This is what drives you. What you have not yet reached. There is always something missing.

'That is exactly why luxury in the real sense is hidden. It's very well hidden. You have to struggle before you get it. It's about reality and substance – and I highlight the *sub*-stance. It's not so easy to explain. It's the same for people – you can clearly see there's nothing under the surface of certain people. And it's not a matter of education. My mother used to say, "Don't go with that child, because he's superficial." She didn't say that that boy was bad or good, but that he was superficial. At the time, of course, I didn't understand.

'The term luxury, in a way, has been stolen. Even the word "brand" itself. Today it's almost looking, not being. It's very subtle, and it's difficult to express that subtlety. Perhaps we really have to go back to Baudelaire, and that should be the title of this book,' he suggests with a smile.

We ask about Piano's father, who was a builder – and the relationship between building and architecture. 'It's a complex issue. Legacy is about childhood. Somebody said that by the time you are ten years old, you have already absorbed the essence of your life, and you should spend the rest of your life digging in the quarry that is your childhood. It's there that you collect certain things that then stay with you, and that are essential. For me, there were three important things. First, the sea. Growing up by the sea in Genoa, I had this funny feeling that there was always something that must be happening on the other side of the sea. Again, it's not something obvious, but subconscious – this made the sea a kind of canvas,

something on which you feel you have to make your mark one day or another.

'Another thing, for me, was the harbour of Genoa,' he remembers with great affection. 'The harbour is a magnificent place. Fantastic. My father used to take me there most Sundays – it was always a discovery. The harbour is like a city, where everything moves and floats. Nothing is on ground. It's like fighting gravity, the same as in architecture.

'The third thing was my father, and his work. It was about building. Modest buildings, but even so they were, and still are, miracles in their own right. I grew up with this consciousness. One day it's simply sand. Days later it's standing there solid. Like most Genoese, my father was a silent character. A man of few words. The first time I showed my father some of my work, it took me all day to explain it to him and to show what I had done and why. I then asked him, "What do you think of it?". All he answered with was a dubitative monosyllable,' he laughs. 'We loved each other, of course. What I wanted to do was to make this miracle happen. I didn't want to be an architect originally – I wanted to be a builder myself. Then a number of things happened.

'But perhaps the greatest thing I learned from my father was the sense and the value of a job well done. The idea of putting the right number of hours into what you do to make sure it's well done. It's something you learn. It gets under your skin, it becomes like a capital. And then, from time to time you'll go back and scratch your skin', he gestures, 'or look in your pocket and return to it at different stages of your life. This is something which is fundamentally done by being again a child and remaining humble enough to go back to all that and never betray it.'

For Piano, there is a deep-rooted and innate sense of inspiration. One that has endured since childhood, quests and visions fostered from an early age. 'Dreams, the sea, the desire to be far away, the

harbour, the floating, the miracle of building, the love of a job well done – all of these were my inspirations. It's these things that stay with you. But you need to come of age to realise it. It's like roots. Nobody really understands what roots are, until at a certain point in life you start to realise they are there. You draw from them, although you don't know it. It is the kind of thing upon which you could potentially build a castle of rhetoric – the most terrible rhetoric, actually – origins, roots – it can really become awfully boring! But in fact, even if you don't know your roots are there, they are – and you grab something from them. And as you come of age, you slowly discover and understand them.

'I discovered this, myself, 25 years ago, when a friend came to see me. He told me, "You know, the Centre Pompidou is really a ship." I had always thought of it as a metaphor for a spaceship. But he said, "No, it's a ship. Look at it!" In a parallel way, Richard [Rogers] brought to the building the imagination of the free-thinking London of the late 60s. I realised this friend was probably right in some way. When you do it, you don't think about the ship, and the harbour and Genoa. But there's something inside, an aesthetic origin, a visual capital you have inside. And it's not bad for you not to know and not to talk about it, because otherwise you start building a lot of rhetoric. It's good to gradually start to find out at a certain age. Childhood is visually important – the images you have inside – and it's morally important too.'

This sense of roots is important to the cultures that Piano connects with from one building to the next. He points to a photograph on the wall – of a building that he created in the Pacific Ocean that literally sings. It is the Jean-Marie Tjibaou Cultural Centre, devoted to the Kanak culture. 'The structure is built entirely of wood and was designed so that when the wind blows through, the buildings resonate. It's not my idea, though,' he is keen to observe. 'In this culture, they use sound as part of their identity. As an architect you are also an anthropologist.'

We ask what true 'luxury' is for him personally. He tells us about
a new project he is working on for the new university of Amiens
– the citadel. 'I was talking to the mayor not so long ago, and I
said, "*Le luxe, Monsieur le Maire, c'est le vide*", because he wanted
to put something in a certain space. And luxury is indeed space,
sometimes. I attended, with my good friend Roberto Benigni, a
concert given by our common friend Claudio Abbado, who was
conducting Mahler's Ninth Symphony in Lucerne. The Ninth fades
away into silence, whose length is decided by the conductor. Usually
it lasts for a few seconds, but he had chosen to let it go on for
almost a minute. We asked him, at the end of the symphony, why
he decided to have almost a minute of silence. He answered simply,
"*Questo è un lusso*". Luxury can be silence. The silence of music, but
even the silence of the word. Silence is something we're missing.

'We've just built the smallest of convents for the Poor Clare Sisters
in the northeast of France at Ronchamp. It houses just 12 nuns – it's
all about silence. The motto of the *Clarisses* is Silence, Joy, Prayer.
Prayer I couldn't do too much about, of course,' he smiles, 'but we
had to think very carefully about the silence and the joy. Silence
doesn't come alone; you have to build it up. Creating silence is a
good thing.'

It is unsurprising, perhaps, that to an architect there is a
substantive quality to the nature of silence. All the more so because,
as Piano goes on to explain, 'In Italian you "make" silence (*far
silenzio*). So, even though I could give many other answers and
perhaps there are many other answers, I am tempted to say that
space is indeed, sometimes, a form of luxury.'

He pauses to think. 'In architecture, in music, in painting …
When I was working on his museum in Texas, Cy Twombly was
always talking about the emptiness of canvas. Gillo Dorfles recently
wrote an interesting book about the "*horror pleni*" – as opposed
to the traditional idea of *horror vacui*. He points out that today
everyone is horrified by emptiness. We are always filling everything

up. Look at the streets, full of images and sounds. Life is full. We no longer appreciate emptiness, silence and space. I believe this is one of the things about luxury. Architectural voids, musical voids – even cinematic voids.

'Think about the silences of the great actors and actresses. These are some of the greatest moments in the history of cinema! One minute of silence, where it is all about the metamorphosis of expression. And you have to be an extremely good actor – silence is difficult to achieve. It's far harder to create emptiness than fullness.'

It is a poignant point, on which our conversation draws to a close. As Piano returns to his team to review progress on a new dream in the making, that personal luxury of silence remains an elusive quest ... for now.

Manifesto

Meta-luxury is the economic reflection
of a culture of excellence.

Meta-luxury brands embody the human quest
for unique achievements
that can stand the test of time,
enduring and evolving
from one generation to the next.

They challenge the boundaries of knowledge,
transforming history into the future,
sustaining excellence into eternity.

Index